WEAVING A CHRONICLE

JUDITH POXSON FAWKES

All men of whatsoever quality they be,
who have done anything of excellence, or which may properly resemble excellence,
ought, if they are persons of truth and honesty,
to describe their life with their own hand;
but they ought not to attempt so fine an enterprise till they have passed the age
of forty.

Benvenuto Cellini
age 58
born 1500

Schiffer Publishing Ltd®

4880 Lower Valley Road Atglen, Pennsylvania 19310

Other Schiffer Books on Related Subjects:
Geometric Design in Weaving. Else Regensteiner. ISBN: 0887400787. $29.95
Pictorial Weavings of the Navajo. Nancy N. Schiffer. ISBN: 0887403182. $12.95
Weaving as an Art Form. Theo Moorman. ISBN: 088740068X. $12.95
Weaving of the Southwest. Marian Rodee. ISBN: 0764318543. $29.95

Cover Design: Bruce Waters
Type set in Trajan Pro/Goudy Oldstyle

ISBN: 978-0-7643-4063-5
Printed in China

Schiffer Books are available at special discounts for bulk purchases for sales promotions or premiums. Special editions, including personalized covers, corporate imprints, and excerpts can be created in large quantities for special needs. For more information contact the publisher:

Published by Schiffer Publishing Ltd.
4880 Lower Valley Road
Atglen, PA 19310
Phone: (610) 593-1777; Fax: (610) 593-2002
E-mail: Info@schifferbooks.com

For the largest selection of fine reference books on this and related subjects, please visit our website at
www.schifferbooks.com
We are always looking for people to write books on new and related subjects. If you have an idea for a book, please contact us at
proposals@schifferbooks.com

This book may be purchased from the publisher.
Include $5.00 for shipping.
Please try your bookstore first.
You may write for a free catalog.

In Europe, Schiffer books are distributed by
Bushwood Books
6 Marksbury Ave.
Kew Gardens
Surrey TW9 4JF England
Phone: 44 (0) 20 8392 8585; Fax: 44 (0) 20 8392 9876
E-mail: info@bushwoodbooks.co.uk
Website: www.bushwoodbooks.co.uk

CONTENTS

Chapter IV

Tapestry Maps and More Axonometric Perspective ..60

Chapter V

Linen Inlay and its Applications: Abstract, Architectural, Botanical..........................**74**

Chapter VI

Weaving a Weaver's World...**88**

Chapter VII

Woven Landscapes—Near and Far.. 112

PREFACE

Weaving a Chronicle is the book I wanted when I was teaching weaving from 1965 to 1984. I wanted a history, written by a working weaver, of how the weaving techniques—inlay, double weave, and pattern weaves—are linked with imagery and how those links evolve. I wanted stories of weavings that provided answers to questions of motivation paired with technique. Consequently, in 2007, even though I had given up teaching, I self-published a catalog to accompany an exhibition of my tapestries. Its ninety-six pages contained colored images of forty-six tapestries made between 1965 and 1998. In the thirteen years since, I have produced fifty-seven tapestries for exhibition and nine commissioned tapestries (several commissions have tapestry pairs counted as one). The astute reader will notice that fewer tapestries than the ones counted above are reproduced in *Weaving a Chronicle*. Not all tapestries are equal aesthetically and I have tried to picture and discuss those that posses seminal ideas. Throughout this text I have indiscriminately and interchangeably used the terms weavings and tapestries for those described technically as inlay. Therefore tapestries labeled double weave and pattern weave avoid any controversy of correct technical identification sometimes engaged in by weavers and writers.

Of the two parts of this chronicle—tapestry and description—the tapestry is the truer chronicle. Each woven row chronicles an inviolate, momentary decision from the brain and heart of the weaver. Each row systematically builds, on the grid of warp and weft, a record of preoccupation. Each row is a triumph of either adherence to plan or spontaneous adaptation. The sum of the rows, a finished tapestry, illuminates daily existence and is a part of the on-going chronicle of how design ideas are conceived and executed. Each tapestry traces the origins, growth, and maturity of the wedding of imagery, technique, and material. Each tapestry revisits the lucky circumstances of commissions, travels, and Portland's sustaining environment. In writing about the tapestries forty-six years after the first tapestry was made, my written words are subject to revision. Although I've tried to focus on the circumstances of the tapestries' creation, the same as I try to do when I give slide talks, I'm prone to disclose very different aspects depending on audience, time, and place. My telling about the tapestries may metamorphose, but their woven structure does not.

The tapestries are grouped in chapters according to subject matter and circumstances surrounding their creation. Each series' concepts and techniques are not exclusive, nor were they woven chronologically. For example, the diagonal construction of the double woven Precipitation Series reemerged years later in the Invented Landscape Series woven in inlay. By contemplating the interplay of life's experiences with design concepts, techniques, and materials, I hope to include in my audience all those who are interested in a chronicle of visual ideas. A pleasurable, spontaneous loss of self occurs when I am at the loom making imagery emerge from process. It is my hope that these tapestries and their stories will provide a similar transport to the reader.

If Laura Russo had not taken me, the sole tapestry maker, into her family of painters and sculptors twenty-three years ago, I would not be the weaver I am. *Weaving a Chronicle* would not have been possible without the technical expertise of Katrina Woltze, assistant director of The Laura Russo gallery. Many thanks to Bill Bachhuber, my photographer for thirty-three years, responsible for all images, slides and digitals, except the first five, which I took myself. All tapestry sizes are in inches, height x width.

CHAPTER I

CRANBROOK—THEN FINDING MY OWN WAY IN NEW ENVIRONMENTS

The two years at Cranbrook Academy of Art, from which I emerged in 1965 with an MFA, began in turbulence. I had no idea of my destiny as a weaver; I only knew I wanted to be engaged in art making in graduate school and escape the terror of teaching high school art. I entered Cranbrook through a side door. Rejected for admission to the Painting Department, my printmaking instructor at Michigan State University John diMartelly pulled some strings and I was admitted to Cranbrook's printmaking program. After a week or so, when space miraculously opened in the Painting Department headed by diMartelly's friend Zoltan Sepeshy, I transferred to painting. Alone in my longed-for painting cubicle, I was at sea. I turned to the comfort of what felt familiar—the weaving studio. I began hanging out there and asking the students lots of questions. During the Christmas break, I determined to return to Cranbrook as a Weaving major or to quit grad school. In the new year, Glen Kaufman, chair of the Weaving department, counseled me on the gravity of my erratic course at Cranbrook, then admitted me on probation. He assigned me ten sample warps to be completed before Spring Break with no help from him. Because I had never woven before, I had to prevail on the ten MFA Weaving candidates to show me how to dress a loom. They, and books, taught me weaving techniques.

During that winter of 1964, while working at building a textile systematically on a grid of warp and weft, the uncertainty of long, lonely hours in a painting cubicle vanished. Having been taught to knit and sew by my mother from an early age, yarns and scissors were old friends. Step by step I wound the warp, threaded a pattern, and wove row by row. The long-term involvement required to create a weaving was as familiar and as reassuring as day follows night. Weaving wanted me and I gratefully embraced the loom with its exacting processes and felt at home.

That same winter I was falling in love with a fellow student, a painter, Tom Fawkes. He and I took long walks on the grounds of Cranbrook. I remember he showed me bright red stems emerging from blue snow. We both made drawings from the landscape. After I completed the ten sample warps, Glen Kaufman encouraged me to begin with tapestry. The combination of my under grad Painting major and my new pictorial woven samples indicated to Kaufman that I'd best build on past strengths. I tried various tapestry techniques in several small pieces that culminated in *Winter Walk*.

My thesis was a rambling paper that sought reasons for why humans make what they do, no doubt prompted by my irregular route at Cranbrook, and still being considered in this chronicle. The 1965 degree show requirements were met with three yards of fabric (mine included hand spun and dyed yarn), a blanket, a casement, a rug, tapestries, and three-dimensional structures. As students, we were aware of the new emphasis on art fabrics because of the exhibitions *Woven Forms* at the new Museum of Contemporary Crafts, opened in 1957 in New York, and the first (now defunct) *International Biennale of Tapestry* in Lausanne in 1962. But the woven works I admired most came from the Bauhaus, because they most evidenced the workings of the loom. I knew that my show, except for the non-art textiles, contained no works unique to the loom. Armed with the knowledge that what I admired most in historic textiles had not been present in the weavings in my own show, I began teaching at Southern Oregon State College in Ashland.

Here is the chronicle's visual beginning. It begins with *Winter Walk* and a remark. The tapestry was shown in my 1965 Master of Fine Arts Degree exhibition, the culmination of two years at Cranbrook Academy of Art. A watercolor made from a drawing of the Cranbrook campus was the source for *Winter Walk*. On seeing *Winter Walk* in my degree show a fellow student commented, "How sweet, your wove your boyfriend's watercolor." Outraged at being labeled craftsman to Tom Fawkes artist, I vainly tried to justify myself as having woven from my own watercolor. But that comment, as others in the future—equally off-hand—had profound implications for the direction in which I pursued weaving. I determined to never again translate another medium into tapestry. I resolved to produce, as did many of the Bauhaus weavers, what is unique to the loom.

Tom Fawkes and I were married August 25, 1967. We lived for one year in West Bend, Wisconsin, half way between our two teaching jobs—his at University of Wisconsin in Milwaukee, mine at Wisconsin State University-Oshkosh—two hour commutes for both of us. We spent our first married summer together in northern Europe. In the fall we moved to Eugene, Oregon, where Tom began teaching at the University of Oregon, and I at Maude Kerns Art Center.

Although *Winter Walk* was the pinnacle of my graduate work in tapestry, it was a mistake to be overcome. For several years I moved it with me from studio to new studio. Finally, in ultimate disavowal, I cut it up and threw it in the garbage.

Winter Walk, 36" x 40", wool, inlay, and soumak, 1965

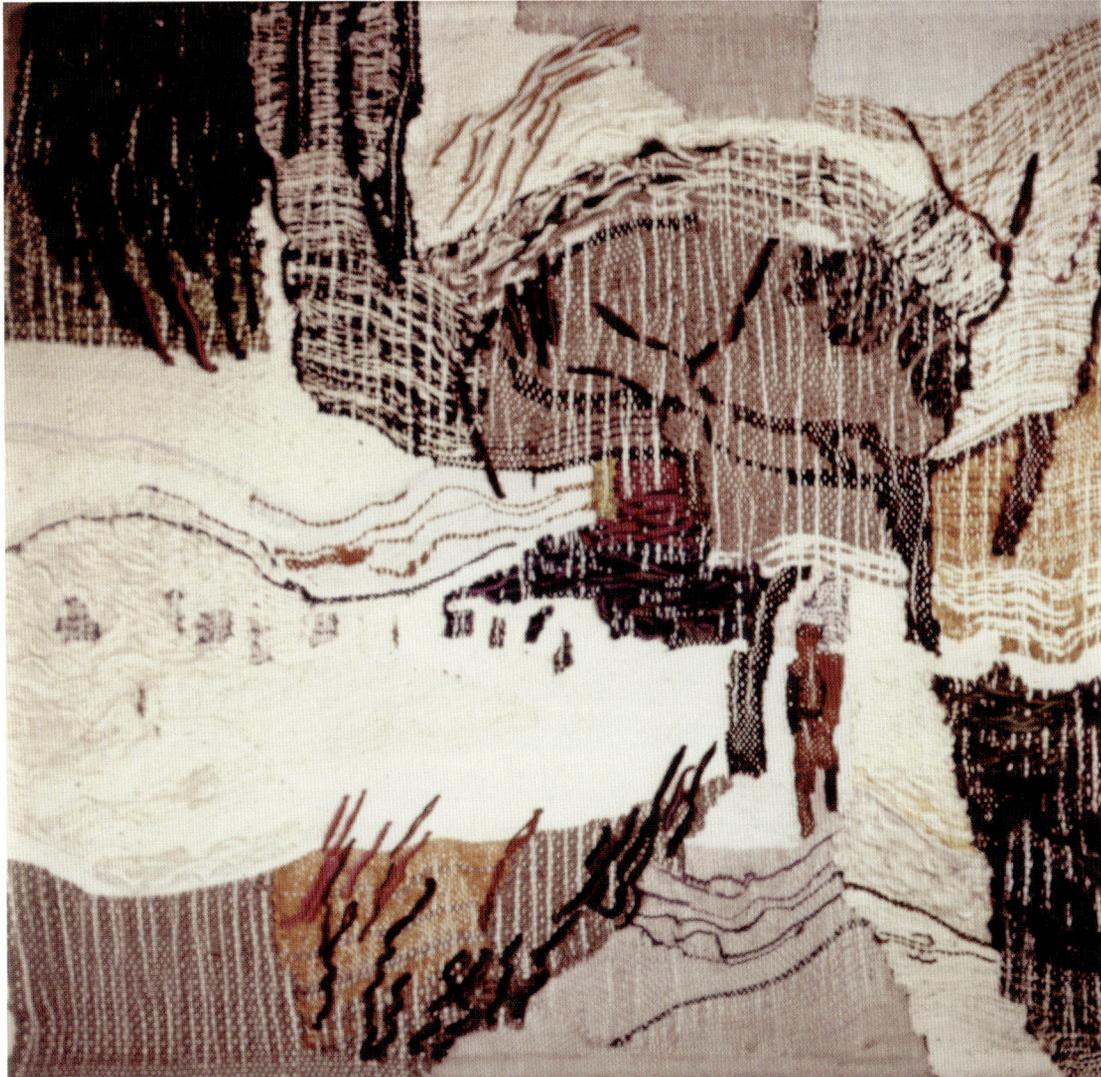

The weavings from the Bauhaus I admire most are double weave. In *On Weaving* (pg. 50) Anni Albers, of the Bauhaus, discusses the technique.

> Double weaves have a special nimbus about them for reasons not clear to me. They are thought to be intricate, hard to grasp, open only to advanced students. To my mind they are simple to understand and can be handled by anyone with just common sense—which, I admit, sometimes seems rare.
>
> Double weaves are fabrics that have two separate layers which can be locked at both sides, at one side, or, within the fabric, at any number of places where the design asks for an exchange of top and bottom layers, usually of different colors…

Incredibly I had not learned double weave at Cranbrook. During the summer of 1966, after one year of teaching at Southern Oregon State College, I received a tuition scholarship to Haystack Mountain School of Crafts in Maine to study multi-layered weaving. There, on a loom on a deck overlooking the Atlantic Ocean, I wove my first double and triple weaves. In the fall, in my new studio in Oshkosh, Wisconsin, where I taught at Wisconsin State University, I continued experiments begun at Haystack in balanced weave double cloths in wool and cotton, similar to the 1920s work of Anni Albers.

I also felt a growing kinship with many of the artists whose works were shown in *The Responsive Eye* exhibition at the Museum of Modern Art in 1965. Their systematic methods of construction: their warp and weft-like verticals and horizontals, the grid, the repetitive markings, and emphasis on geometry were the methods and results of weaving, especially double weave. For *Blue, Green and White*, I wanted a substantial, sculptural fabric so I joined two layers of weft-faced weave. The upper layer of the tapestry is woven in 4" wide vertical strips, which are pinched and sewn together to reveal the lower layer.

Blue, Green and White was shown in "Young Americans" at the Museum of Contemporary Crafts in New York in 1969. The exhibition was a competition open to crafts people in all media under the age of 30.

Blue, Green, and White, 44" square, wool, weft faced double weave, 1968.

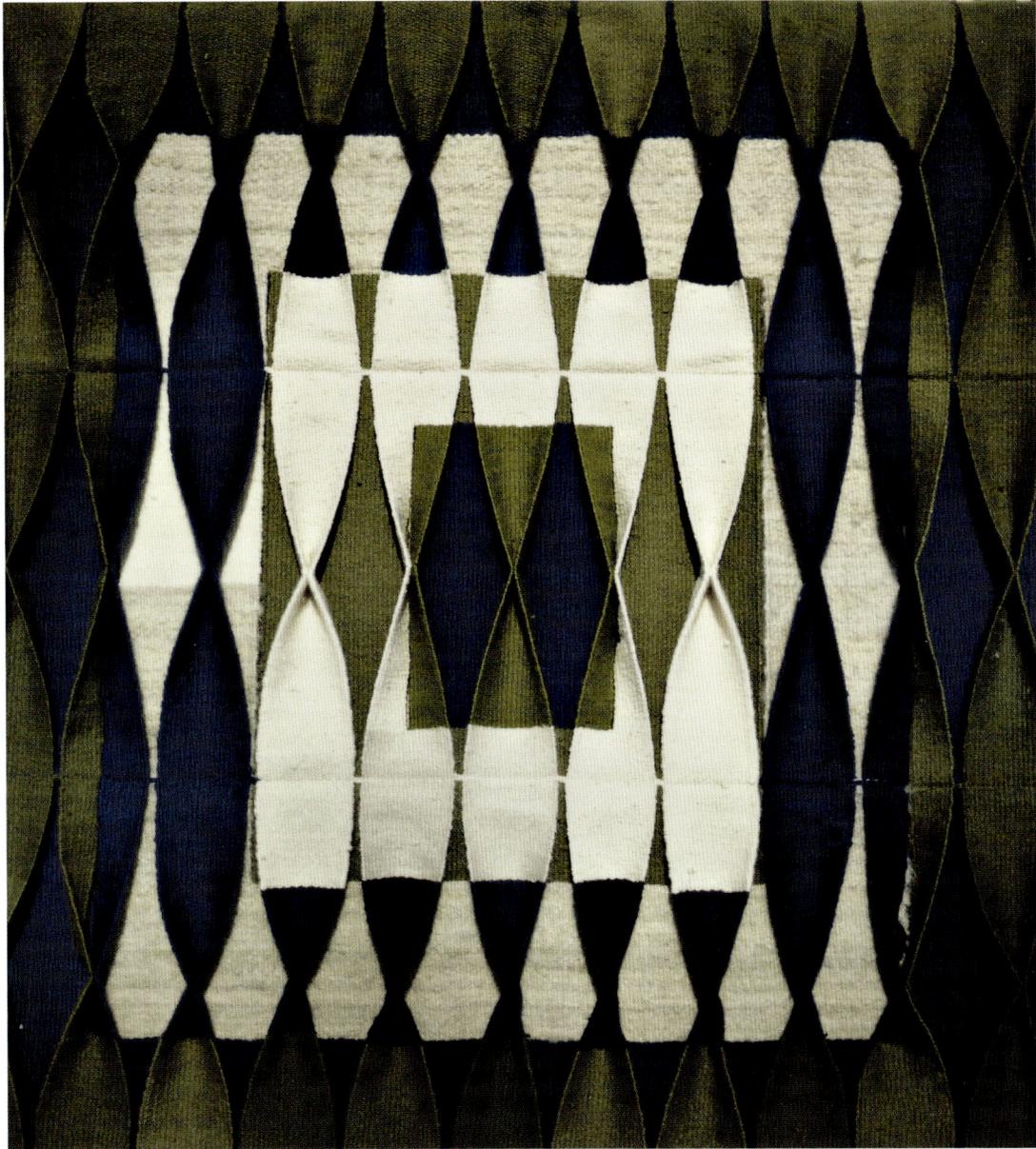

Home Sweet Home grew out of a great family sadness. Two years before, my twenty-one-month-old niece, Sarah Poxson Sparks, died. The toy she was riding fell into the street and she was run over. My sister, Anne, was witness to her daughter's death. My sister asked if I would make a weaving for Sarah. In grief for my sister's family, I wanted to weave a tapestry that would comfort me as I worked. Needing to feel part of a continuum, I turned to pattern books. I wanted to weave what other women before me had woven. I studied the pages of patterns whose names made a litany: Pioneer Trail, Winding Stairs, Voice of the Woods, The Cloudless Beauty, Rhode Island Perplexity, Soldier's Return, Cabin in the Lane, Cluster of Vines, Boston, Flourishing Wave, Rising and Setting Sun. Following old weaving directions, I submerged myself in the same work as women before and, I hope, after me. Sarah's tapestry looks like a baby blanket, a shroud, of overshot pattern in whites and pinks. In the center, I discontinued the pattern, (the same as in *Home Sweet Home*) and there I inlaid block letters in a vertical stack paling as they descended: her initials SPS, my initials JPF, the year of her death, 1973.

When Sarah died in 1973 our two daughters, Anne Glynnis and Elizabeth Poxson, were three and ten months old respectively. The year before, in 1972, Tom and I moved our family from Eugene to Portland so he could teach at the Museum Art School, now called Pacific Northwest College of Art (PNCA), from which Tom is now retired.

Home Sweet Home was woven from a cartoon suspended below the warp. The cartoon was made by projecting the negative of a photograph I took of our freeway exit. The imagery is woven inlay and it is surrounded by a large overshot pattern. At the time I wove the tapestry I was teaching at three different colleges around the Portland area. My existence was fragmented. In addition to coordinating plans for three classes and care for our baby, Elizabeth, and preschooler, Glynnis, I spent hours in a VW bus commuting. The hours driving were lulling, exhausting, recuperating, and real. After making Sarah's tapestry, I needed to continue the rhythmic escape provided by pattern weaving and I wove several freeway tapestries, of which *Home Sweet Home* was the first. Only now do I find irony in the fact that I escaped reality by weaving it.

Home Sweet Home was purchased by Alice and Wayne Plummer, who lived off the Terwilliger Blvd. Exit. Alice was preschool teacher for Glynnis. The tapestry was shown in the exhibit Contemporary Crafts of the Americas: 1975, which opened at Colorado State University, Fort Collins, and then was toured by the Smithsonian for two years.

Home Sweet Home, 43" x 42", wool, overshot pattern weave with inlay, 1974.

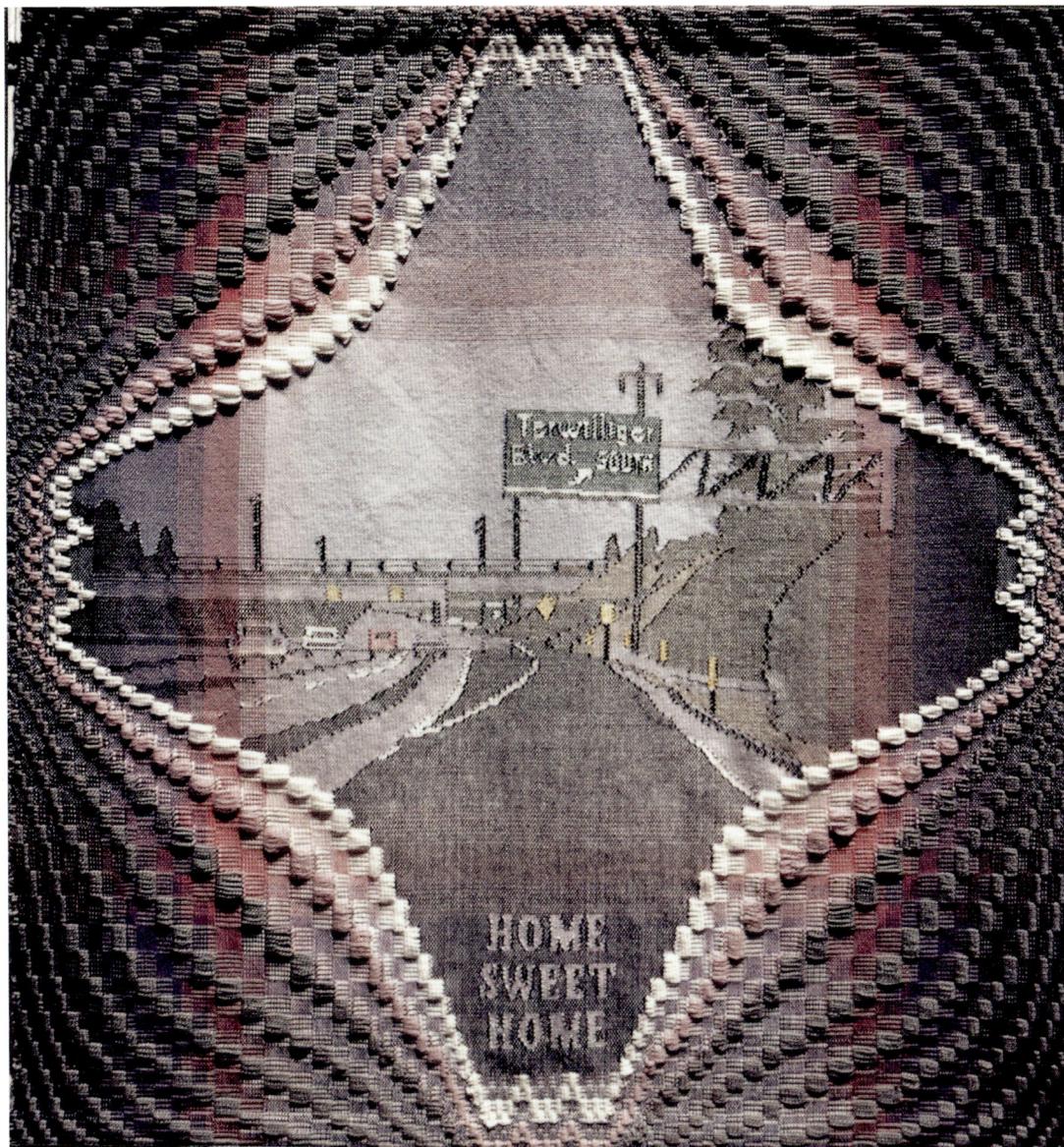

After *Home Sweet Home*, I reviewed black and white photographs taken by my grandfather, my father, and by me of summers in Michigan on Burt Lake. Photographs of the forty acres of land that fronted the lake provided imagery for a series of new tapestries. Summering on Burt Lake was escape, safety, an abolition of time, a reliance on self, an envelopment of family. Weaving *Burt Lake* from a photograph taken by my grandfather, Elijah Poxson, I continued comforting myself for the loss of Sarah, the loss of visits to Michigan, the loss of youth.

S. Zielinski's *Encyclopaedia of Handweaving* (pg. 111) defines Overshot Weave.

> This weave is or has been known in every country where hand-weaving reached a fairly advanced stage, but it has been developed to the highest degree in Colonial weaving. Overshot is essentially a 4-shaft weave, although it can be woven on a higher number. The pattern is produced by floats (nearly always in weft) on a plain tabby ground.

Burt Lake's overshot pattern was chosen because it suggests the effect of a stone thrown in water. As in Sarah's weaving, the function of the ghiordes knotted cut pile is to provide a third texture in addition to the flat tabby and the pattern floats. As weaving old overshot patterns made me part of a continuum, weaving from a photograph taken by my dead grandfather further immersed me in family history. *Burt Lake* is the second of several tapestries based on photographs of childhood summers.

I gave *Burt Lake* to my parents, now deceased, and it hung in their California townhouse. The rolled tapestry resides in our storage room.

Burt Lake, 49" x 41", wool, overshot pattern, inlay and cut pile, 1974 .

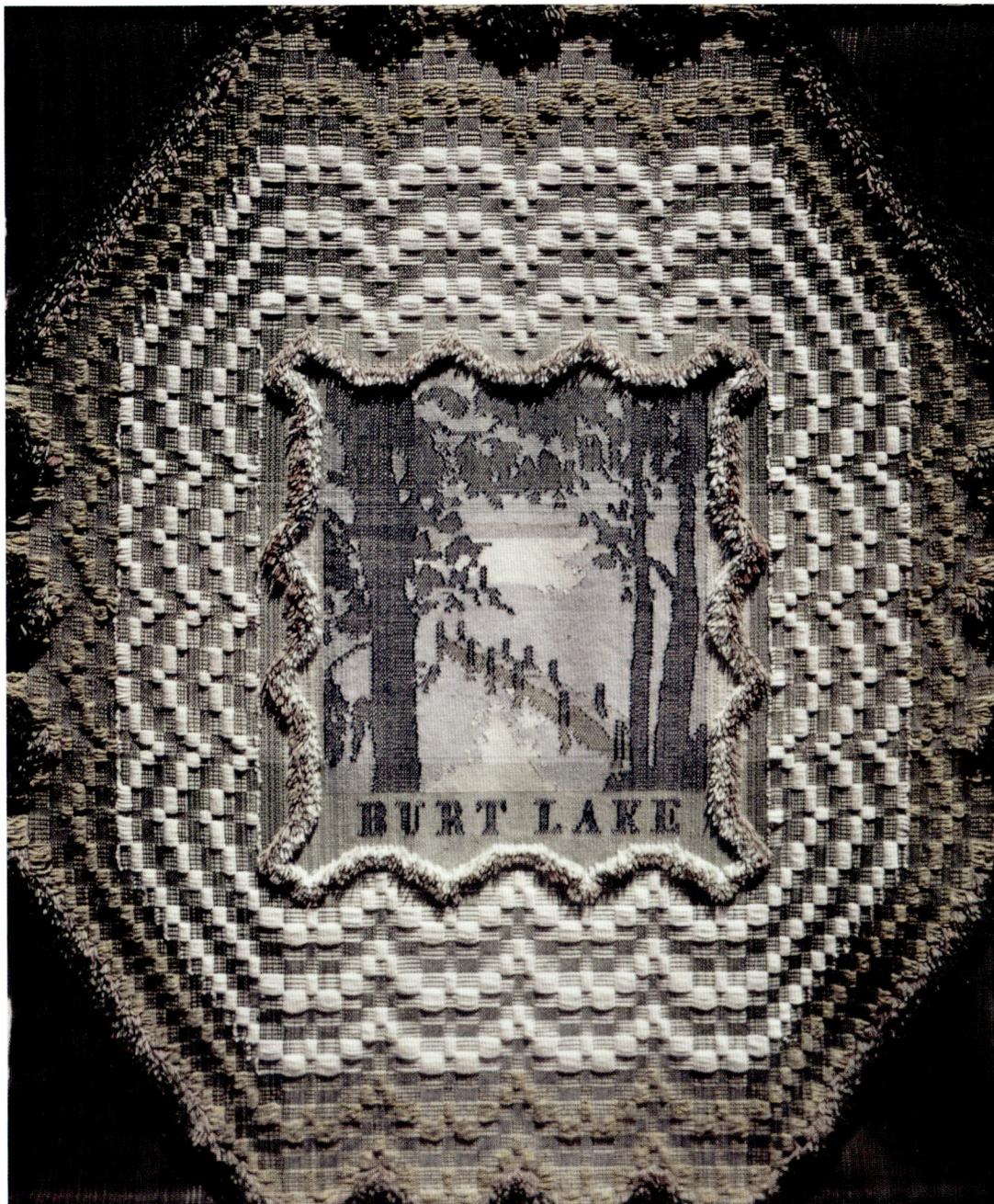

Although I'd preferred a weft-faced substantial two layer fabric for *Blue, Green and White*, I hadn't given up on the balanced weave favored by Anni Albers. I'd been using colored warps in the Freeway series and liked their dramatic grading effect in the plain woven areas. For *Color Quadrant* I used the entire color spectrum for the warp and the weft in a balanced weave which I hoped would create an illusion of depth that would overpower the light weight, domestic size of this first experiment in returning to double weave.

The two separate warps for *Color Quadrant* were set up in stripes on the loom like this:

top warp
Black Violet Blue Green Yellow White Yellow Orange Red Violet Black
bottom warp
White Yellow Orange Red Violet Black Violet Blue Green Yellow White

During weaving, I joined the top and bottom layers in vertical stripes by "lifting them out of the way" with a pick up stick, as described by Anni Albers. Weaving up the warp, I progressively used all the colors of the warp in order, in the same amounts, thereby finishing a square tapestry. The inevitableness of this tapestry's construction is inextricably linked with the mystery of undulating color that results from its logical construction process. Off the loom and on the wall—shimmering color. Blue and orange threads woven together read as grey—a lively vibrating grey very different in character than black woven with white. Blue woven with blue looks flat, pure, and still. Because many variants of these examples occur in *Color Quadrant*, flat color appears to hover above and below a mist of grays.

Color Quadrant was purchased by Rachael Griffin from a 1975 show at Contemporary Crafts Gallery. She subsequently wrote an article about me for *Fiberarts* magazine in 1980, "A Conversion of Sorts. Judith Poxson Fawkes: A Background in Painting, A Present in Weaving." Rachael Griffin was identified as "Curator Emeritus of the Portland Art Museum, has organized craft exhibitions there and written numerous articles about crafts." Rachael told me she hung *Color Quadrant* at the foot of her bed to see first thing in the morning and last thing at night. When Rachael Griffin died, a scholarship was established in her name at Pacific Northwest College of Art. When our daughter Glynnis was a student at the college, she won the annual Rachael Griffin Scholarship.

Color Quadrant, 32" square, cotton double weave, 1976.

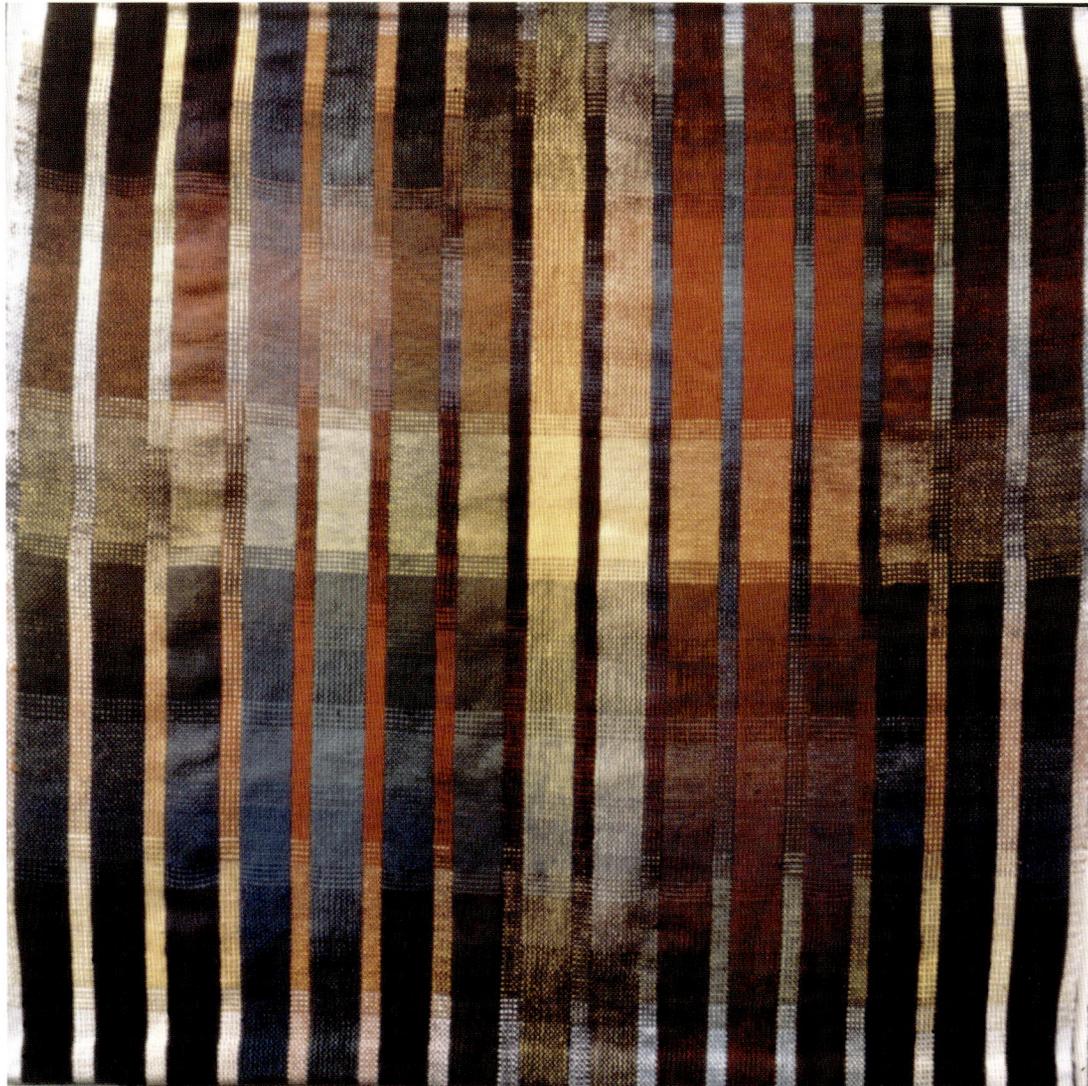

Following *Color Quadrant*, *Rainbow Columns* is a large sample of what might be possible in cotton double weave. As in its predecessor, I began at the bottom. With no plan on paper, I started by joining both layers with various treadlings—twills and plain weave—and incorporated three horizontal rows of double weave. Twelve inches up from the bottom I broke into two layers of double weave of graded colors to make subtle, transitional horizontal stripes. The graded color in the columns are one inch squares separated by four rows of transition color to the next square—eight rows of red, transitioning to violet, red, violet, red, eight rows of violet, blue, violet, blue, violet, eight rows of blue—continuing though the colors of the spectrum.

Rainbow Columns, 60" x 36", cotton double weave, 1977.

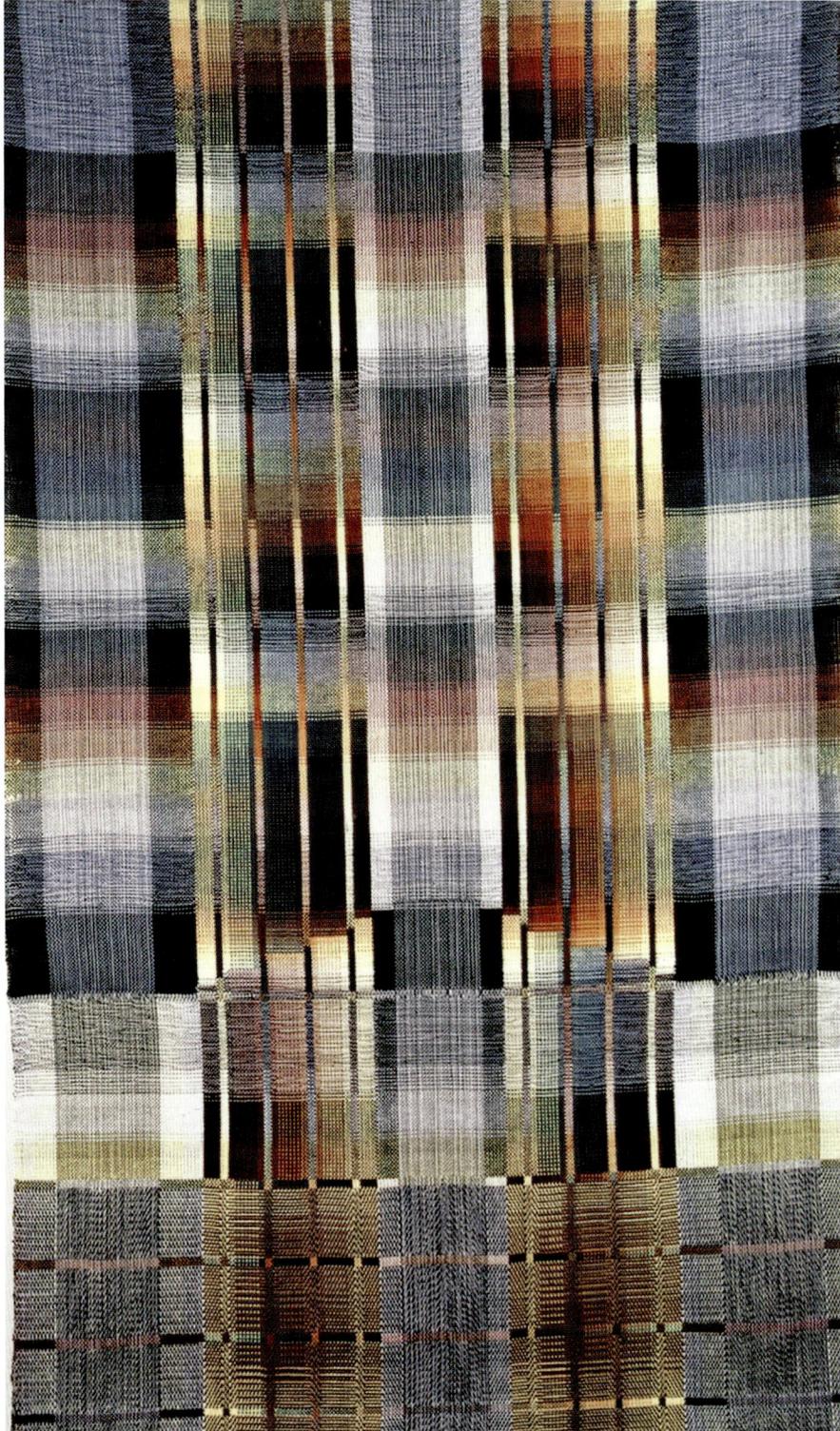

We moved. We sold our one story, two bedroom, one bath house, with separate garage studios, in southwest Portland for a three story, five bedroom, five bath, with in house studios, in northwest Portland. *Slow* pictures our new and present Home Sweet Home.

Our new 1905 south facing house is in the artists' community of Willamette Heights. Now there are more doctors and lawyers here than artists. When we came here in 1977, many of the big old houses were inhabited by artists and teachers who became friends. They were affiliated with the Museum Art School, Portland State University, and with Lewis and Clark College, where I taught. My studio is a sun porch on the east side, ground floor of the house; Tom's studio is on the third floor. From my studio windows I see Mt. St. Helens to the north, my garden, shared driveway, and handsome house of our neighbors to the east, and Forest Park runners and cyclists passing on the Thurman Street side to the south.

Into the new studio I moved the forty-eight inch wide Macomber loom containing my half finished first commission—eight cotton double woven panels—similar to *Color Quadrant*—for a thirty foot wall in Hearing Room C of the State Capitol in Salem. Tom gave up half a year of studio time to fix and paint the house. Five years before, in rehabilitating our much smaller house in southwest Portland, Tom taught me to paint woodwork and roll a wall. As soon as I finished the commission, I joined him in working on the house.

Geographically, Willamette Heights is as nurturing as our house and neighbors. Entrance to the neighborhood is clearly defined by walking or driving over the Thurman Street Bridge above Balch Creek in Forest Park. The Thurman-Aspen loop, the neighborhood's main arterial, is an uphill-downhill half hour walk. Willamette Heights nestles between the industrial-zoned flats along the Willamette River to the north and Forest Park, the nation's largest urban reserve, to the southwest. North views from our back windows: foreground—flat warehouse roofs, mid-ground—ships gliding the river, background—east side neighborhoods, the Fremont Bridge, planes landing and taking off from Portland International. To the southwest, one may escape into old growth forest. Willamette Heights and this house have provided astonishing riches, visual and social.

Slow was purchased by the law firm of Lindsay, Hart, Neil, and Weigler, Portland. Carol and Gerry Weigler were our neighbors kitty-corner in Willamette Heights.

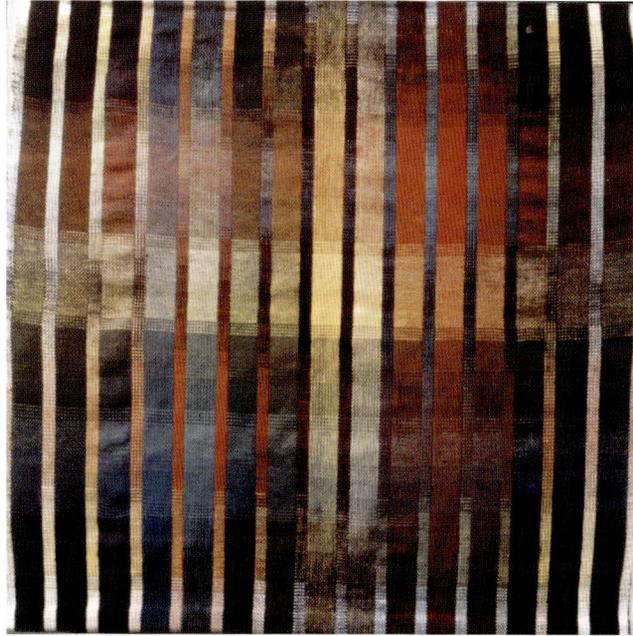

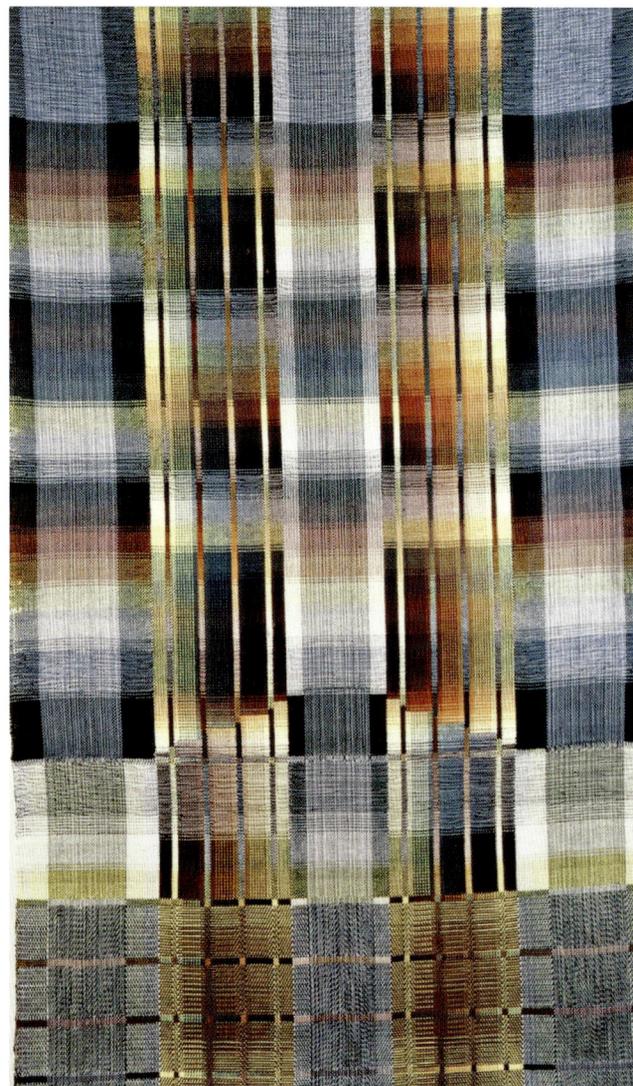

After *Color Quadrant* and *Rainbow Columns,* I wove approximately a dozen double weave tapestries in the 1970s. I also created my first public commission for a hearing room in the State of Oregon Capitol Expansion Project, Salem, Oregon. The cotton warp for eight double weave panels to cover a thirty foot curving wall behind a curving desk was on my loom when we moved into our new house. The loom and warp survived the move and provided a welcome consolation for me, spending time weaving amidst the chaos of unpacking into a new, much larger house.

Through the thirty-three years since *Rainbow Columns,* I've climbed periodically to the third floor storage room & brought the weaving down to hang in the living room to raise my spirits with the beauty of graded colors, the daring I experienced while weaving without a pattern, a consideration of returning to cotton as linen is so much more expensive, and for the reminder of the possibilities double weave offers.

Slow, 48" square, linen and wool, overshot pattern weave with inlay, 1977.

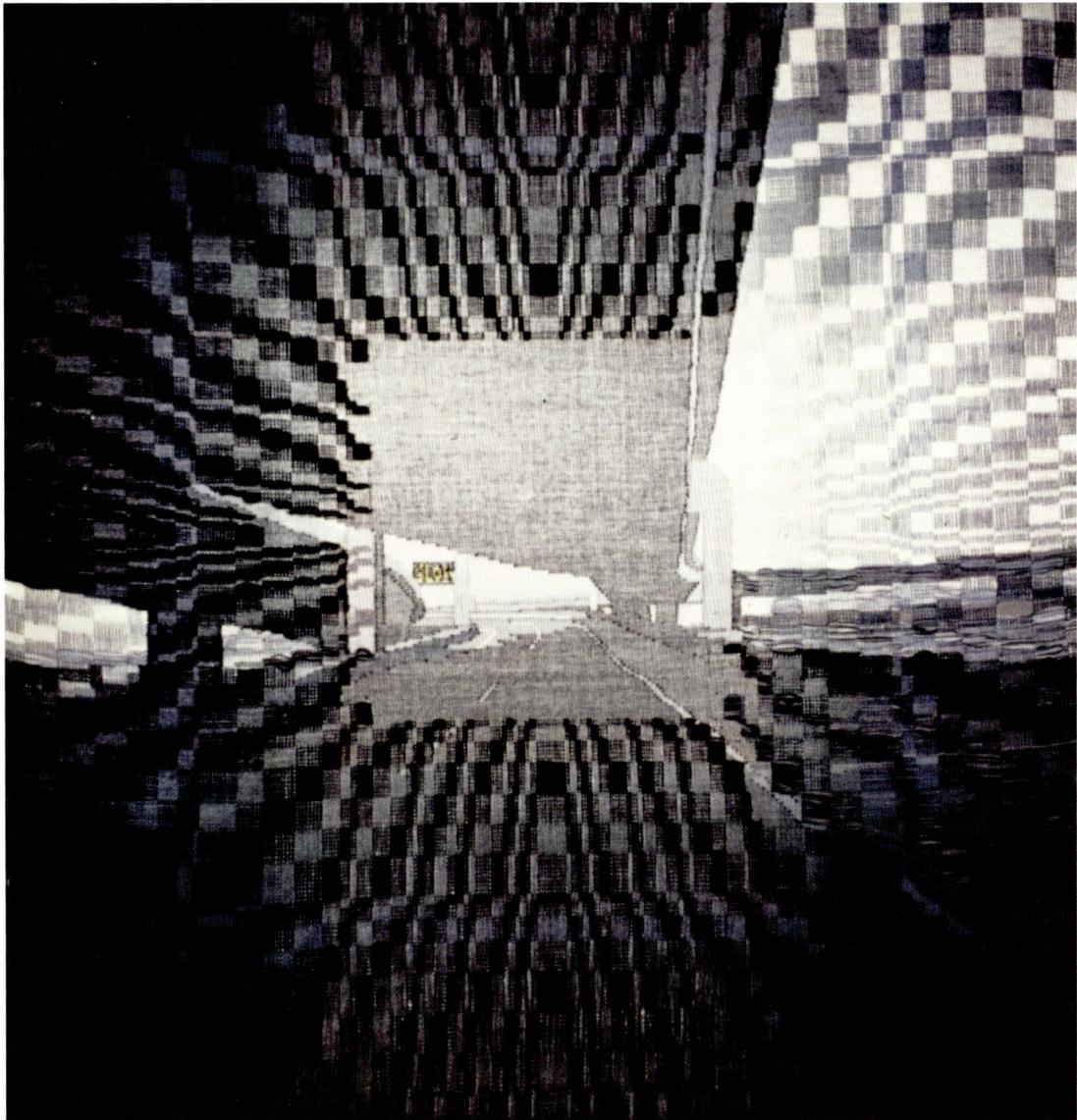

CHAPTER II

PORTLAND'S PRECIPITATION AND PLANNED ENVIRONMENT

Luxuriating in the interior space of the Thurman Street house, the beckoning surroundings of northwest Portland, the daily walks with our daughters to Chapman school, and my sole commute to teach at Lewis and Clark College, we eased into a more expansive existence. With children in school, I had more time to weave. My mother jubilantly greeted my thirty-eighth birthday in 1979—it had been her favorite year.

During 1980, I received a Crafts Fellowship from the National Endowment for the Arts. At that time, a peer review process was in place for awarding the $10,000 grants. I was elated to be acknowledged by fellow craftspersons across the country. The Fellowship enabled me to take a year away from teaching. In 1981, Tom and I traveled to Europe for a fourth time. We saw the *International Biennale of Tapestry* in Lausanne, which was my first look at contemporary, non-American tapestry. We also visited Paris, Giverny, and the Italian Lakes. Bellagio on Lake Como was to become a fated future return destination. I was proud to go home to the City of Roses and rain.

Tapestries of these years directly reflect Portland's climate and man-made environment. The Shadow series depend on rare Portland sunshine. Each tapestry of the Precipitation series is named after the month in which it was woven. Although Portland gets no more rain per year than New York City, it falls slowly. Skies remain leaden. When rains darkened the winter sky for weeks, I did indeed feel like one of the prisoners chained inside the cave as described by Socrates in Plato's *Republic*. There too I huddled, fire at my back, watching shadows of unseen real people and objects on cave walls. Sunshine is rare in Portland in winter. I turned from weaving freeway exits perceived inside a speeding VW bus to weaving still shadows caused by sunshine. The people and objects of the Shadow series exist because they're made of longed-for light. I shone a projector light on Anne Glynnis Fawkes and Elizabeth Poxson Fawkes and traced their silhouettes to make a cartoon for *AGF, EPF, 1980*. The girls' shadows fall on panels modeled after those in our dining room. The cartoon was pinned below the warp during weaving.

The tapestry hangs in the upstairs family room. In its presence I can almost hold those life-size bodies, now grown into young women, both partnered, both mothers—giving us a total of three grandchildren—living in Burlington, Vermont, and Denver, Colorado.

AGF, EPF, 1980, 44" x 41", linen and cotton inlay, 1980.

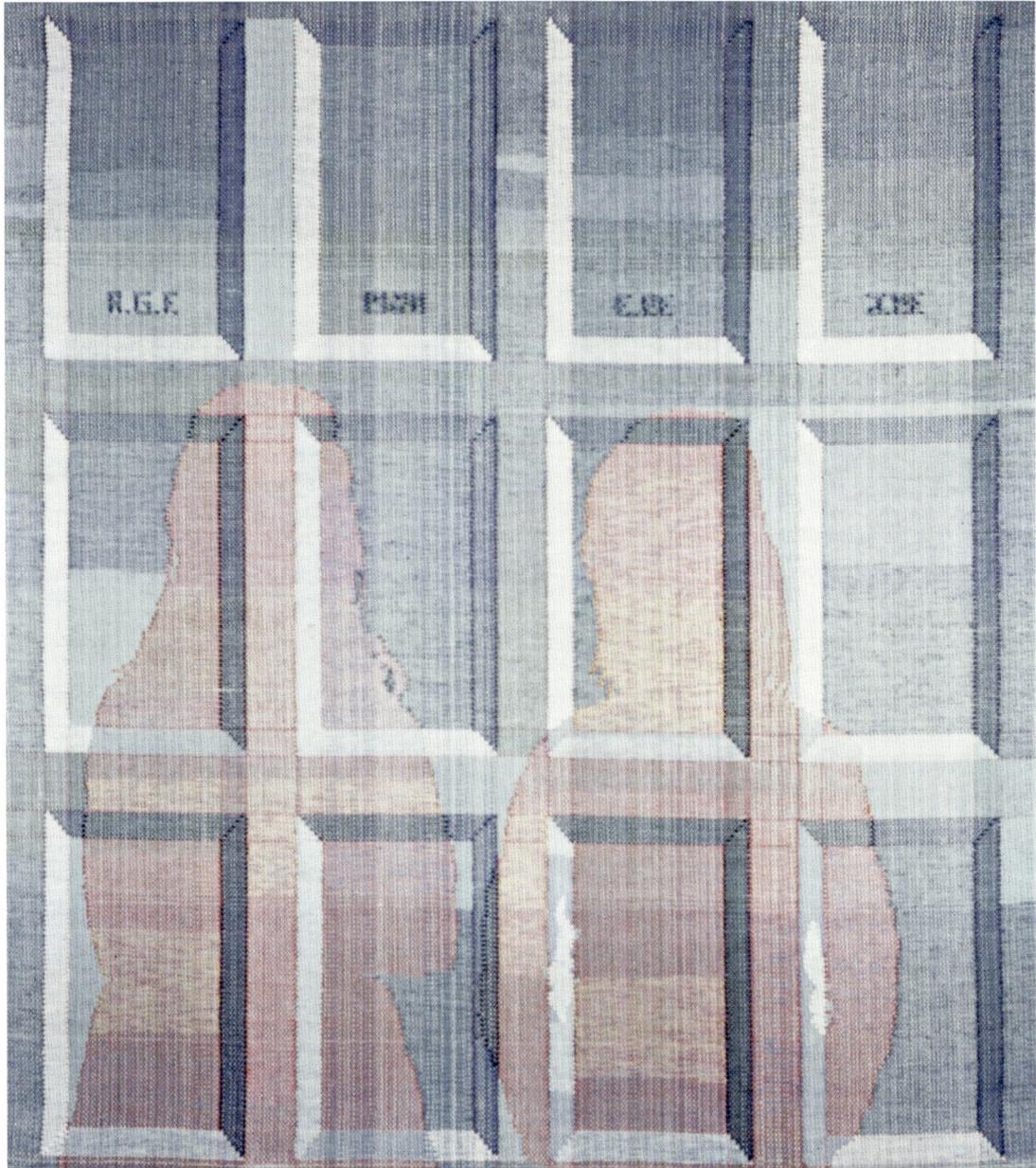

The grid of painted-over industrial casement windows receives the shadow of the Fremont Bridge in this tapestry. The bridge, which carries I-405 across the Willamette River, is a short walk away from our house straight down Thurman Street. On the west side of the river the Fremont connects to a magnificent, hugely elevated interchange that almost arches over the dome of St. Patrick's church. Walks below the interchange and the bridge, filled with the rushing roar of traffic overhead, are invigorating. I measured the proportions of industrial windows and took photographs of the Fremont Bridge from many angles. In the studio these source materials allowed me to play with superimposing various bridge images on the grid to make a cartoon.

Inlay is defined by Zielinski (pg. 87) as "Any free weave in which the pattern weft is 'laid in' with fingers, and not thrown in as usual." By "thrown in" Zielinski means on a shuttle, selvage to selvage. Picture, then, white Mexican cloth with small red wool inlaid animals. Then picture my addition of background color over the white plain weave. The plain weave, or ground, on a separate shuttle, is thrown selvedge to selvedge. The color inlay "is 'laid in' with fingers" on top of each ground thread. All tapestry warps in the Aerial Views of Cities are set at twelve ends per inch. The inlay threads are used two or three fold.

The tapestry was purchased by the Metropolitan Arts Commission, now Regional Arts and Culture Council. It is rotated among city offices.

Fremont Bridge—December, 40" x 44", linen inlay, 1980.

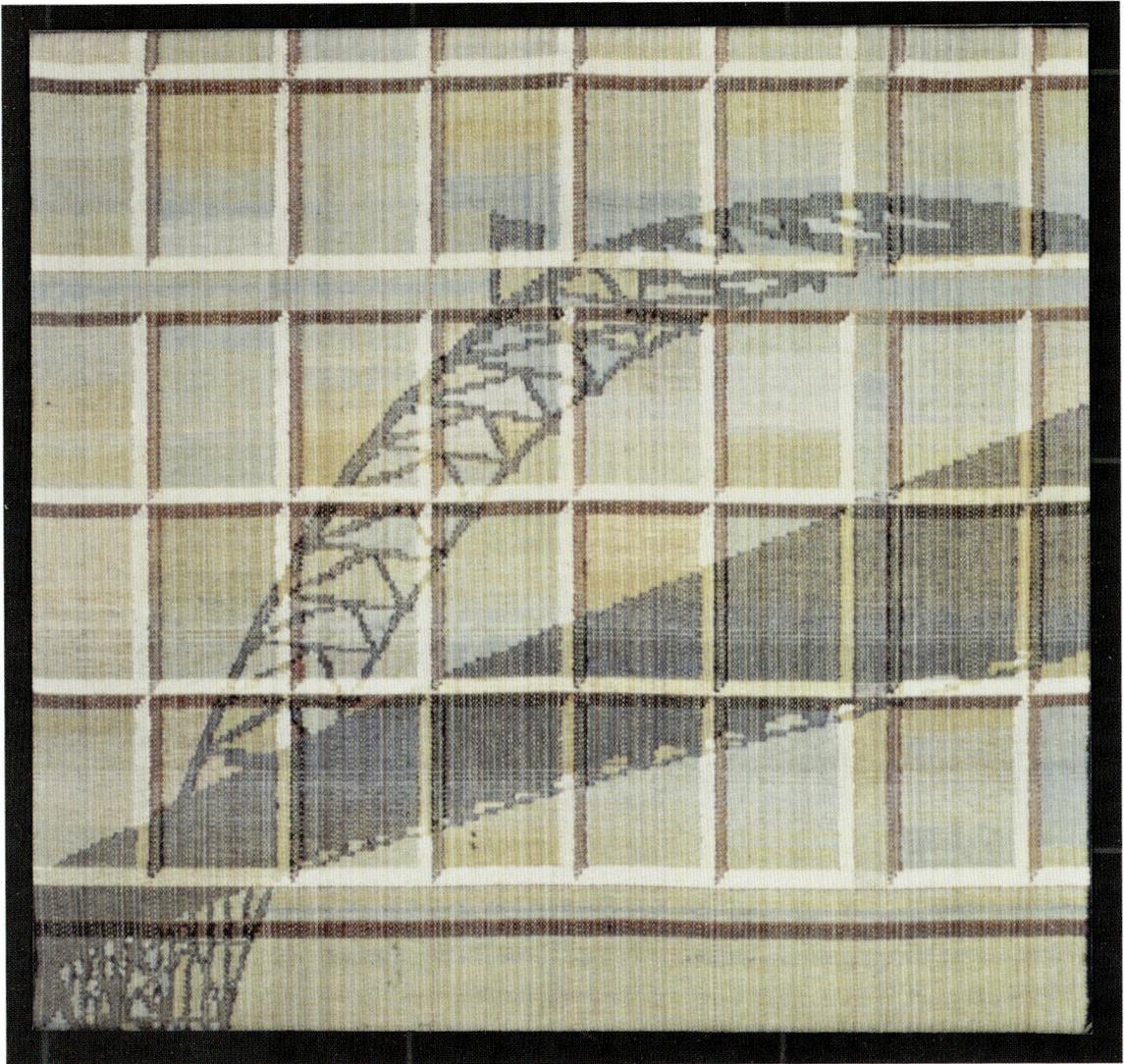

My approximately eleven by twenty-four foot studio is surrounded by windows on three sides, a fireplace on the fourth. Its entrance from the house is through three sets of french doors. Here, the smaller of my two Macomber looms is pictured in shadow against one pair of french doors. *Studio* is a portrait of sanctuary, the place on earth I am most at home. *Studio* is the last of the Shadows series. *Myself*, not pictured, was the first. A shadow's existence depends on rare sunshine. In the next use of the inlay technique I looked directly at subject matter in varying conditions of light, yet from a removed vantage point, in the Aerial Views of Cities series.

Studio was shown in *New Directions: Clay and Fiber—1982* at the East Carolina University Museum of Art/ Gray Art Gallery, Greenville, NC, in 1982. The tapestry is in the collection of the School of Medicine, East Carolina University.

Studio, 78" x 42", linen inlay, 1981.

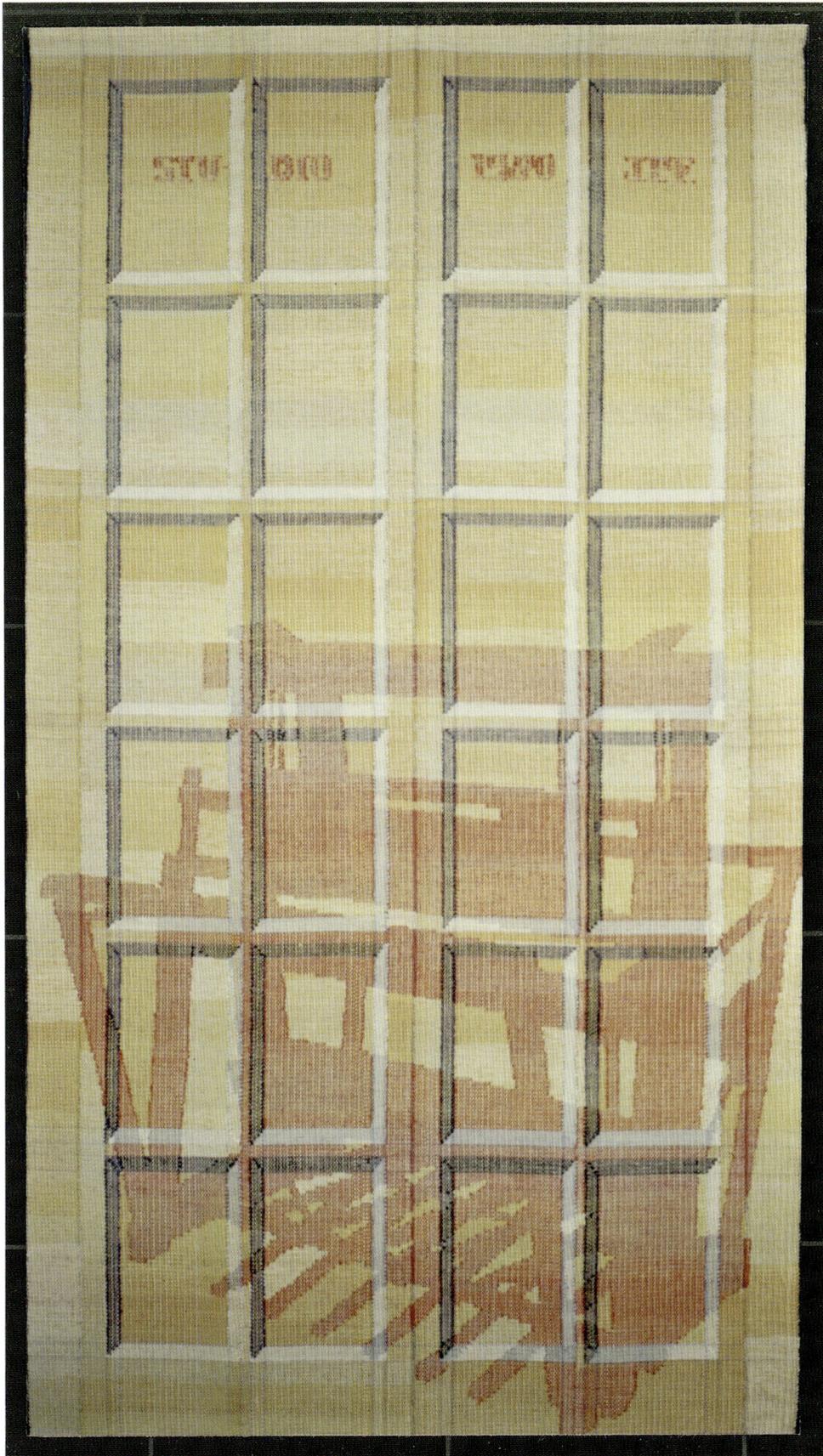

During the three years between *Color Quadrant* and *September Precipitation*, I wove double weaves joined horizontally and vertically. The eight double woven panels, completed in 1977 for the State of Oregon Capitol Expansion Project, were joined vertically similar to *Color Quadrant*. *September Precipitation* is the first, best attempt to join the layers diagonally. Often the weaving process—the moiré pattern of open warp, the insertion of pick-up stick, the slide of stick toward the beater to make a new shed, the pull out, the rhythmic beat-beat—is more beautiful than the finished product. *September Precipitation* tries to be as gorgeous as the process of weaving. The diagonal structure of the Precipitation Series is as unrelenting as rain in the City of Roses. Tapestries are named after the months in which they were woven.

Mikael Henderson of Henderson Massengill art consultants of Houston, Texas, bought *September Precipitation* from a 1979 show at Contemporary Crafts Gallery. The purchase, for the collection of Shell Oil, was the beginning of a fruitful association that accelerated in the mid-1980s.

September Precipitation, 55" x 40", linen double weave, 1979.

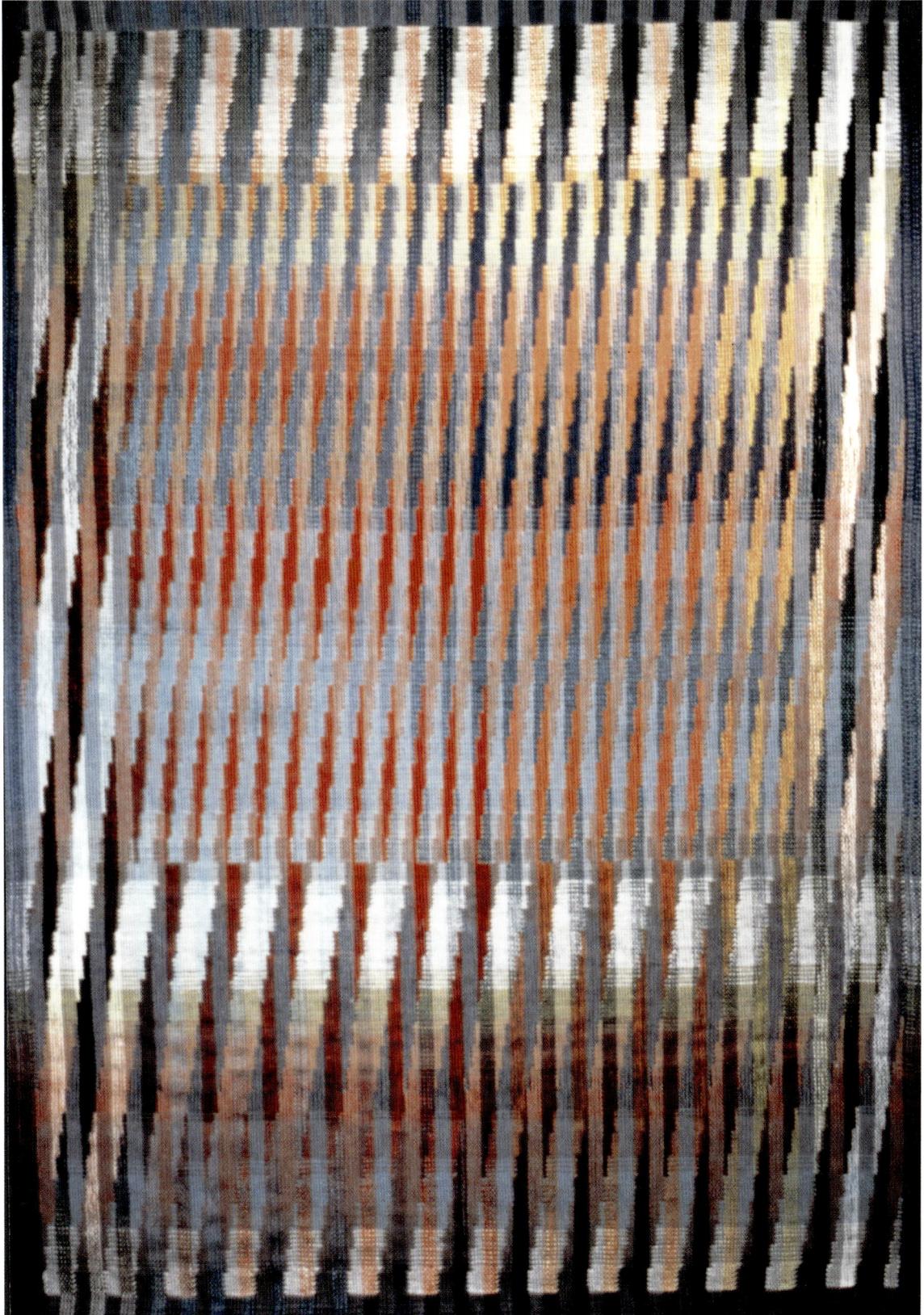

March Precipitation II, 78" x 42", linen double weave, 1981.

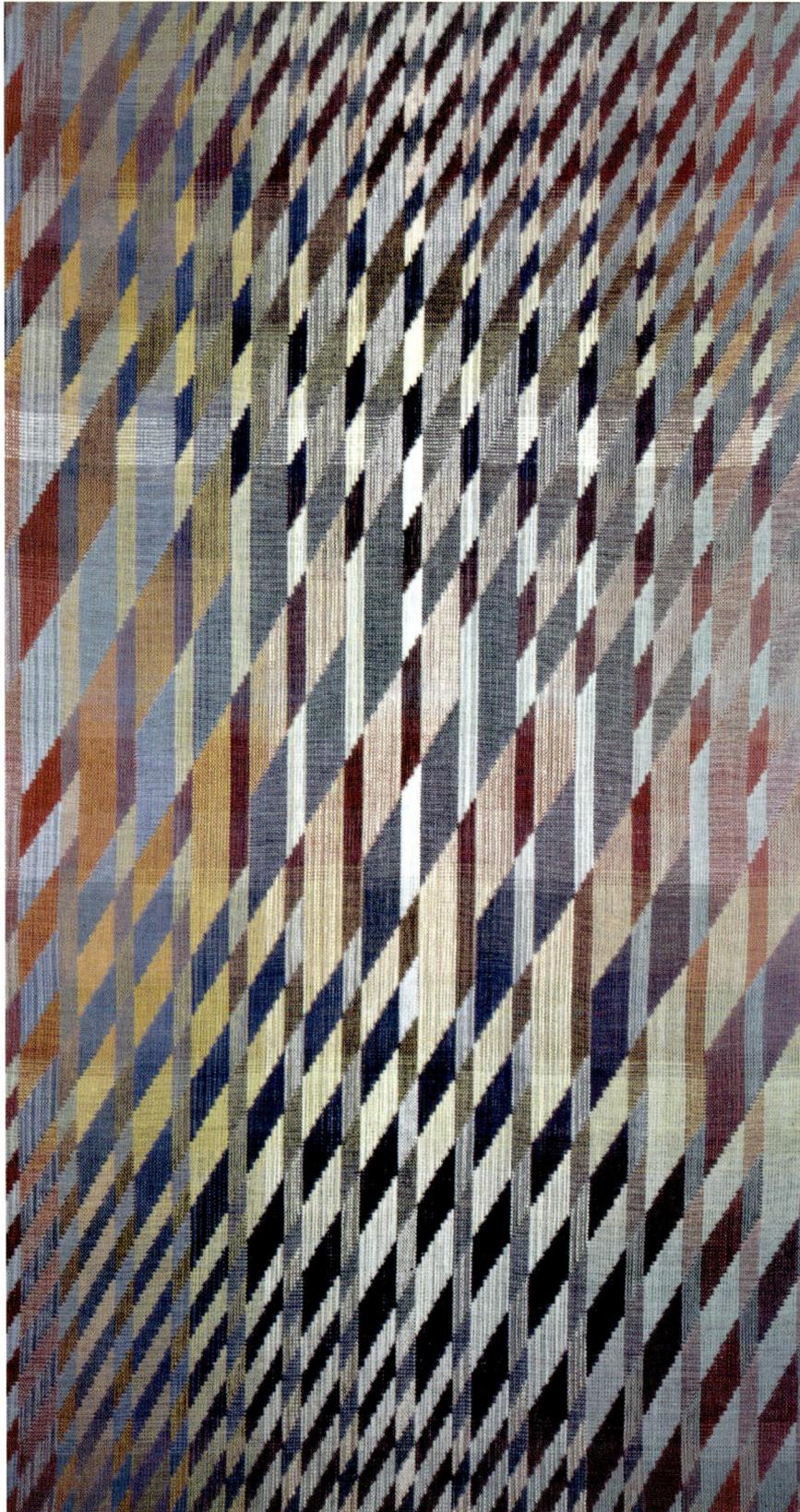

The S curve is an illusion caused by three widths of diagonals—narrowest at the top and bottom, widest in the center. The angle of the diagonal structure never varies, only the width of the diagonals.

June Precipitation II, 79" x 42", linen double weave, 1981.

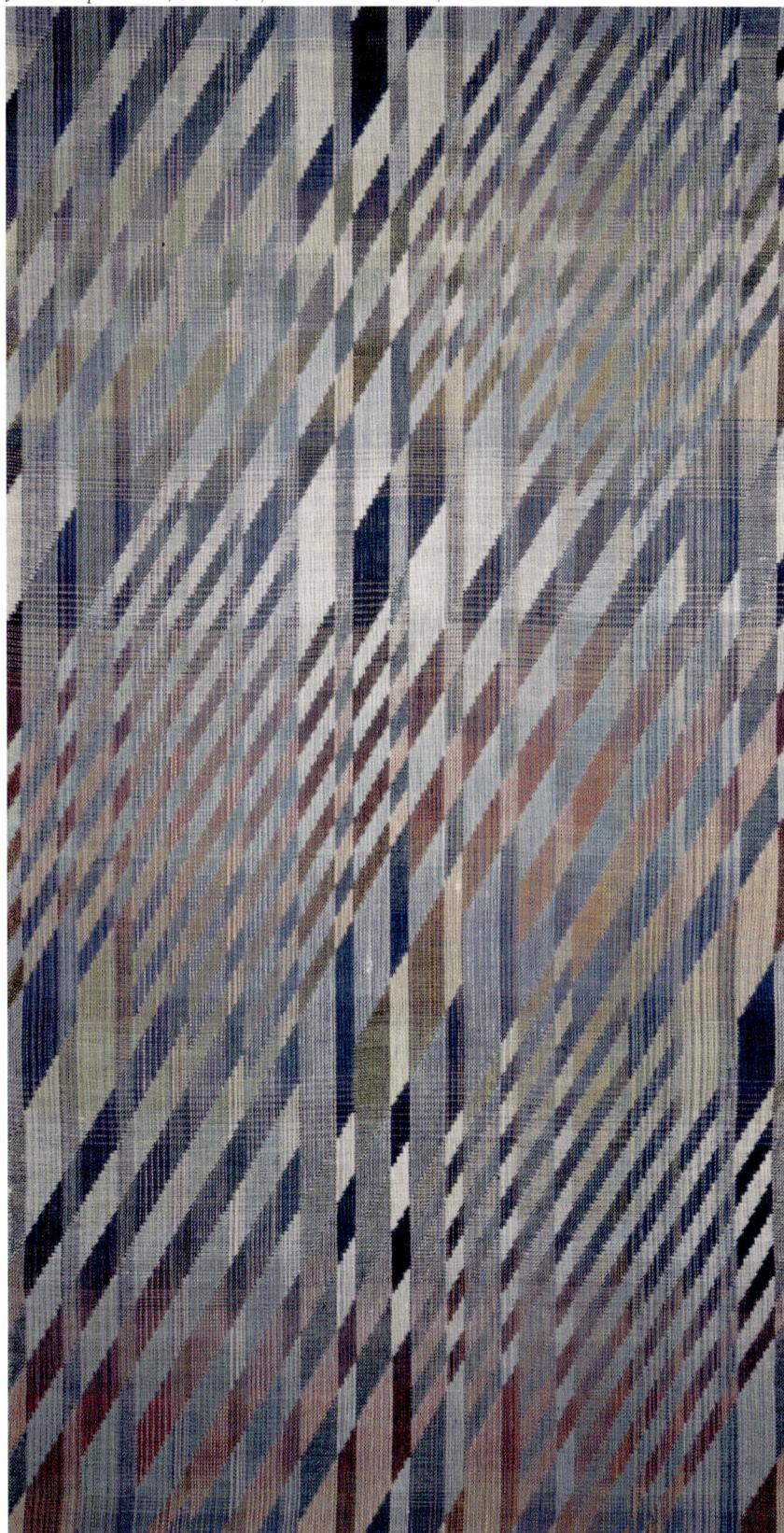

The six "figures" are made of small and mid-width diagonals, the background of wide diagonals.

Collection of Mentor Graphics, Portland.

"You Oregonians can certainly be proud of Carol Edelman, Chairman of ACC and mastermind in so many ways." Letter from Jack Lenor Larsen, January, 1994.

Edelman Associates practiced Portland's century-old tradition of funding art, which, in 1980, was enhanced by mandates of the city of Portland and Multnomah County that one percent of public construction budgets for new buildings or renovations be dedicated to art. For new office headquarters for Omark Industries saw chain division Carol Edelman, my neighbor in Willamette Heights, assembled a group of artists and together we toured the chain saw manufactory. After we understood the production of Omark, we viewed plans and models for the new office building. Each artist was given a site. Edelman specified that my site, at the end of a long hall, be a beacon that read well from a distance and close up, and that the tapestry should reveal itself as one approached it. The diagonals of *September Precipitation III* installed at Omark look, to me, like the sounds of a chain saw.

In my opinion, the most successful commissioned art projects are ones in which selected artists meet together with patron and consultant after sites have been identified and one artist is selected for each, without a competition among finalists. Single artist selections are clear statements that the consultant or art selection committee knows what medium and imagery will best suit the site. Consequently, the artists feel honored, secure, eager for dialogue, and committed to making strong work. Three meetings following the artist selection are helpful: first to visit the site, review slides, and discuss approaches; second to present a preliminary design concept; and third to review and accept the final design. Lastly, an opening or acceptance of the work of art is a welcome celebration. I was fortunate to participate in Edelman's fine working model early in my efforts at commissioned tapestries.

In accepting a commission, the artist must first be responsible to the function of the building and its users. The tapestry must clearly state the purpose of the building and instill pride in those who work or visit. The artist's responsibility must also extend to producing a work of art that is not significantly different than represented in drawings and samples.

The Omark project was the second time I worked on an artist team organized by Carol Edelman, the first time was in 1980 for Kaiser Permanente. In 1983 we worked together again for Bess Kaiser Hospital. That project was the subject of a cover story in *American Craft*, June/July 1984, written by Jane Van Cleve. At least three more times we worked together. Over many years, Carol Edelman's visionary mastermind has changed the face of Portland.

September Precipitation III, 89" x 83", linen double weave mounted, commissioned for Omark Industries, 1981.

My three favorite weaving techniques—double weave, inlay, and pattern weave, were taught separately over three terms at Lewis and Clark College. I often set up a table loom and wove during class. I constructed a small sample for *May Precipitation with West Wind* with a simple pattern block on the one and three harnesses, plain weave on two and four, then joined the layers via a pick up stick. *May Precipitation with West Wind* is a first effort, of a very few more, at combining double weave and pattern weave.

May Precipitation with West Wind, 40" x 54", linen double weave
with overshot pattern weave, 1983.

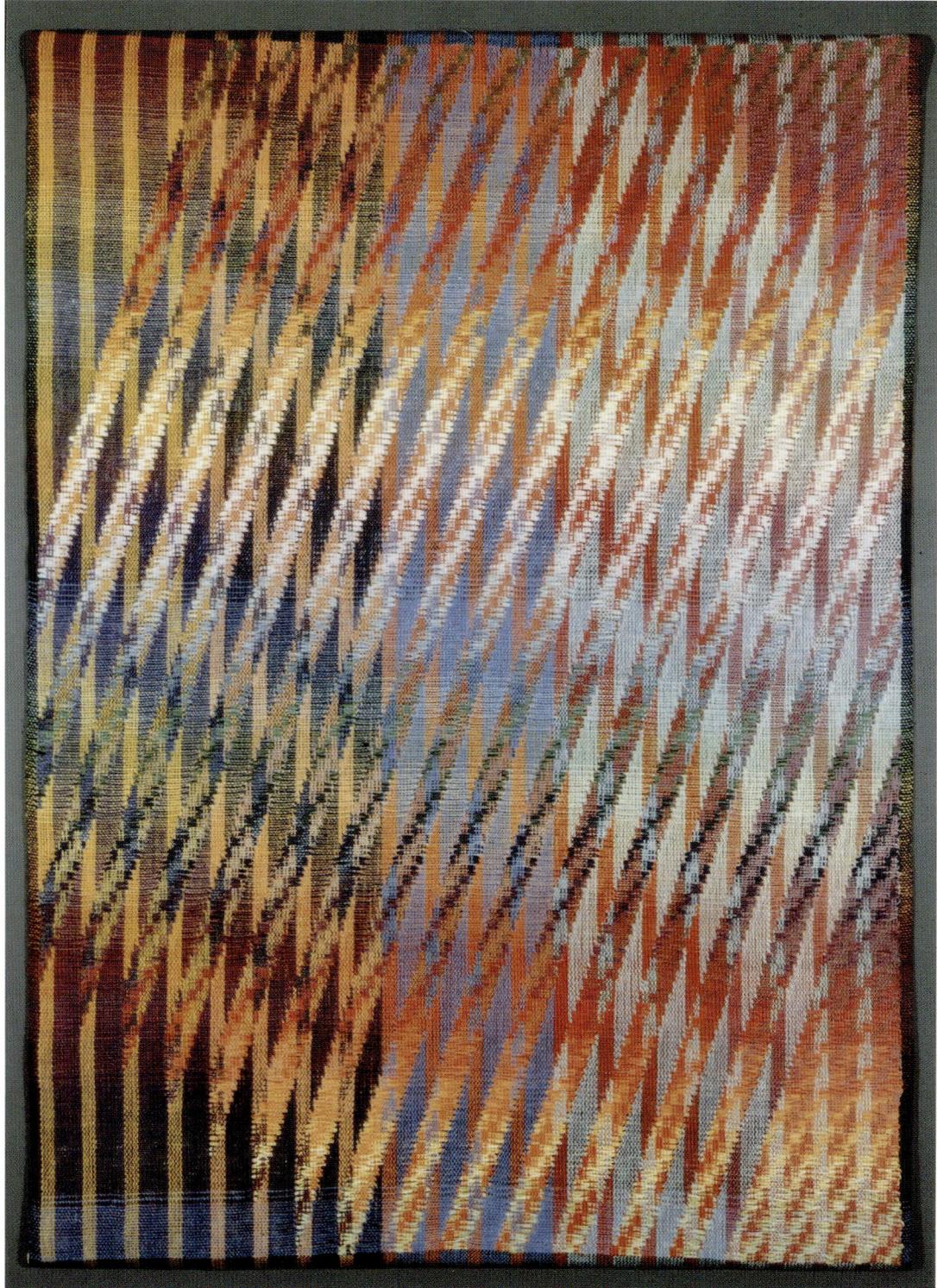

A growing pride of place caused me to buy a commercial photograph, produce a cartoon from it, and weave *Portland Oregon 1983*. The urban landscape of my daily walks was only ninety-six years older than I. It's easy to feel a part of history-in-the-making in young Portland.

Portland's dream began in 1845, sixteen blocks platted out along the river bank. As at the beginning of the century, when Oregon led the nation with the Oregon System of legislative reform, so in the area of environmental protection it has taken the lead with such citizen-supported measures as the Scenic Rivers Act, the Land Conservation and Development Commission (LCDC), and the Bottle Bill. The first settlers believed Oregon to be an Eden. Now, a century and a half later, their descendants appear determined to see that it remains so.

From *That Balance So Rare The Story of Oregon* by Terence O'Donnell, 1988 (pgs. 53 & 110)

Much has been written about Portland's planning that preserves walkable short city blocks, architecture, and green spaces. In 1983 I listened to City Council proceedings on non-commercial radio in my studio. I'd written newsletters for Chapman School and Contemporary Crafts. I taught weaving to students who chose to come to Portland from all over the world. I planned with other artists and Carol Edelman to make works of art that would contribute to significant interiors. I could favorably compare Portland to other Oregon cities in which I'd lived—Ashland and Eugene—and I found all aspects of Portland—educational, environmental, political, and social—to be more openly accessible than any place I'd ever lived. After a fourth trip to Europe, provided by a 1980 Crafts Fellowship from the National Endowment for the Arts, I gladly returned to rolling Portland at the rain-washed, sweet-smelling confluence of the Willamette and Columbia rivers.

Portland Oregon 1983 found a home in the sky-scraper lobby of Louisiana Pacific, not quite as high in the air as the aerial view vantage point of the tapestry. Subsequently Louisiana Pacific left Portland. The location of the tapestry is unknown.

Portland Oregon 1983, 45" x 65", linen and wool inlay with overshot border, mounted, 1983.

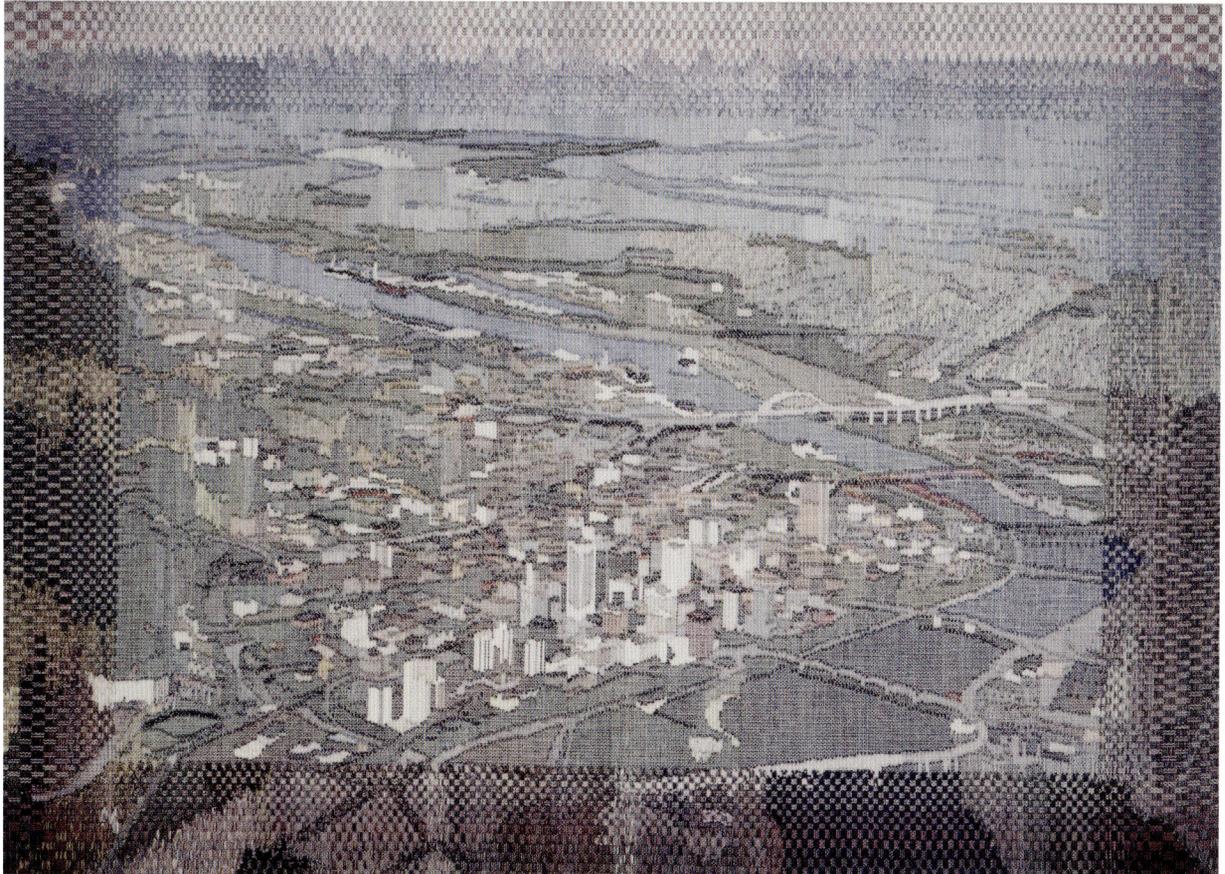

In the 1984 *American Craft* cover story "Portland, Oregon—Kaiser Permanente", Jane Van Cleve quotes Daniel O. Wagster, Kaiser's senior VP and regional manager:

> I wanted to know what the artists were proposing ... Obviously we were interested in works that gave a sense of uplift and joy rather than self-expression. I'm not questioning the appropriateness of what artists feel nor the legitimacy of their making such expressions, but our needs were to have a certain positive impact from the works our members were paying for. We couldn't justify buying anything too forbidding or disturbing.

From Edelman's viewpoint, this censorship served an important function by increasing the client involvement with and commitment to the artworks produced. "I differ from an art consultant in that I don't make decisions about the art," she insists. "I set something up, but the client makes all the decisions and in a strong way."

In these formative years of producing commissioned tapestries, the Wagster-Edelman modus operandi closely fit two historical traditions that de-emphasize personal expression: the late Medieval-early Renaissance method of collaboration, and the Bauhaus emphasis on imagery emerging from process. I welcomed Wagster's unease with "self expression" and Edelman's role as facilitator between artist and client. Her method guarantees access to the client, without third party interpretation, which results in second-guessing and insecurity for the artist. The Kaiser project reinforced a felicitous working model for future commissions.

Having leafed through piles of commercial photographs for *Portland Oregon 1983*, I knew I needed a photographic panorama that would place Bess Kaiser Hospital in the context of the city. During one of my walks, I spied a store front sign downtown on Stark Street—"Michael Parker Landscape Design and Aerial Photography." To get the photo I needed, Michael Parker and I flew together in his Cessna. He allowed me to select the vantage point and he shot the pictures. I projected his slides onto two four by eight foot sheets of paper and traced them to make the cartoon for *Portland Panorama with Bess Kaiser Hospital*. Subsequently we both realized that I needed to learn to shoot aerial photographs myself. Michael Parker generously shared his expertise, which enabled me to accept an exciting series of commissions out of state.

Portland Panorama with Bess Kaiser Hospital hung in the hospital lobby. It now is installed in the waiting area for x-ray in the Kaiser Interstate clinics.

Portland Panorama with Bess Kaiser Hospital, 48" x 192", linen inlay, commission for the lobby, 1983.

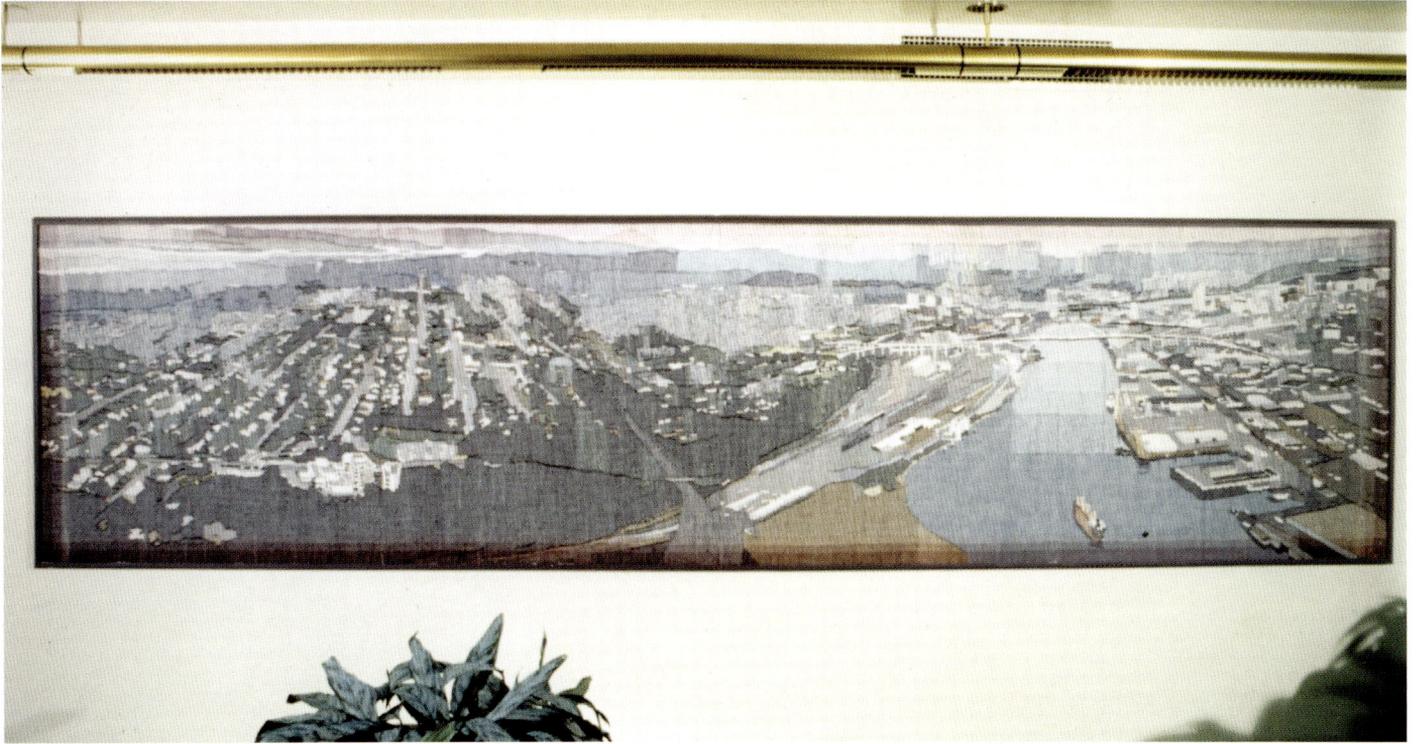

CHAPTER III

AERIAL VIEWS OF CITIES AND THEIR BACKLASH—INVENTED LANDSCAPE

On returning from our fifth trip to Europe in 1984, I learned that my part-time position at Lewis and Clark College had been cut from two quarters to one. I returned to teach fall term, declined a ten week contract for the following year, and my nineteen year teaching career was over. Despite economic insecurity, I was glad. The daily three part battle for time between family, studio, and teaching now had one less contender. Liberated, I literally took off.

The first exciting forays out of state, to at last make tapestries for businesses not located in my beloved City of Roses, I thought at the time to be a dream come true. Although travel frustrations slowly built during the years of the Aerial Views of Cities, often due to uncooperative weather, I felt mostly in control of a large, fascinating marriage of new technology with ancient tapestry techniques. When frustrations turned from travel logistics to more important questions of the worth of what I was accomplishing in the studio, I revolted. I quit Aerial Views because I no longer valued creating tapestries from photographs I'd taken of cities shaped by unknown planners and architects. A new series was born—Invented Landscape.

Baton Rouge is one of three tapestries accomplished after an inaugural adventure out of state. Mikael Henderson, of Henderson Massengill of Houston, arranged helicopter fly-overs in Houston, Dallas, and Baton Rouge. The purpose of the flights was to take aerial portraits of the cities. In preparation, I studied maps and atlas descriptions to insure I'd capture famous landmarks. Most importantly, I needed to include sites relevant to the clients—Fluor in Houston, Coopers Lybrand in Dallas, and Community Coffee in Baton Rouge. The rushing drives between three cities new to me and the straight up helicopter takeoffs were an adrenalin high. My goal was a pile of photographs for tapestry compositions. Each tapestry had to be a drama of high contrast dark shadows and bright sun. Each had to represent the character of the city with recognizable landmarks.

Because Community Coffee was not situated downtown, I showed the Governor's Mansion in the foreground, State Capitol, and city center in mid-ground, and the Mississippi River in the background. The hazy setting sun cast atmospheric deep south shadows and reflections. I am grateful that the client approved my indistinct photograph. Weaving *Baton Rouge* allowed me to emphasize light and climate over the man-made. It allowed me more play than the usual close adherence to the cartoon and reference to the photograph that so many following commissions demanded.

The incongruity of aerial photography resulting in long hours alone at the loom did not dawn on me for some time. I saw aerial photography as an exciting new way to earn a living by weaving. I was never afraid in helicopters or small planes. I was more afraid of the commercial airlines that took me to them. Because I directed the flight paths by communicating via headsets with pilots of small craft, I felt in control. Hanging out open helicopter windows as far as my seat belt would allow, I pointed my Canon straight down over the peaked roofs of sky scrapers and shot the lazily swaying abstract cityscape below...

Community Coffee went out of business. The location of the tapestry is unknown.

Baton Rouge, 48" x 72", linen inlay, commissioned by Community Coffee, Baton Rouge, Louisiana, 1984

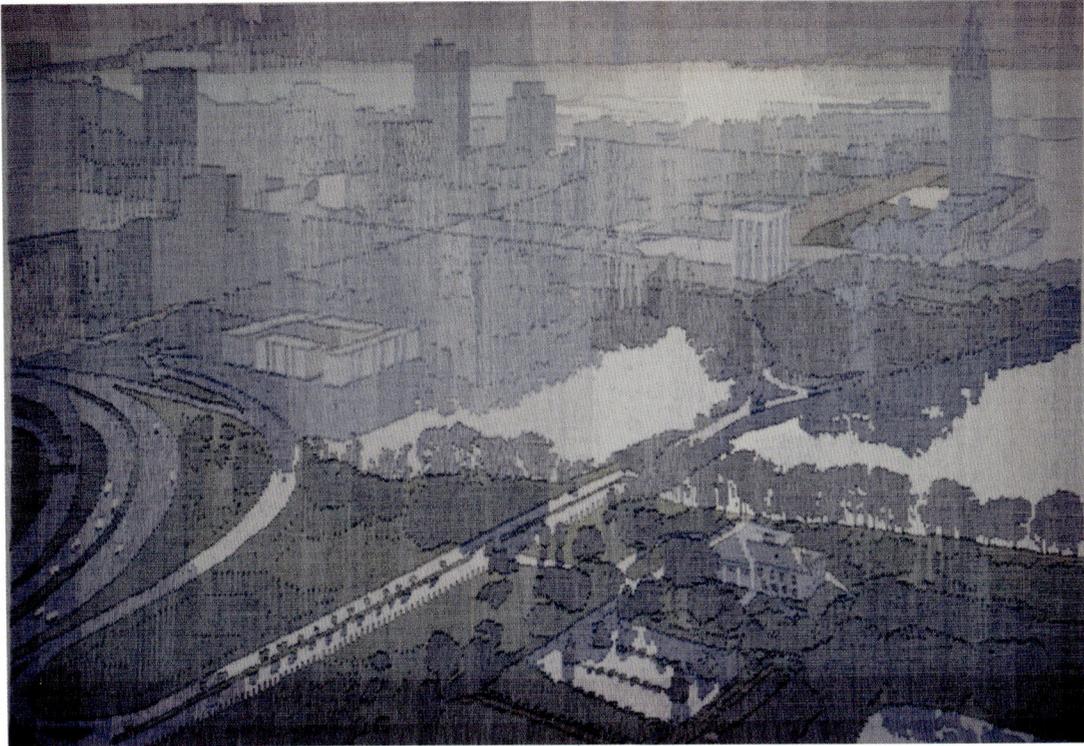

Detail of the Governor's Mansion, Baton Rouge.

Houston from the air looks like Oz in shades of gray. Surrounded by elevated freeways, the city abruptly rises from flat, mostly treeless ground. This panorama is the result of the third fly over of four in three years. The law firm requested that I show the historic domed courthouse in addition to their offices in one of Houston's amazing skyscrapers. At my request, Mikael Henderson took me inside some of these astonishing structures including Republic Bank—right, mid-ground, made of three reddish stepped pyramids—and Pennzoil Place—the black box to the left with slanted roof. Because of the heat and humidity, we toured from building to building in air-conditioned underground passages, the outdoor sidewalks above us empty. The old courthouse, identified by its columned cupola, is left, mid-ground.

More clearly from the air than the ground (especially when the climate prohibits pedestrian activity), cities are portraits of the values of their inhabitants. Visual characteristics of young American cities are shaped by property owners, architects, climate, municipal ordinances, and city planners. During the time I wove Houston four times, the city had no zoning laws. Unlike Portland, one Houston street might legally site, side-by side, a massage parlor, a house, a restaurant. Developers battled to erect ever taller towers. In weaving from a photograph of a city so shaped, the commissioned tapestry was a mirror of the design of others, built to specifications. Was I engaged in collaboration, or was I a sub-contractor?

Houston Panorama for Fulbright and Jaworski is in the collection of the law firm.

Houston Panorama for Fulbright and Jaworski, 60" x 108", linen and wool, commission for Fulbright and Jaworski, Houston, Texas, 1986.

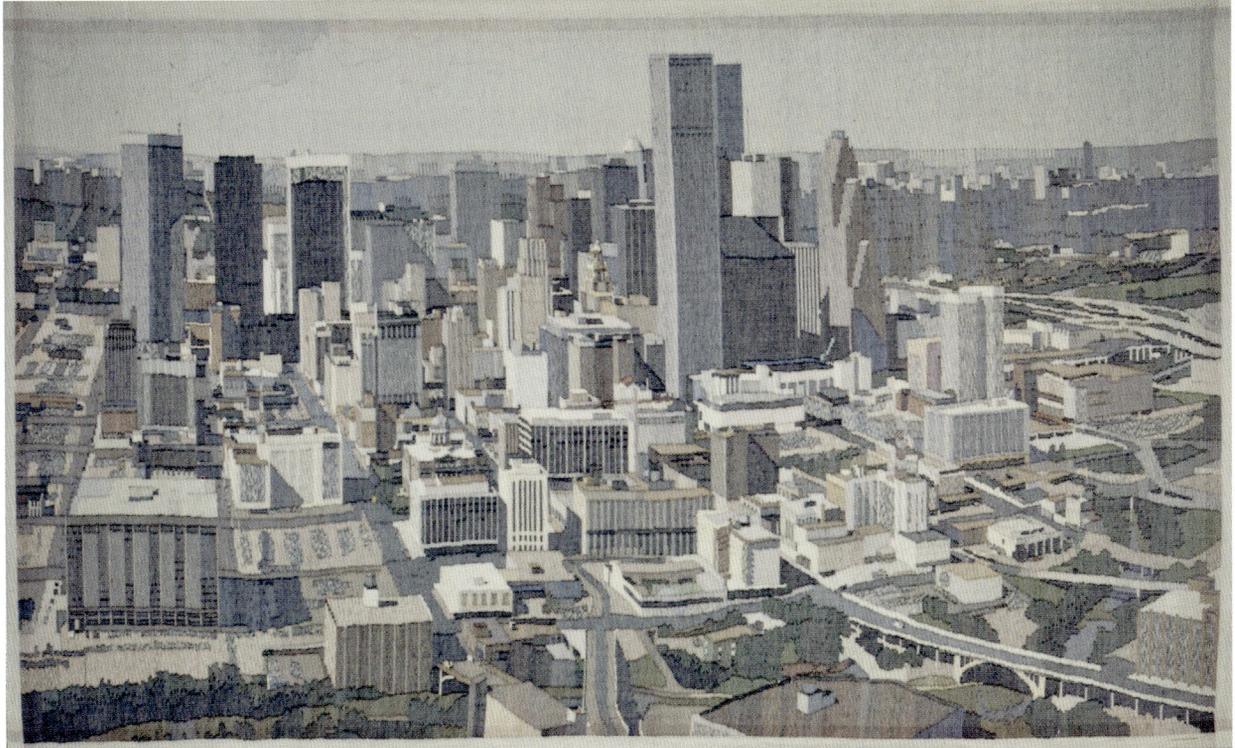

Fluor requested the Houston ship canal rather than its corporate headquarters.

I enlarged the city in the background when tracing the cartoon from the projected slide.

Houston for Fluor, 48" x 72", linen and wool inlay, commission for Fluor, 1984.

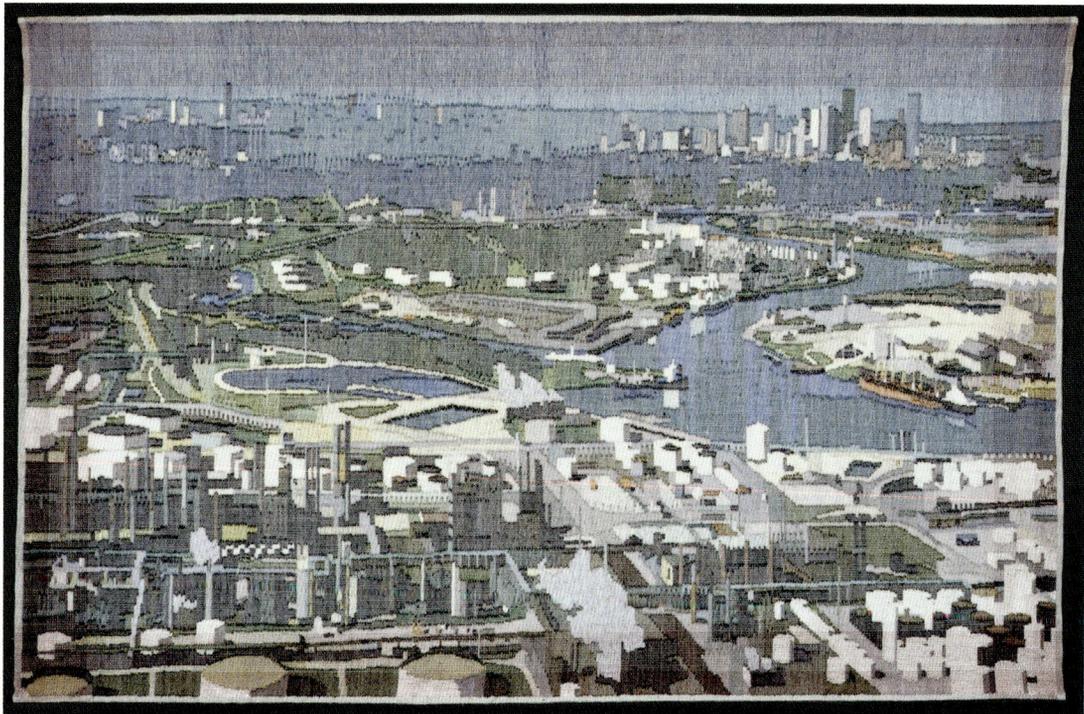

Photo comparison of the Houston ship channel.

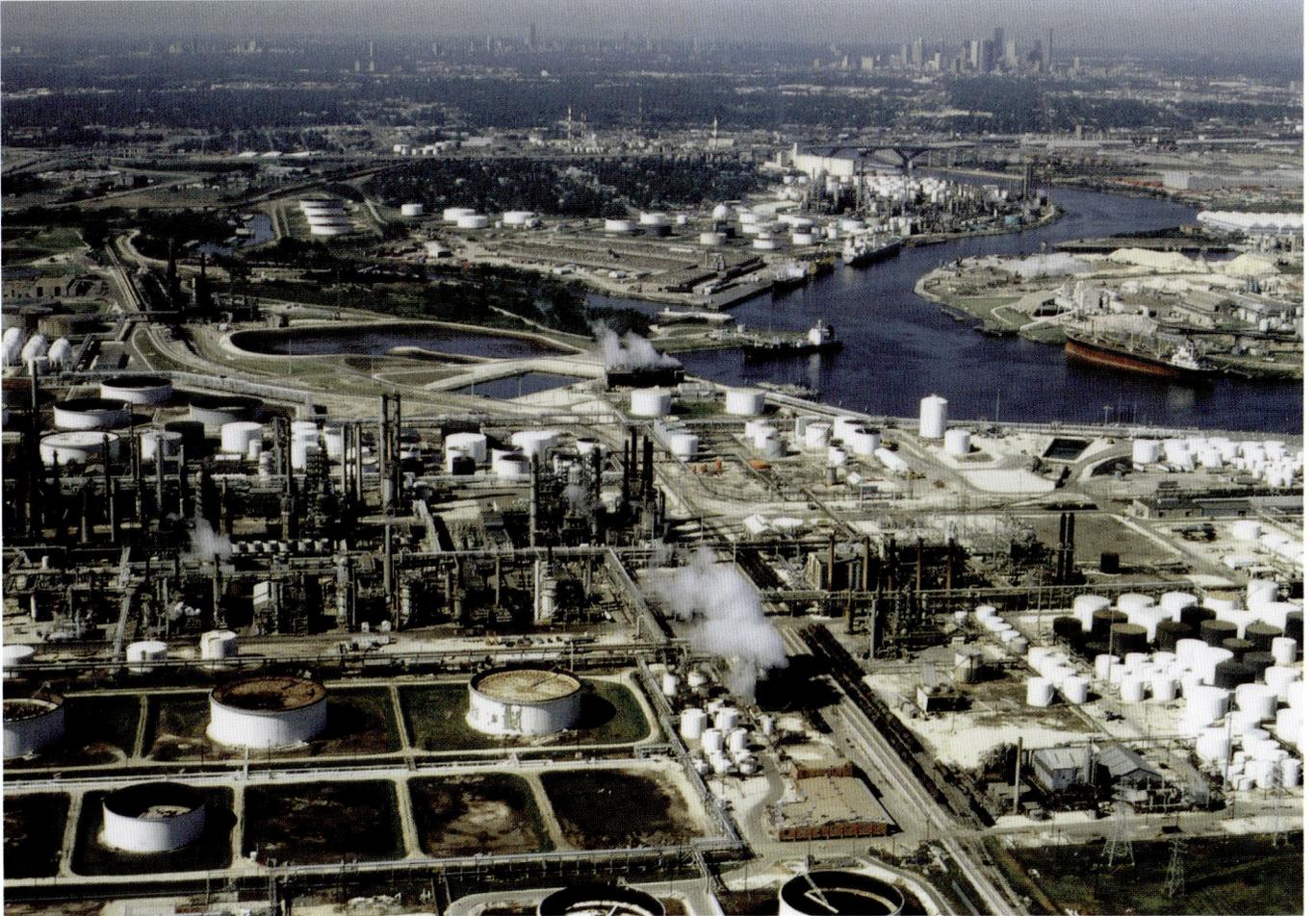

Between 1983 and 1988, I wove a total of nineteen aerial view tapestries. This depiction of three regional bank headquarters buildings in their city sites was the beginning of disenchantment with aerial views. These three fly overs were lonely, exhausting, and tension filled as opposed to the exhilaration of earlier adventures. No one accompanied me in Florida; I flew from city to city by myself. Hurricane strength winds delayed the first take off in Jacksonville for several days. Alone, I waited out the storms in a Jacksonville Beach hotel, its windows lashed with threatening waves. Walks on the beach, which would have settled my nerves, were impossible. When I reached Miami for the final shoot, it was Super Bowl Sunday and only a very young, inexperienced pilot was available. Despite the very unglamorous aspects of the trip, I got the photos I needed, got them approved, and began weaving again.

In the studio, I uncomfortably tried to settle into long hours of "painting by numbers"—into faithfully copying the cartoon traced from a projected slide then pinned below the warp, matching the colors of the photograph to colors of linen inlay threads. Daily walks taken as refreshment were disturbed by instant, automatic analysis of the landscape into inlay. In dreams I rewove the day's work. A sense of remove and lack of spontaneity were the disheartening results of duplicating a city designed by unknown people, from a photograph I'd taken to please a client. I wanted to weave my own designs, not reproduce other individuals' city plans via photographs. I'd fallen into the trap of *Winter Walk*. And in the sky I had been repeating the frantic freeway commutes of *Home Sweet Home*.

The three tapestries are in the collection of Florida National Bank, Jacksonville.

Jacksonville, Tampa, Miami, each 48" x 60", linen inlay mounted, commissioned by Florida National Bank for the Jacksonville headquarters, 1986.

After the backlash, what to weave next? I returned to double weave and wove from drawings on graph paper. I wove several abstract, maze-like double weaves that calmed me, that gave me time to figure what comes next...

Collection of the artist.

Blue Labyrinth, 65" x 40", linen double weave, 1985.

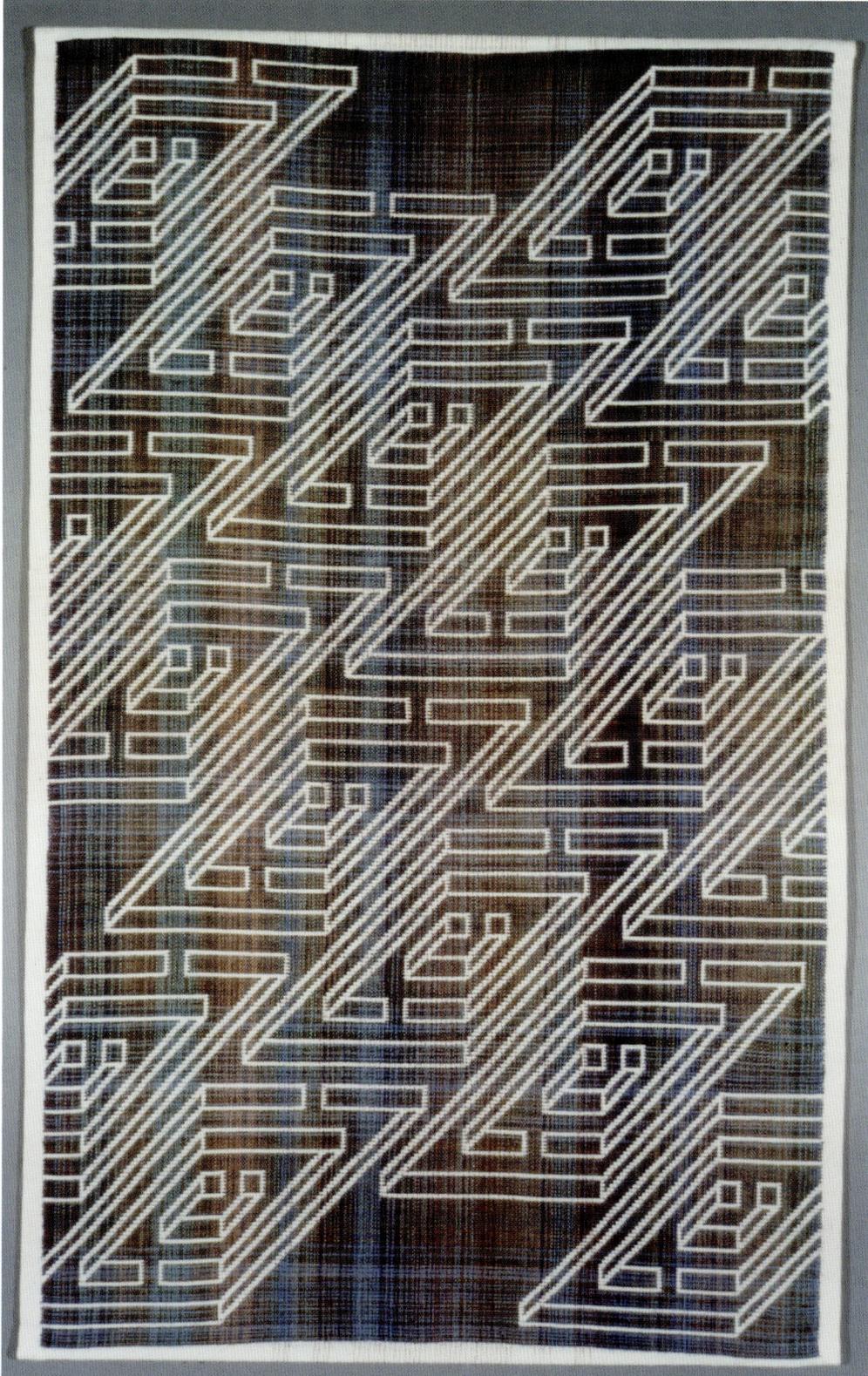

The Invented Landscape series—*Labyrinth* was the first—was a drastic break from the past. Material, weight, drawing, planning, and imagery were all new. I eliminated wool and its infestations and took linen as my sole material. I thickened the inlay weft from two-fold to six-fold and thinned the warp from twelve to eight ends per inch. I gave up taking slides, projecting them, and tracing cartoons. Instead I drew on graph paper. One square of graph paper logically equals one inch of weaving, eight ends wide by eight rows high. Because horizontals, verticals, and diagonals are easy to achieve on the loom, I discovered and adapted a drawing method incorporating them called Axonometric perspective. I wove directly from a drawing on graph paper, taped at eye level on the loom, on a warp with colored threads every inch to duplicate the graph paper grid. The architectural imagery that emerged from this kind of drawing is of my own design and directly related to the buildings and gardens of Italy I'd photographed in 1984, 1981, and 1978.

In November of 1978 I accompanied Tom for two weeks of his five week residency at the Rockefeller Foundation's Bellagio Study and Conference Center on Lake Como, Italy. From application information:

> The Center, also known as the Villa Serbelloni, occupies a wooded promontory situated in the foothills of the Italian Alps. Surrounded by fifty acres of park and gardens, the main house and seven other buildings, parts of which date back to the 17th century, offer a locale highly conducive to productivity and collaboration.

That environment and I collaborated to produce two changes in my tapestry making: one intangible, of the mind, the other a thick pad of drawings, source of future tapestries. The villa, and other buildings, are hung with European tapestries. Those two weeks are my sole experience of living with centuries old weavings. The tapestries did not feel like irrelevant faded European decadence as they often do in museums. Instead they gaily animated the large, high, and wide indoor spaces. They brought indoors the cared-for details of the surrounding gardens. Tapestries and gardens functioned as parallel partners indoors and out. On the center's promontory site, the steep rocky back side falls into the lake to the north. On the south the panorama of buildings and gardens, visible from windows and walkways, provides a dawn to dusk play of rotating, lengthening, and shortening shadows. I paced out formal hedge row gardens, a vineyard, steps, and terraces and made scale drawings on graph paper in Axonometric perspective. I still refer to the drawings.

Labyrinth was purchased by Northwest Building Corporation for the lobby of the Norton building in Seattle from a 1987 exhibition at Linda Hodges Gallery, Seattle.

Labyrinth, 71" x 43", linen inlay, 1987.

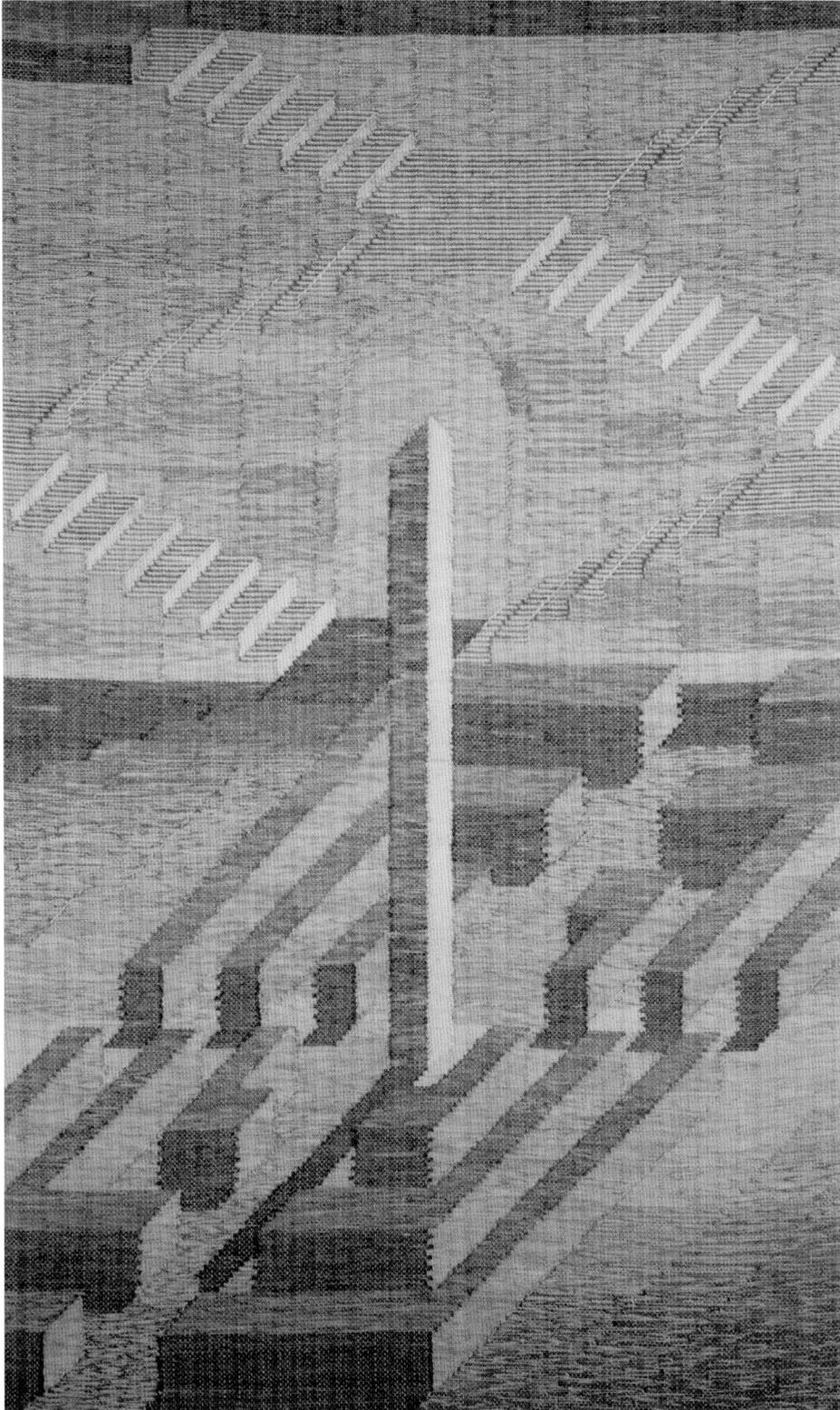

For the board room of a Portland Law firm, Carol Edelman requested two tapestries, sometimes separated by a folding door, that would read as separate compositions and as a whole.

The Invented Landscape series evolved to include dark shadows, which enhance depth, and water, which promotes reflections. I built a miniature landscape of columns made of dowels, steps made of books, and a pool in a bread pan. Moving a spot light over the set-up, I preferred angled shadows over straight, and saw that there are no shadows on the surface of clear water, only reflections. Employing rules of Axonometric perspective, I drew from the set-up, from the Villa Serbelloni drawings, and from books on historic gardens. An especially helpful book—*The Classical Orders of Architecture* by Robert Chitham—enabled me to hone the proportions of columns and steps to finalize a plan for *Orae Aequitatis* (Shores of Equity).

Although developing and expanding, this new Invented Landscape series had its roots in tapestries of the past. The inlay technique, the same used in other series, is now altered by fattening the weft, and the diagonal structure of the Precipitation Series is now in forty-five degree angles required for Axonometric perspective.

Orae Aequitatis is in the collection of Perkins, Coie, Portland.

Orae Aequitatis, each 60" x 108", linen inlay, commission
for the board room of Perkins Coie, Portland, 1989.

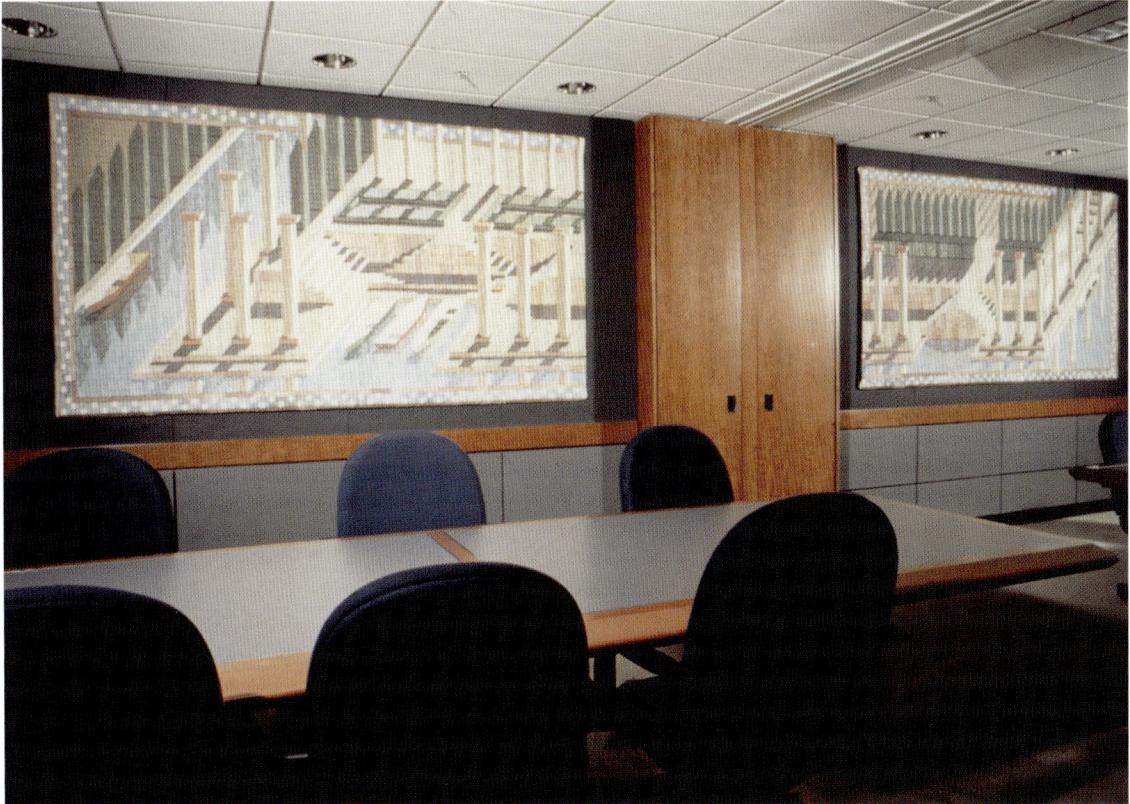

The most satisfactorily proportioned of many boat landing compositions, *Boat Landing II* was shown in my third show at the Linda Hodges gallery.

The tapestry was purchased by Bogle & Gates, Seattle, who loaned it for exhibition at the International Textile Competition in Kyoto, Japan, in 1989.

Boat Landing II, 51" x 72", linen inlay, 1989.

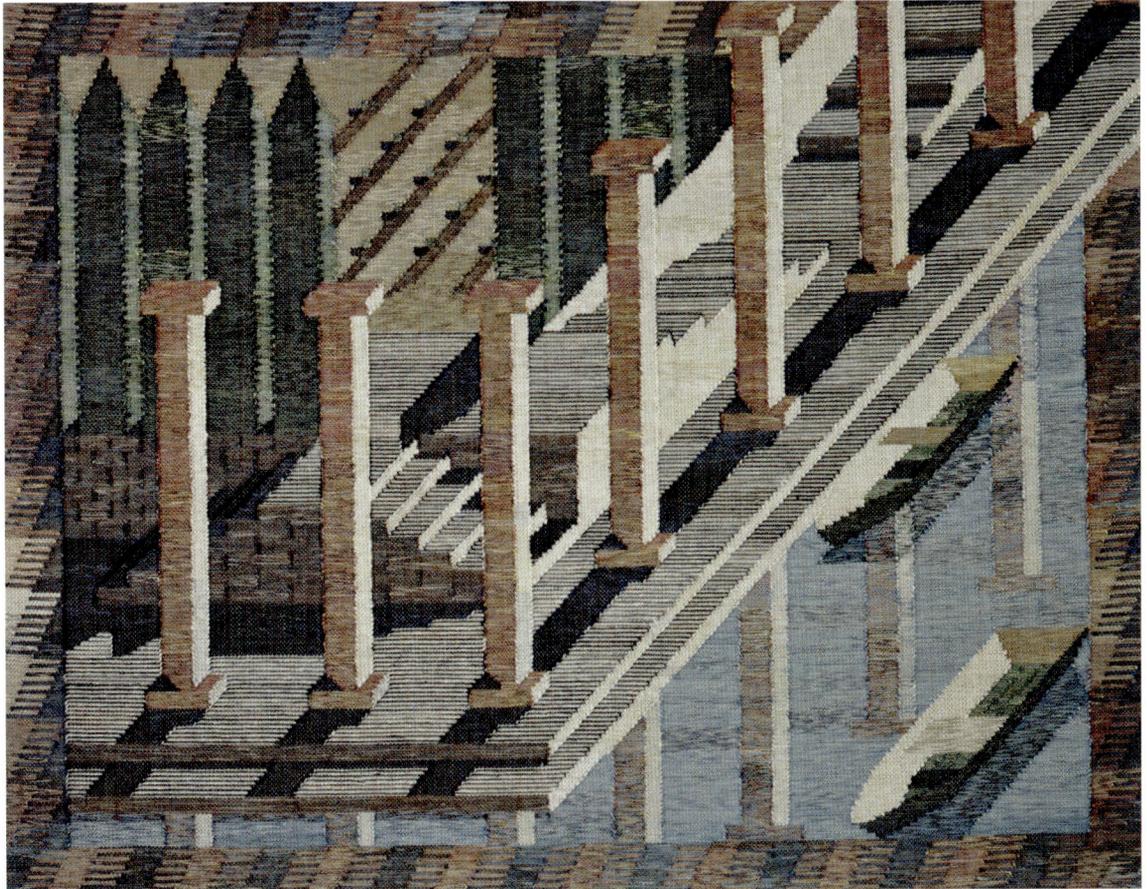

Important meetings often photographed by the media are held in front of the wall on which the tapestry is to be hung—that was the charge. I knew the imagery must somehow incorporate the handsome campus strung along the downtown south park blocks. I met with Ken Hall, of Yost, Grube, Hall architects, who demonstrated their animated drive-around computer plan of the campus. The plan is used for long-term university planning

I asked for a translation of their plan into Axonometric perspective within the tapestry perimeters of a long horizontal. Ken Hall and I made an agreement. If he would, in no more than eight hours at the computer, produce a printed plan from which I could weave, I'd give him ten percent of the commission allocation—$1,000. If he could not provide me with a print-out that would secure the commission for both of us, he'd get nothing.

The first attempt produced a line drawing that looked like a collection of boxes and lollipops. In the software Autoprod, Axonometric perspective is called Parallel Vertical Oblique Projection. "For a generally rectangular object, plans and side elevations are transformed as parallelograms and the consequent lack of convergence is psychologically disturbing." I think of tapestry imagery, unlike painted imagery, as democratic. Weave structure gives equal emphasis to fore and backgrounds—to the face of the virgin and the leaves of a tree—whereas a painted composition may contain various effects—a finely rendered portrait with brushed-in background suggesting landscape. So my "democratic" added to Autoprod's "psychologically disturbing" as a definition of design combined with technique pleased and amused me.

A second printed translation produced see-through buildings which relieved the monotony of blank boxes with lively patterning. To the computer print-out I added a light source and a border, then redrew the whole plan on graph paper. I wove the tapestry on a warp with colored stripes placed every inch so I could easily relate weaving to drawing. PSU's tapestry is my only experience with computer generated design and it was thoroughly enjoyable.

Tom and I attended an evening archaeology lecture in Smith Center several years ago. After the lecture we visited the tapestry in the Vanport room of Smith Center. I had not seen the tapestry in several years and its condition was very poor. The upper hem had come undone so the right side of the tapestry draped away from its inner slat support. Most troubling was the bits of silver duct tape adhering to its surface, obviously used to hang a poster. I called PSU maintenance the next day and asked permission to repair the tapestry. After a few days, permission was given and I made the sewing and tape-picking repairs. I'm almost afraid to return to the scene of the crime.

Portland State University 1989, 60" x 232", linen inlay, commission for the PSU ballroom, 1989.

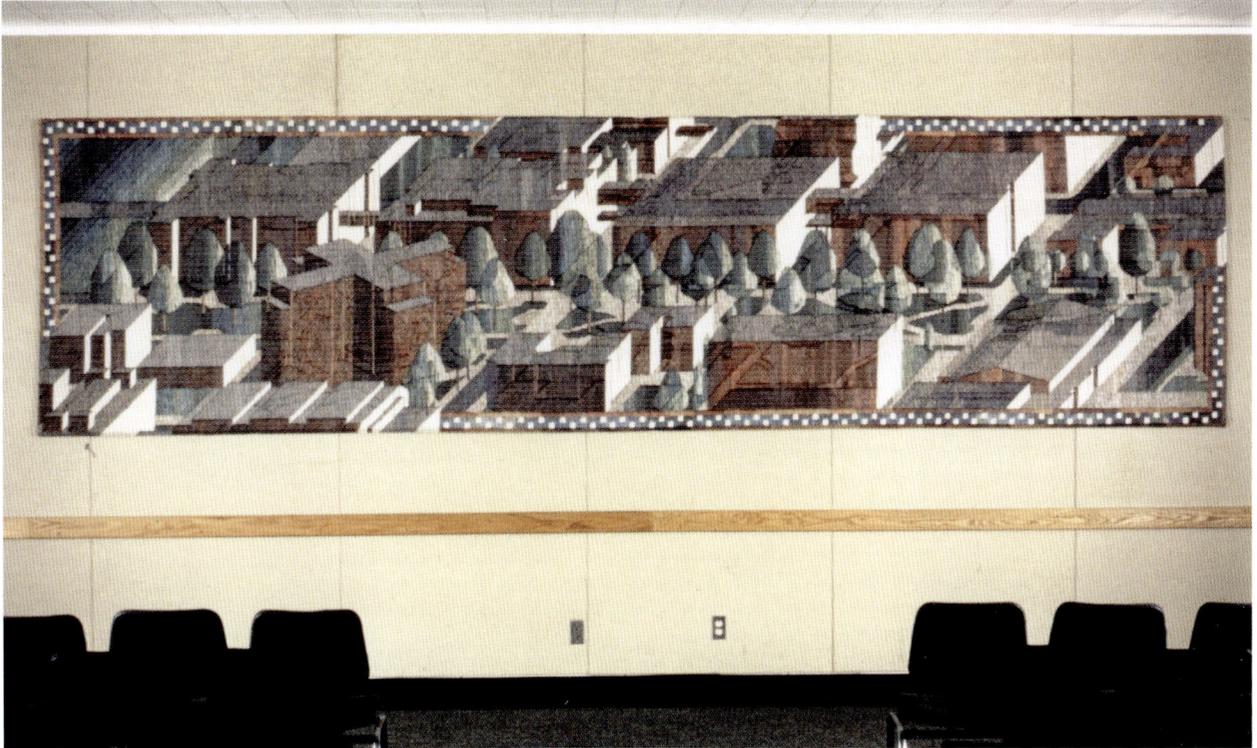

CHAPTER IV

TAPESTRY MAPS AND MORE
AXONOMETRIC PERSPECTIVE

The Laura Russo gallery was founded in 1986. In 1972, when we came to Portland, there was essentially one viable commercial gallery—the Fountain Gallery of Art. Laura Russo was a long-time associate of the Fountain and a graduate of the Museum Art School (now Pacific Northwest College of Art). Tom had been represented by the Fountain, but I showed at Contemporary Crafts Gallery, a non-profit, and at the Portland branch of Lawrence Gallery, now-defunct. When the Fountain gallery closed in 1986, after twenty-five years of operation, many artists, including Tom, went with Laura to her new space at 805 NW 21st Avenue, about a twenty minute walk from our house. Three years later I joined her family of artists, the only weaver. In 1990 I had my first exhibition at the Laura Russo gallery, and have shown new tapestries in solo exhibitions approximately every other year since then.

The first tapestry map was created as an alternative to an aerial view. Topographical maps, rather than photographs of cities, provided refreshing portraits of landscape devoid of the marks of civilization. With the addition of front elevations of recognizable architectural landmarks placed in borders, I could create a composition as much my own as in the Invented Landscape series via axonometric perspective. *A Tapestry Map for Sequent* was the first commission through the gallery.

The art selection committee from Sequent, before purchasing or commissioning works of art for their new headquarters, toured Portland collections. They saw *Portland Panorama with Bess Kaiser Hospital* and contacted me through the Laura Russo gallery. They wanted a tapestry that would function as a geographical orientation for their clients, many foreign. Sequent's Beaverton location on the other side the west hills, undistinguished from the air, is topographically interesting in relation to Portland in a wide horizontal format. I proposed a tapestry map.

The cartoon preparation was as time consuming as the weaving. The four by sixteen foot cartoon was traced in sections from various US Geological Survey topo maps made into slides. Building elevations were obtained from architects and the Oregon Beaverton Oregon Historical Societies. In several cases, I had to make tracings of historic buildings from old, fragile drawings. I made slides from the drawings and blueprints. I projected slides of the buildings, sized them to fit an allotted space on the cartoon, then traced. The buildings are distributed around the edge of the tapestry, and their locations are designated by one inch red squares on the map. Additional sites, such as the Rose Garden and the Washington Park Zoo, not pictured, are also located by dots on the map. After the tapestry was installed, Sequent requested a key to the map. A design firm produced a plaque that identifies twenty-four sites designated by red dots, beginning at Sequent—located by the corporate logo—and progressing east.

In 1999 Sequent was acquired by IBM. Location of the tapestry is unknown.

A *Tapestry Map for Sequent*, 48" x 192", linen inlay, commission for the headquarters of Sequent Computer Systems, Beaverton, Oregon, 1990.

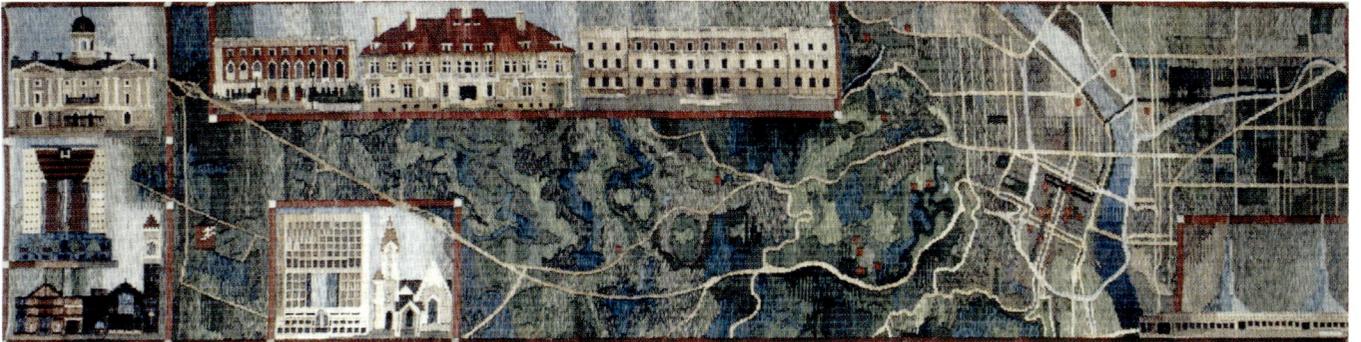

It was an honor to be selected by a parent and staff committee of Chapman, our daughter's grade school alma mater, to make a tapestry for the lobby. The centerpiece of Wallace Park, Chapman is a two story, symmetrical, gracious, classical school building with center entrance up a flight of steps. The generous lobby faces double entrance doors to the auditorium, which are surrounded by wood marquetry panels. A *Tapestry Map* hangs on the right lobby wall, separated from the earlier works of art by the hallway leading to classrooms. As at Sequent, the tapestry functions as an orientation to the landscape and architectural landmarks.

A *Tapestry Map for Chapman School* shows northwest Portland in the upper left, southwest Portland in the lower left, the Willamette River dividing the city north and south, and the east side on the far right. In preparing the cartoon prior to weaving, I was able to use much of the same material I'd developed for the Sequent tapestry. Red dots on the map indicate locations of the buildings, which are, beginning at one o'clock and progressing clockwise: Oregon Convention Center and MAX light rail, Pioneer Courthouse, Public Library, Justice Center, Old Church, City Hall, Performing Arts Center and First Congregational Church, Pittock Mansion, Portland Art Museum, and the Portland Building. Chapman School itself is located in Wallace Park by the northern-most red dot. It is my hope that the students, parents, and faculty use the map as part of the educational process.

Several spring vacations ago I brought this tapestry map to our big basement table and rehabilitated it by mending the hanging system and hems, finishing with a good pressing. Tom and I rehung it when school resumed. This year I made a little framed explanation of the tapestry imagery, using parts of the text above, and it hangs beside the tapestry. Over the years, the tapestry has been taken down to make way for other images, but I do try to look in frequently and maintain it as we live within walking distance of the school.

A *Tapestry Map for Chapman School*, linen inlay, 74" x 116",
commission for lobby of Chapman School, 1990.

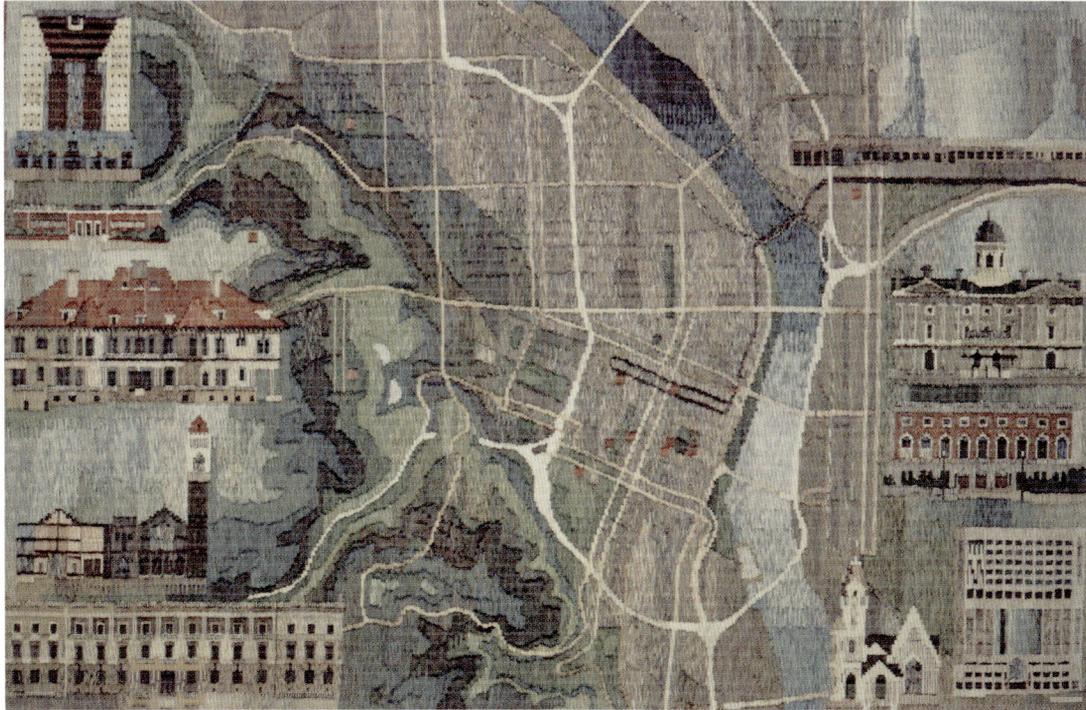

What could be more fortuitous in 1990 than to be asked to make a third tapestry map of Portland that shows the location and facades of the owner's buildings? The answer to this question was an agreement by Melvin (Pete) Mark to allow me to weave only the most architecturally interesting of his buildings, along with well-known Portland landmarks. I was supplied with blueprints of facades of Melvin Mark buildings from which I made slides. I already had slides of the Old Church, the Portland Building, and the Convention Center towers. The twice-used slides, along with new Melvin Mark slides, enabled me to trace a cartoon mixing public and private properties along the bottom of the tapestry. As in the previous two tapestries, properties are identified with a red square.

The designs of the tapestry maps are also a result of the intangible mind change begun at the Villa Serbelloni three years before. I wanted my tapestries to reflect the city outside the walls on which they were hung, as the villa tapestries reflected the surrounding gardens and *joie de vivre*. I'd once again taken a break from producing studio works to collaborate for large scale woven narratives. It was a privilege to be a part of the late Mediaeval-early Renaissance continuum—collaboration between patron, scholar, artist, and weaver—that created the villa tapestries, and to which I'd been introduced, in my own city, by Carol Edelman.

The tapestry was hung in the downtown lobby of Melvin Mark Properties.

A *Tapestry Map for Melvin Mark Properties*, linen inlay, 42" x 80",
commission by Melvin Mark Properties, Portland, 1990.

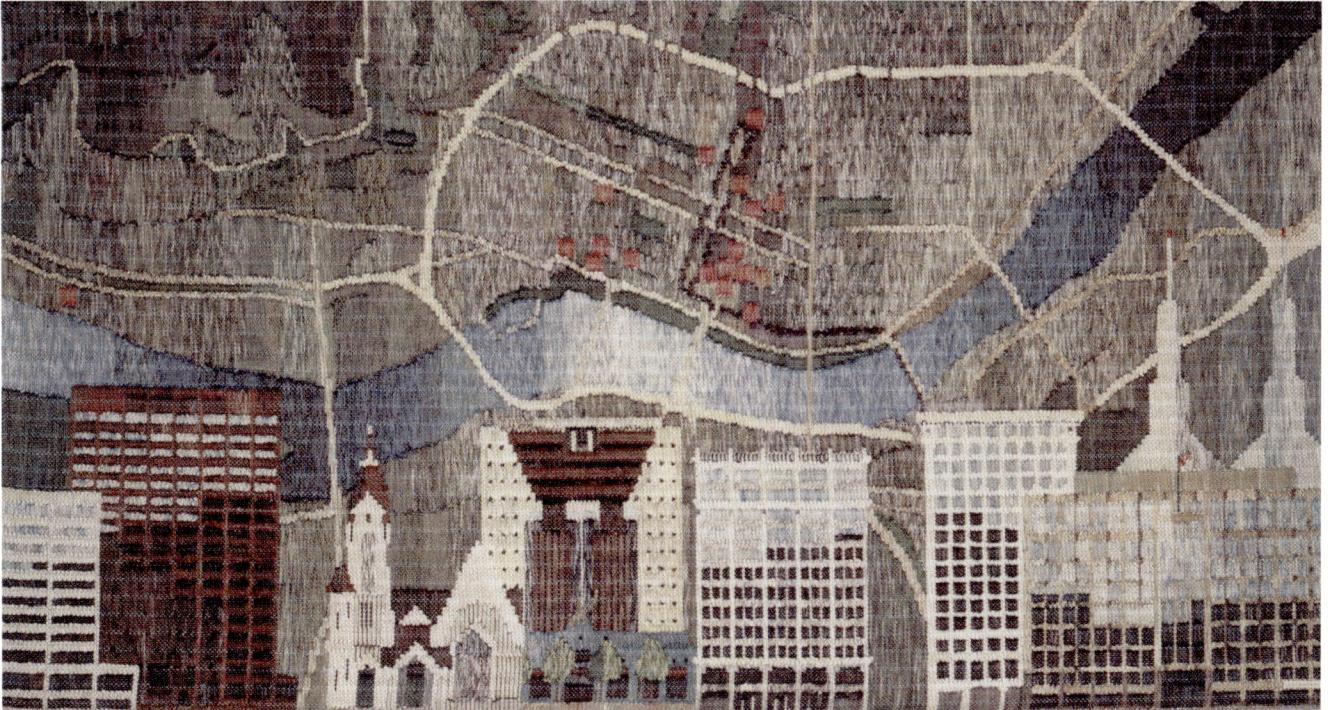

Since *Labyrinth* of '87, I'd been reveling in the marriage of axonometric drawing on graph paper with woven inlay to produce imagery of gardens and architecture. Although I'd woven front view Roman arches before, *Ariadne's Landing* is one of the first attempts to define deep curved space. Curves, I discovered, could as easily be systematized via axonometric drawing as verticals, horizontals, and right angles. I continued to weave on a natural linen warp with colored threads every inch to duplicate the graph paper grid on which the drawings were made. In this tapestry unruly, non-geometric vines on a wall playfully break strict adherence to the grid.

In 1990 I traveled in Italy twice. In the spring I flew to Milan to meet my parents and to rendezvous with Glynnis, who was studying in Sienna. After a late afternoon arrival, I attempted to stay awake by walking from my hotel to the Castello Sforzesco. Museum visiting hours were over, but a poster announcing the restoration and exhibition of tapestries *Dodici Mesi* (each pictured postcard size) set my heart racing. I'd read about this famous, rare Italian-designed series in Phyllis Ackerman's *Tapestry the Mirror of Civilization*, hoped to see them in the Trivulzio Villa in Vigevano, and now they were in Milan. Anticipation of the architecturally inspired tapestries and the reunion with family kept sleep at bay that night in Milan.

The twelve tapestries of the *Dodici Mesi* (Twelve Months), all about fifteen feet square, were designed by the painter Bramantino and woven by Flanders-trained Benedetto da Milano in workshops in Vigevano, outside Milan. They were commissioned by the Trivulzio family to hang in their villa, and were completed in 1509. Each tapestry has the same wide, geometric border of crests. Each has a central allegorical figure above a Latin inscription surrounded by an architectural framework. A medallion containing the Trivulzio arms is centered in the sky area above the figure, and is flanked on the left by a face of the sun and on the right by a sign of the zodiac. These organizing elements—border, figure, architecture, and arms—are the unvarying structure around which the designer and weavers play with objects that depict the rich abundance of everyday life during the changing seasons in Renaissance Italy.

In October, Tom and I looked at gardens in Tuscany. Ever since our 1981 trip to the Italian Lakes to see gardens, both Tom's painting and my tapestries have been increasingly influenced by Italian gardens and architecture. During the '81 tour of the gardens of the Villa Serbelloni in Bellagio we learned about residencies there. We returned home to do extensive research on gardens: locations, hours, pre-visit permissions to private properties, and histories. When Tom was selected for a residency in Bellagio in 1987, our appetites for Italian gardens were whetted. Returning in 1990, our exhaustive itinerary was planned to the half day. We grew to depend on photographs of gardens and architecture as primary resources for our works.

Ariadne's Landing, linen inlay, 60" x 57", 1991,
collection of Museum of Art and Design, New York.

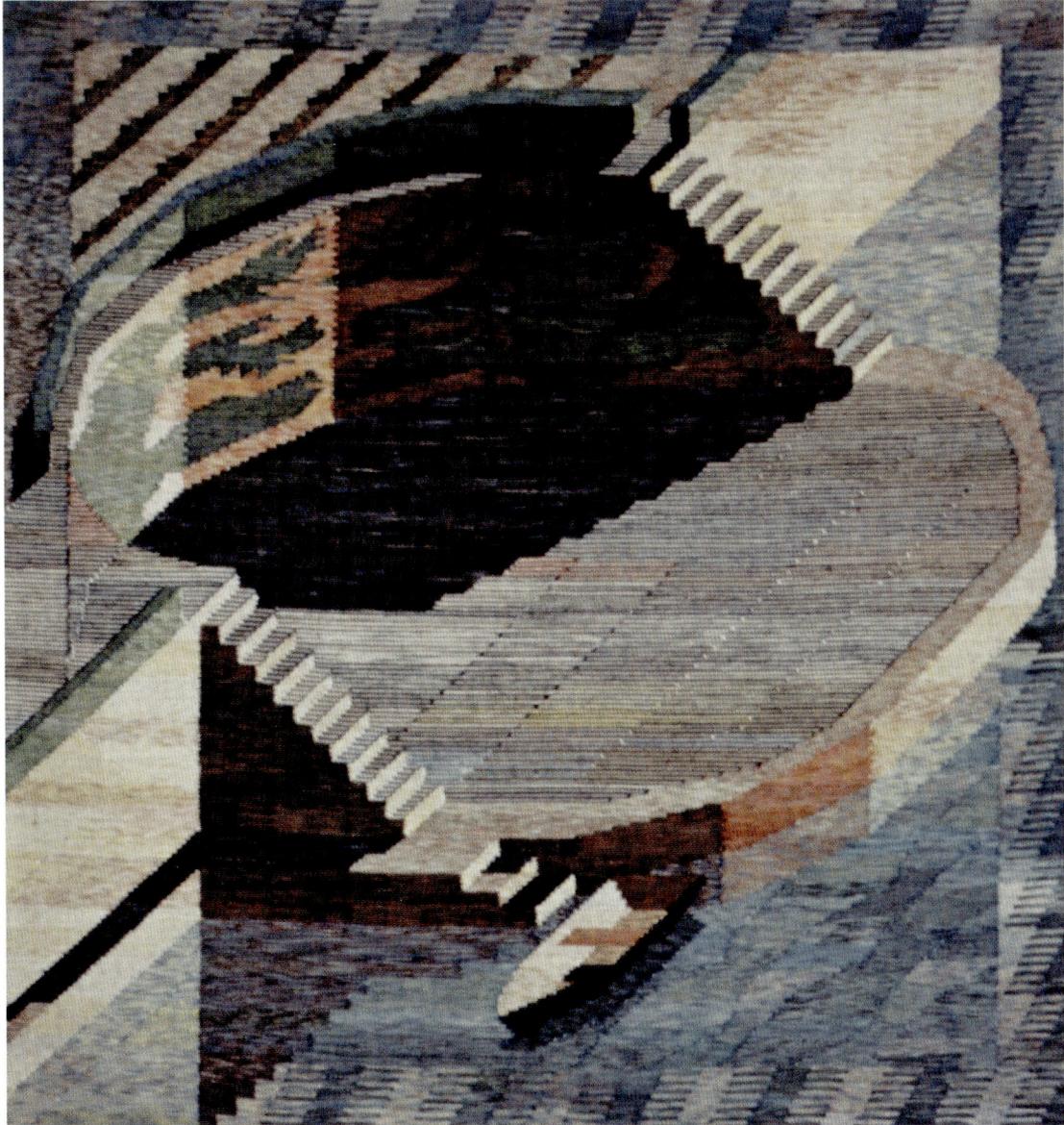

Salishan Lodge Gallery, in the distinguished Salishan Lodge at Glen Eden Beach, Oregon, has a history of inviting artists to exhibit and give a talk in exchange for one night's stay, including use of the pool, other amenities, and dinner. *Sunken Oval Garden* was on the exhibition card and *Quatrafoil Sunken Garden* was part of the show.

Sunken Oval Garden, 45" x 57", linen inlay, 1991.

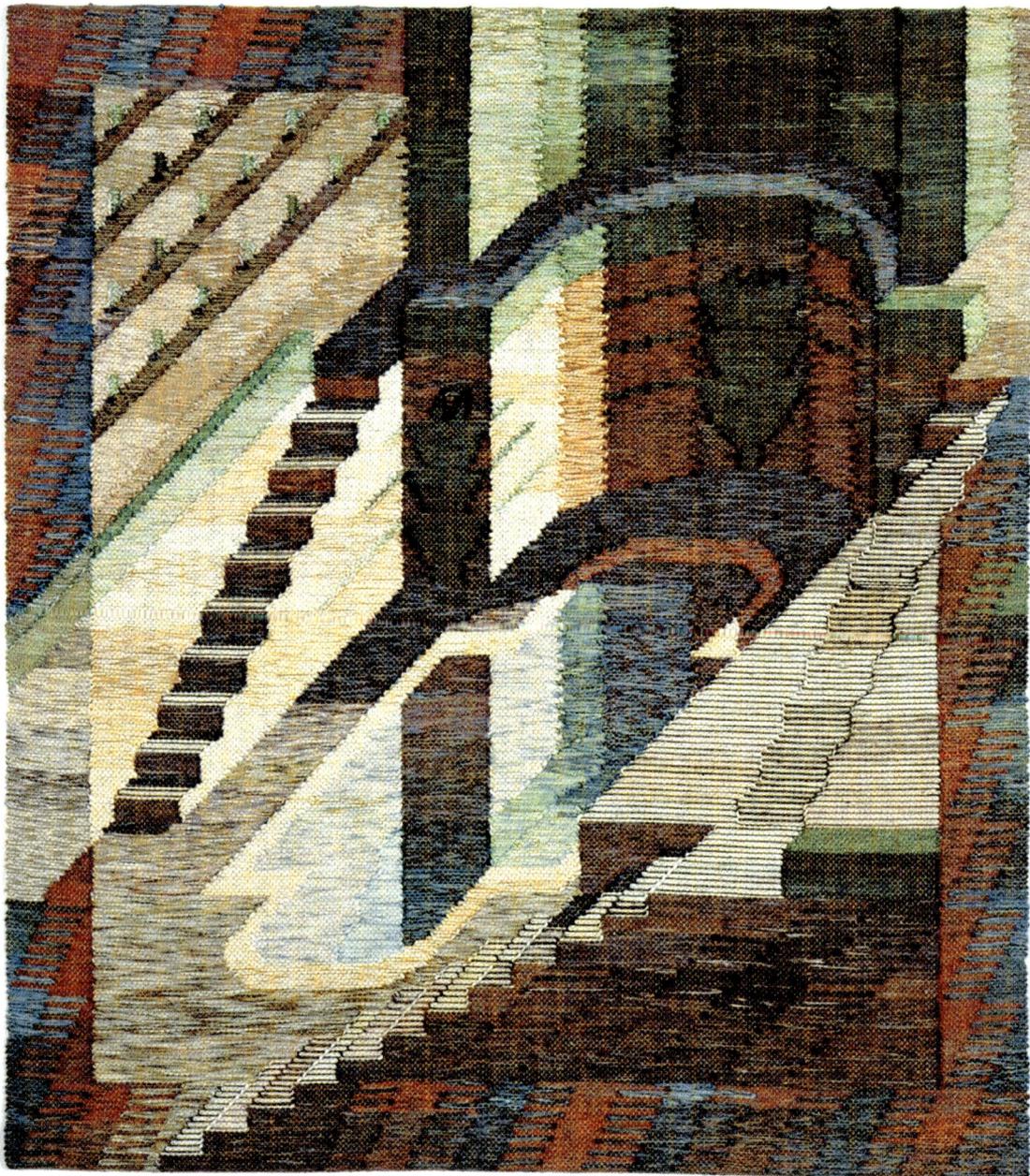

Quatrafoil Sunken Garden, 41" x 80", linen inlay, 1991.

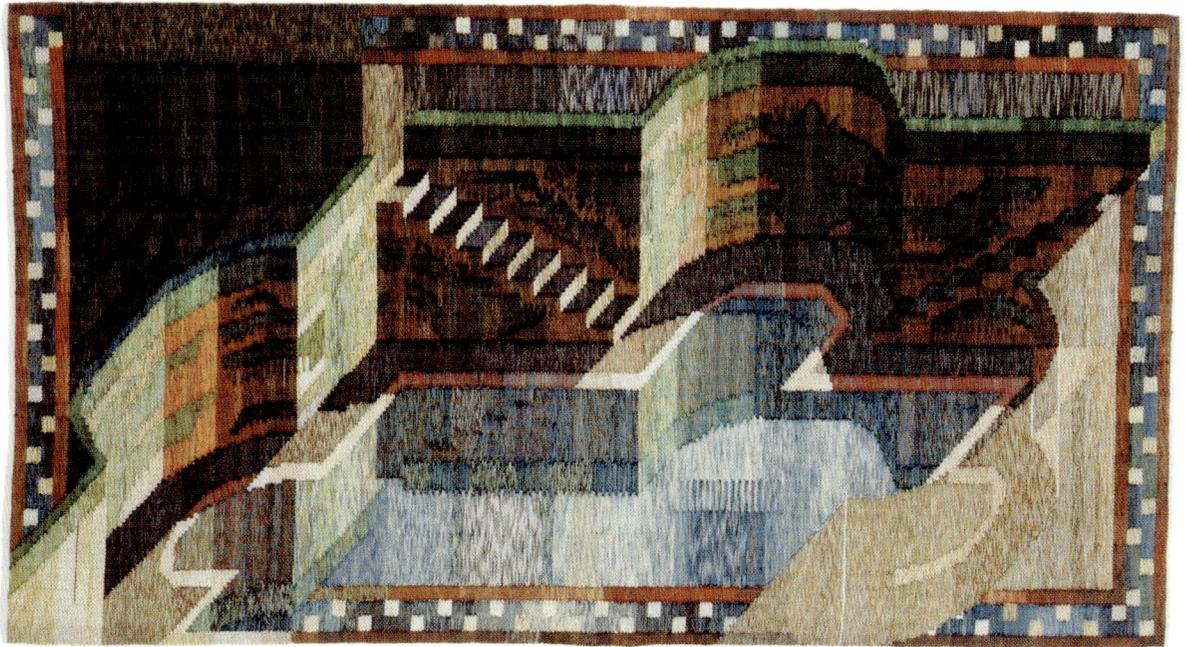

Duomo was woven on warp left over from *Sunken Garden and Waterslide*. The curve of the retaining wall and hedges is reversed in the curve of the dome. I'm still delighted at having achieved a dome and depth via shadow and facade coloring in this simple centralized structure.

Sunken Garden and Waterslide, 60" x 58", linen inlay, 1992, *collection Commerce Bank, Seattle.*

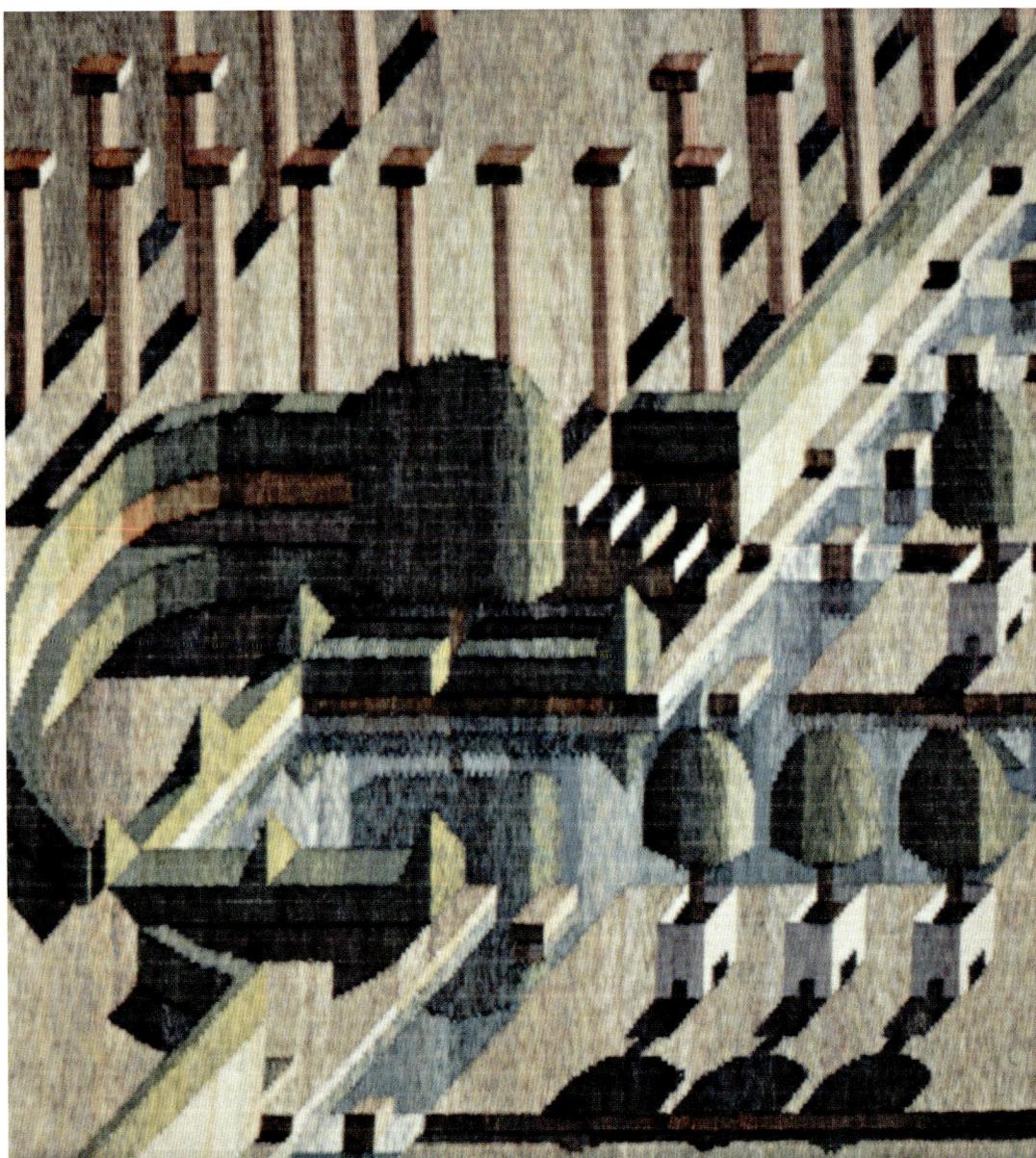

Duomo, 60" x 30", linen inlay, 1992, *collection of the artist.*

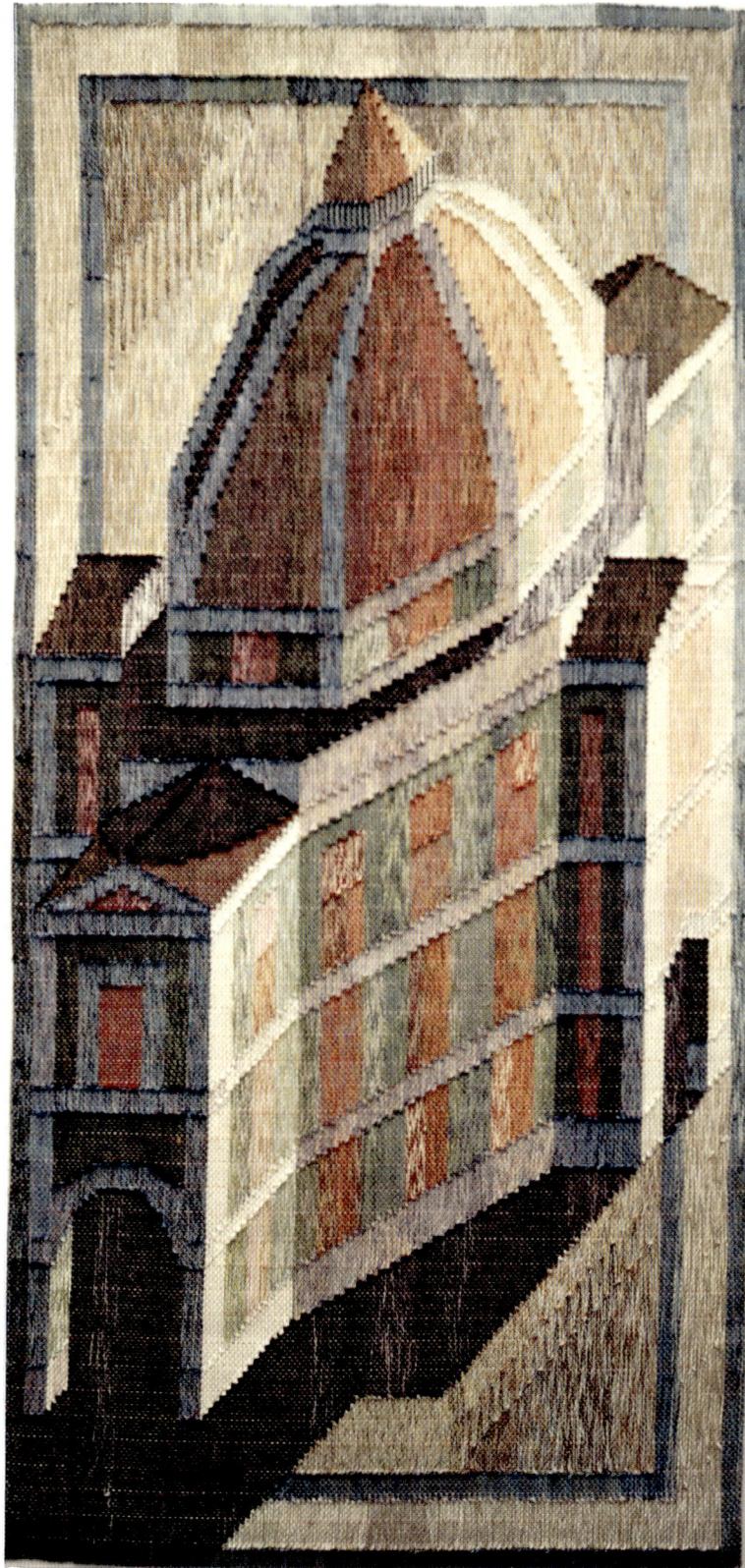

Oregon's Percent for Art mandate specifies that one percent of funds for new building construction be allocated for art. I hadn't won a state commission in fourteen years—not since I wove panels for a Hearing Room in the Capitol Expansion Project in 1977. A group of artists were selected in a competition sponsored by the Oregon Arts Commission to form a team to provide works of art for the new Archives Building. Each artist was assigned a site. Because the Archives Building houses the written records of the state, I wanted the tapestry to be a visual metaphor for our heritage.

For the reception room, first open door on the left after entering the building, I proposed a tapestry picturing cabinets containing objects that symbolize Oregon. The writer Sandra Stone was included on the team. I welcomed the opportunity to work with a researcher, in the Renaissance method of collaboration between patron, scholar, and artist. I asked Sandra to provide me with a list of Oregon's most significant products—agricultural, natural, manufactured, cultural, recreational— over ten year time spans to the present. Sandra's list in hand, I searched the library and recreation mail-order catalogues for pictures of such Oregon icons as cowboy boots, a saddle, rifle, paddles, cross-cut saw, salmon, skis, and the latest Nike running shoe. I redrew those symbols on graph paper to conform to the axonometric perspective of the cabinets. The idea for the cabinets came from seeing *tromp l'oeil* Renaissance marquetry cabinet panels in a museum in Lucca the year before.

The design for the tapestry took about the same time as the weaving. A light source from the right, the direction toward the room's entrance, illuminates the open cabinet doors, increasing the tapestry's three dimensional effect.

Archives Cabinets, 60" x 96", linen inlay, commission by the
State of Oregon for the Archives Building, Salem, 1991.

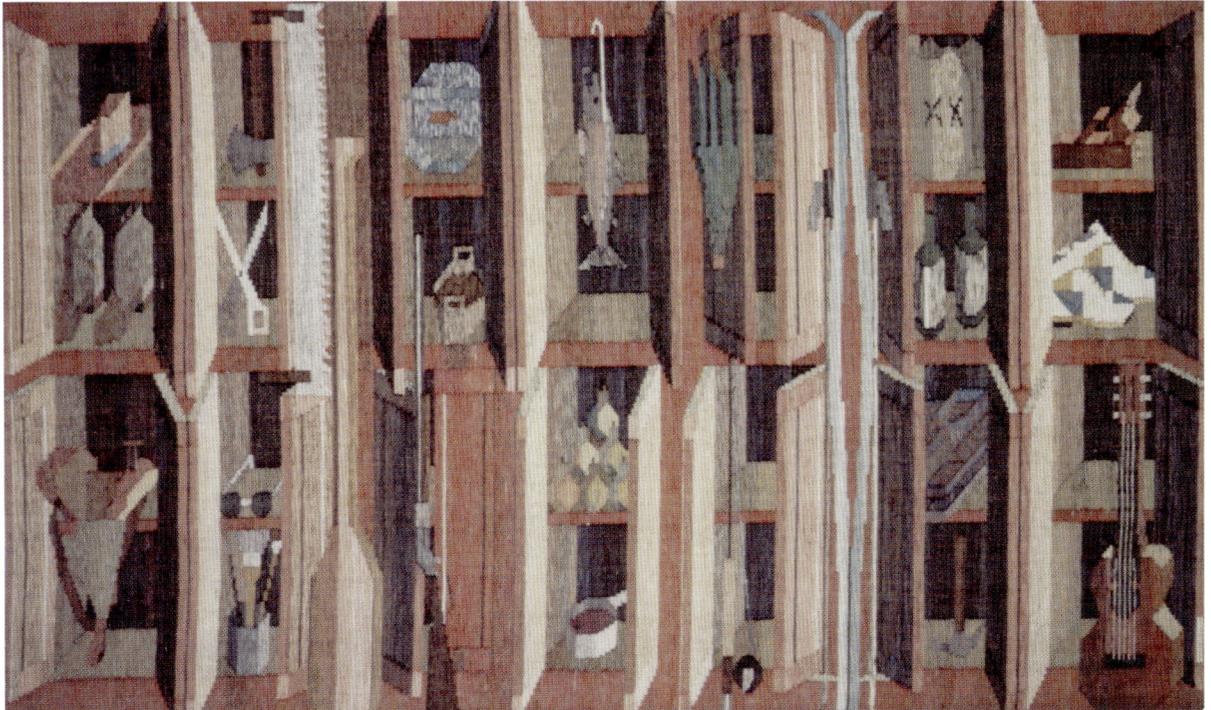

CHAPTER V

LINEN INLAY AND ITS APPLICATIONS:
ABSTRACT, ARCHITECTURAL, BOTANICAL

To prepare a proposal for a linen inlay tapestry, I use one of two methods—a scale drawing on graph paper or an actual size traced cartoon—or a combination of both. Imagery appropriate to the commission determines which method I use. Abstract and architectural imagery is best proposed via scale drawings on graph paper. Botanical imagery—specific recognizable species of boughs of leaves and plants—come from photographs I take. These require projection and the tracing of a cartoon (this method, dear reader, you will understand is out of favor with me). For a proposal, however, I may present a scale collage of photographs of foliage on graph paper. The foliage may be combined with a drawn systematized water/wave pattern on the graph paper ground between the leaves, along with a border in geometric patterns. Tension and play is created between the botanical patterns and the systematized patterns that relate to the underlying grid structure of warp and weft. The collage is a shortcut to the cartoon, which still must be traced before beginning weaving. In the cartoon, I draw only the botanicals and not the systematized patterns because they can be woven from a drawing on graph paper. The drawings—the construction plan—are a pleasure to finalize. The follow-up trick is to find play in the execution of the tapestry. There needs be room to invent as I weave.

Patience prevailed for my second commission through the Linda Hodges Gallery—maybe because UNICO was unsure about how to fix low occupancy rates in their glamorous downtown tower next to the Seattle Convention Center. An art selection committee for UNICO had seen slides of the 1989 show at Linda Hodges, which included *Boat Landing II* and other architectural tapestries. Negotiations for the three lobby tapestries took a year.

I was instructed to develop a northwest theme for the three end walls of the elevator lobbies. The walls of polished green granite looked to me like dirty mirrors. For the first presentation I drew cartoons of three separate northwest foliages surrounded by open doors, as in *Archives Cabinets*, capped with Roman arches. The proposal was rejected as "too Mediterranean. We want something less definite, more northwest." I protested that my work is about definite volume and structure, and that perhaps they had the wrong artist. They were sure they had the right artist, wrong approach. Together we reviewed a design philosophy developed for Two Union Square that viewed the tower as metaphor of northwest landscape: the basement as below ground/underwater, the lobbies at ground level (the dark green granite = forest floor below the canopy of trees), upper floors ascending into clouds. We toured the building to see how the design philosophy was implemented in color, wall and floor coverings, furniture, and works of art.

Red Alder, 1 of 3, each 82" x 58", linen inlay, commission by UNICO
for the three elevator lobbies of Two Union Square, Seattle, 1991.

Returning to the drawing table to make a second presentation, I drew "less definite" water/wave patterns based on geometry that could vary during weaving. I threw out all architectural references and added side borders that relate to the structure of the water/wave. These revisions made the foliage—*Red Alder, Douglas Fir,* and *Bigleaf Maple*—the third and most important element in the design. Weaving the tapestries was especially enjoyable because I could play in the bottom water/ wave areas, then follow a cartoon of foliage while progressively lightening the background color. The tapestries have an Asian delicacy balanced with the strength of the varied geometric weave.

I am grateful for the many months of design time, and the assurance from the committee that I was the artist they wanted. Time and support are not often so gracefully a part of the commission process. I'm proud to have my tapestries in such a dramatic space.

Continental Savings Bank, a tenant of Two Union Square, subsequently commissioned a tapestry for their lobby upstairs.

At the opening and slide talk of the September 1991 show at Salishan Lodge on the Oregon coast, long-time acquaintance Lisa Andrus-Rivera became a friend and teacher. She was interested in my depiction of architecture and I was excited to learn that she was scheduled to teach History of Architecture at Portland State University. Lisa allowed me to audit her class. Sitting in on her twice weekly morning slide lectures was exhilarating and wonderfully pleasurable. Walking home from class, I chose varied routes to look at Portland structures of iron, brick, and wood. I returned to the studio to draw what I'd learned from the lectures: earth mounds, pyramids, post and lintel, arches, arches joined, and finally domes. The step-by-step structural analysis of Lisa's lectures enchantingly directed new drawings, new tapestries.

I enjoyed Lisa's class so much that I went back for more. During the following two years I audited histories of American Art and Ancient Art.

History of Architecture, 41" x 113", linen inlay, *collection UPS Headquarters, Atlanta*, 1993.

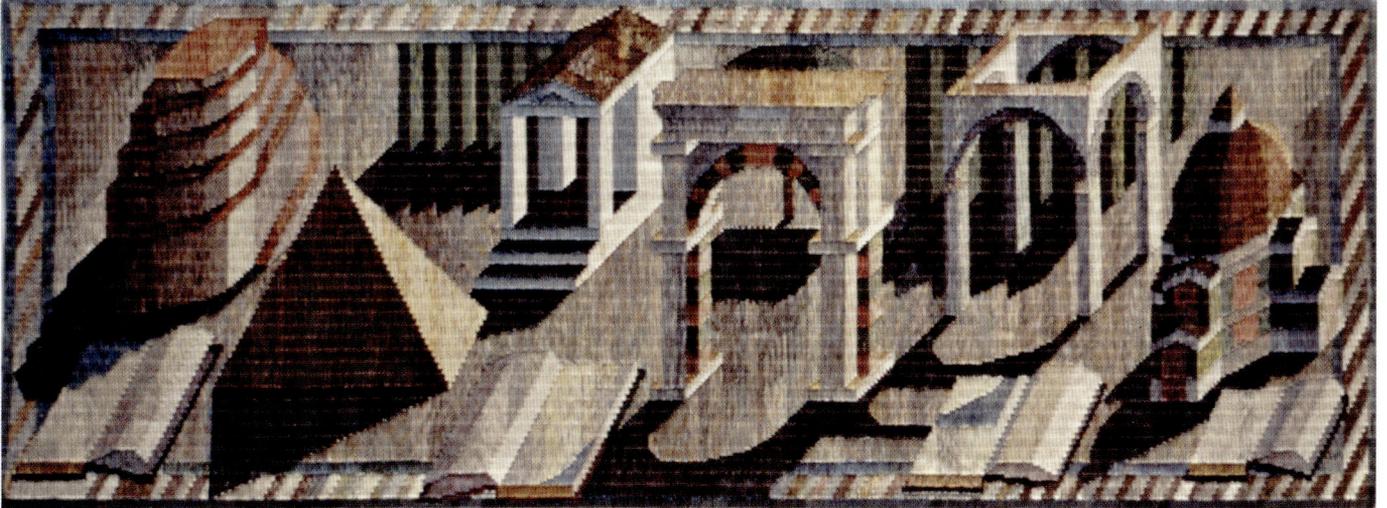

The Weil family wanted to donate a work of art to enhance the Administrative Center of the temple. They contacted the art committee of the congregation. Deanne Rubinstein, a member of the committee, an art consultant, and long-time collector, suggested a tapestry and contacted me through the Laura Russo gallery. Deanne and I began a series of meetings with Rabbi Emanuel Rose. I read in the congregation's library and received valuable loans of books, especially a picture encyclopedia, from members. Because of the tapestry site—a long horizontal wall—the three of us agreed on a history timeline. As I have for many tapestries, I redrew symbols on graph paper to conform to axonometric perspective.

The congregation requested the following written explanation that hangs near the tapestry.

> Symbols of Jewish history, ancient and modern, are the content of the tapestry.
>
> Subjects presented are the Twelve Tribes, Egyptian Exodus, Parting of the Red Sea, Passover/ Kiddush Cup, Mount Sinai, Tablets of Moses, Golden Calf, Ark, Grapes of Promised Land, Shofar/ Walls of Jericho, Menorah, Fire of Destruction/Torch of Hope, Torah Consecrated, Diaspora, Holocaust, Congregation Beth Israel, and the Founding of Israel. Symbols for the subjects represent change and stability, destruction and rebirth, and are a visual, metaphorical library. Along the bottom edge of the tapestry five books/scrolls of the Torah are pictured at regular intervals. They are meant to contain the stories represented by the symbols. The five books, like a reoccurring chorus, affirm the Jewish love of learning and study.

The tapestry hangs in the second floor entrance hall to the Weil Center. It is across from an elevator and a balcony that overlooks a two story window.

A Tapestry for Congregation Beth Israel, 36" x 168", linen inlay, commissioned for the Robert P. Weil Administrative Center, Portland, 1993.

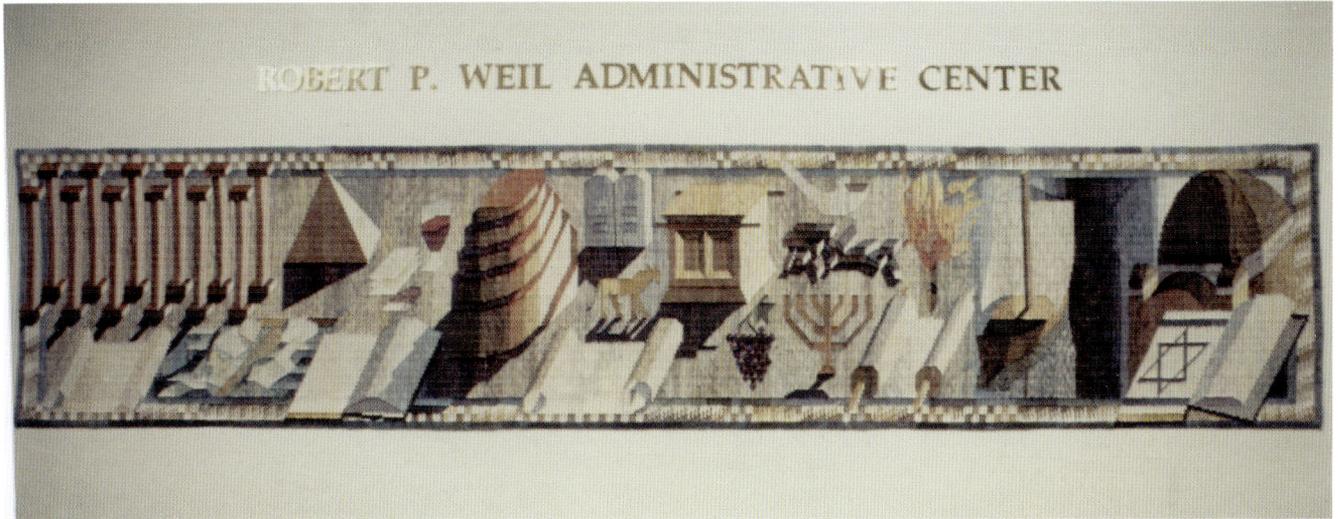

Endeavour Radar Imaging: Michigan Forests, 55" x 53", linen and synthetic inlay, 1994.

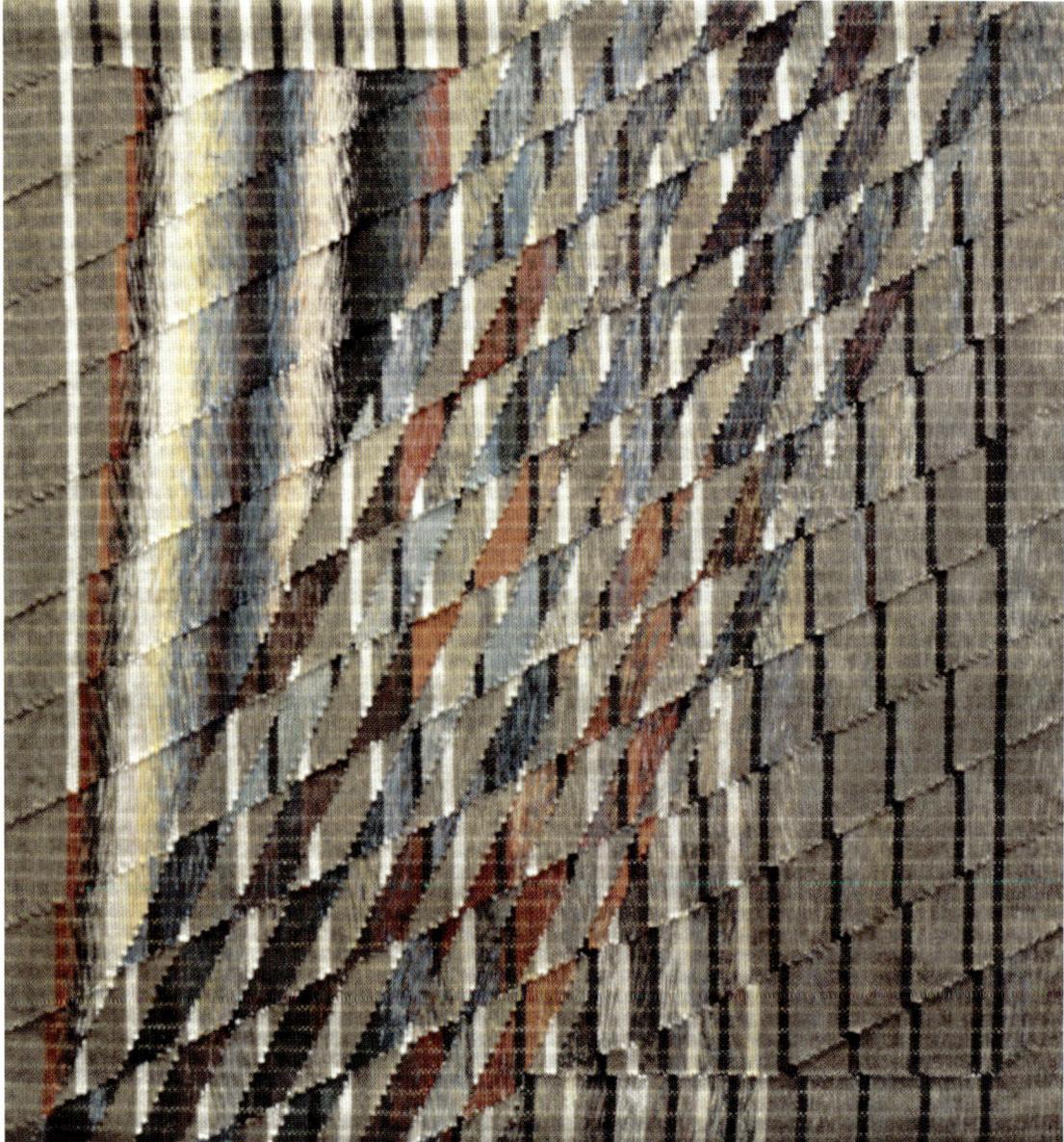

In April and October of 1994 the space shuttle Endeavour took radar images of earth, paying "particular attention to nineteen well-studied sites around the world that are representative of many other areas." Two of those sites were Michigan Forests (would Burt Lake be visible?) and Death Valley. Because of my history of photographing cities from the air and using maps in the making of tapestries, and because axonometric perspective, employed in the Invented Landscape series, is an aerial view with no horizon line, I gravitated to newspaper descriptions of the Endeavour's adventures. (Quote from a *New York Times* article of October 1, 1994, titled "Shuttle Soars Into Space on Mission to Detect Environmental Changes on Earth").

Endeavour Radar Imaging: Death Valley, 55" x 53", linen and synthetic inlay, 1994.

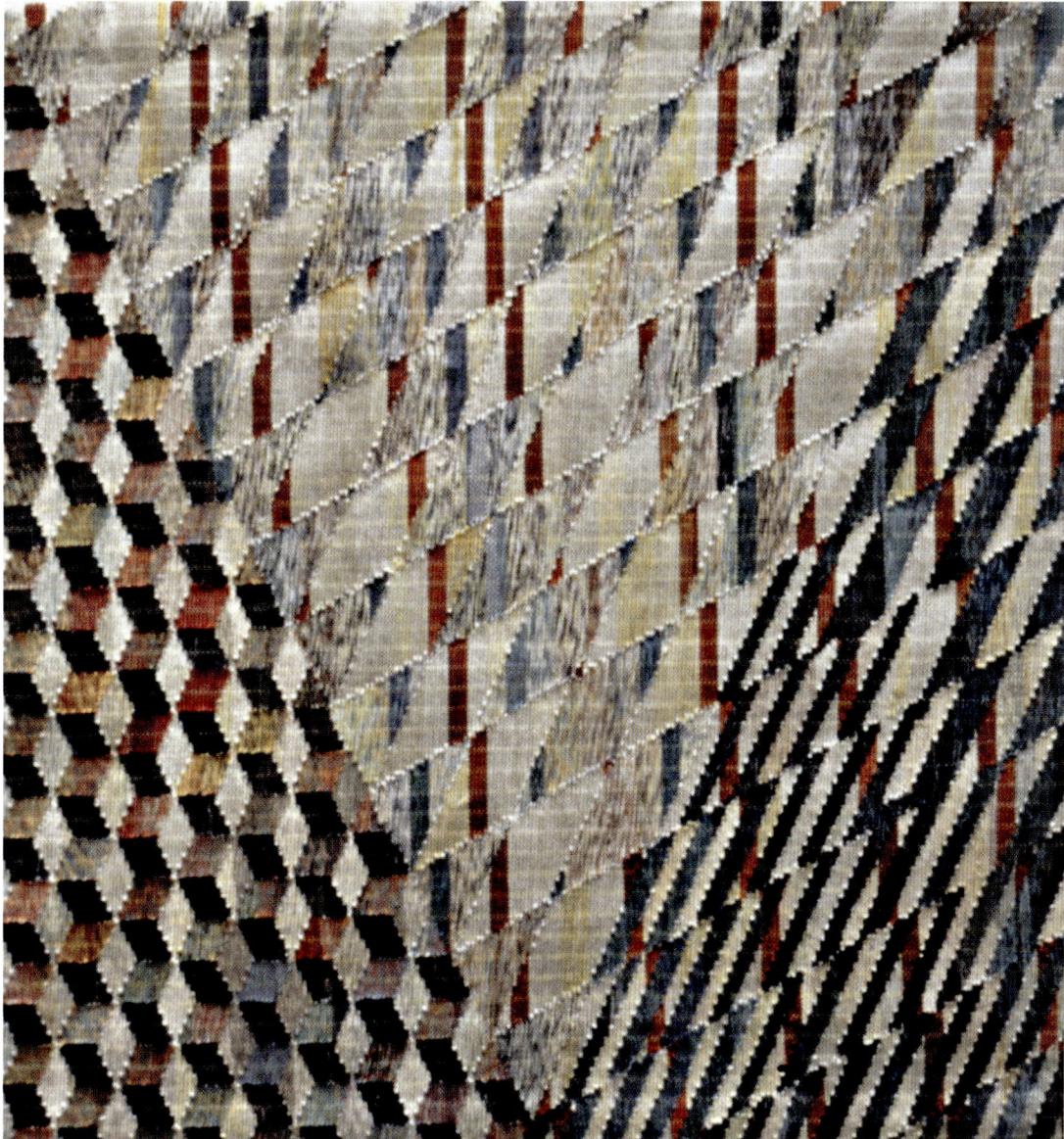

The radars, which are in Endeavour's cargo bay, scan the planet in wide swaths, bouncing radio-wave energy off the surface and producing photo-like, three dimensional images from the reflected energy ... In a secondary mission, the radars will be used to look for archeological sites along a network of trade routes in northwest China known as the Silk Road. This area of the Taklamakan Desert, north of Tibet, was used by Marco Polo and other traders going back more than 2,000 years to conduct commerce in ancient China ... Researchers want to use the Endeavour's radars, which can penetrate more than twelve feet of sand, to detect the buried mud walls and timbers of ancient structures in an effort to find new sites and relocate old ones.

These amazing descriptions suggested abstract moiré pattern imagery. The diagonal structures of the two tapestries spring from the precipitation series, which I miss weaving. The addition of shiny synthetic threads is a fine foil against natural linen.

What is the essence of making tapestry at the millennium? If, historically, tapestry flourished in late Medieval-early Renaissance times, primarily in workshops in Belgium and France as collaborations between patron, scholar, artist, and weaver, suffered a decline beginning in 1514 with the commissioning of cartoons from Raphael for *The Acts of the Apostles* for the Sistine Chapel, then a revival in the Arts and Crafts movement and the Bauhaus, how are we to find a place in the continuum? Knowing full well that the large commissioned tapestries I admire most—*Dodeci Mesi* in Milan, *Apocalypse* in Angers—would not exist without collaboration, I must function as patron, scholar, artist, and weaver in order to make tapestry. When commissions provide a patron, my role as scholar, artist, and weaver is enhanced and enriched.

Alone in the studio, singular in the combined role of patron, scholar, artist, weaver, I flip-flop between two ways of working—between the abstract, counted, systematization of *Square Tilt* and the pictorial, narrative, cartoon-control of the tapestry for Beth Israel. Although the latter method works best for commissions because it more easily allows collaboration via pictorial, historic, and symbolic imagery, in both ways of working I want to be able to invent as I weave. Spontaneous enjoyment occurs when I am able to set up designs on paper in which variation is an enhancement, not a mistake. The raggedy edges of the overlapping squares and the right edge motifs in *Square Tilt* were opportunities to play while weaving. Without play during weaving, tapestry disintegrates into predictable sterility. For me, here are some of the situations in which play is most likely to occur:

– from a drawing on graph paper, not a cartoon.
– from plans based on counting or systematization, not on drawings from observation.
– from uncolored drawings, not full-color renderings.
– from a plan that includes empty areas that need filling during weaving.

This balance between plan and play, recorded in every woven row of a tapestry, unlike our own undocumented reactions to events of daily life, is the idea and practice that must motivate and sustain tapestry makers at the millennium.

My friend and neighbor Janet Sherman traded free accommodations for Tom and me in a house in Hawaii with Janet and husband John for *Square Tilt*. She hung the tapestry opposite the command post in her office at Children's Center of Vancouver, Washington, where she was director. Now that Janet is retired, the tapestry hangs in their Willamette Heights home.

Square Tilt, 41" x 45" w, linen inlay, 1995.

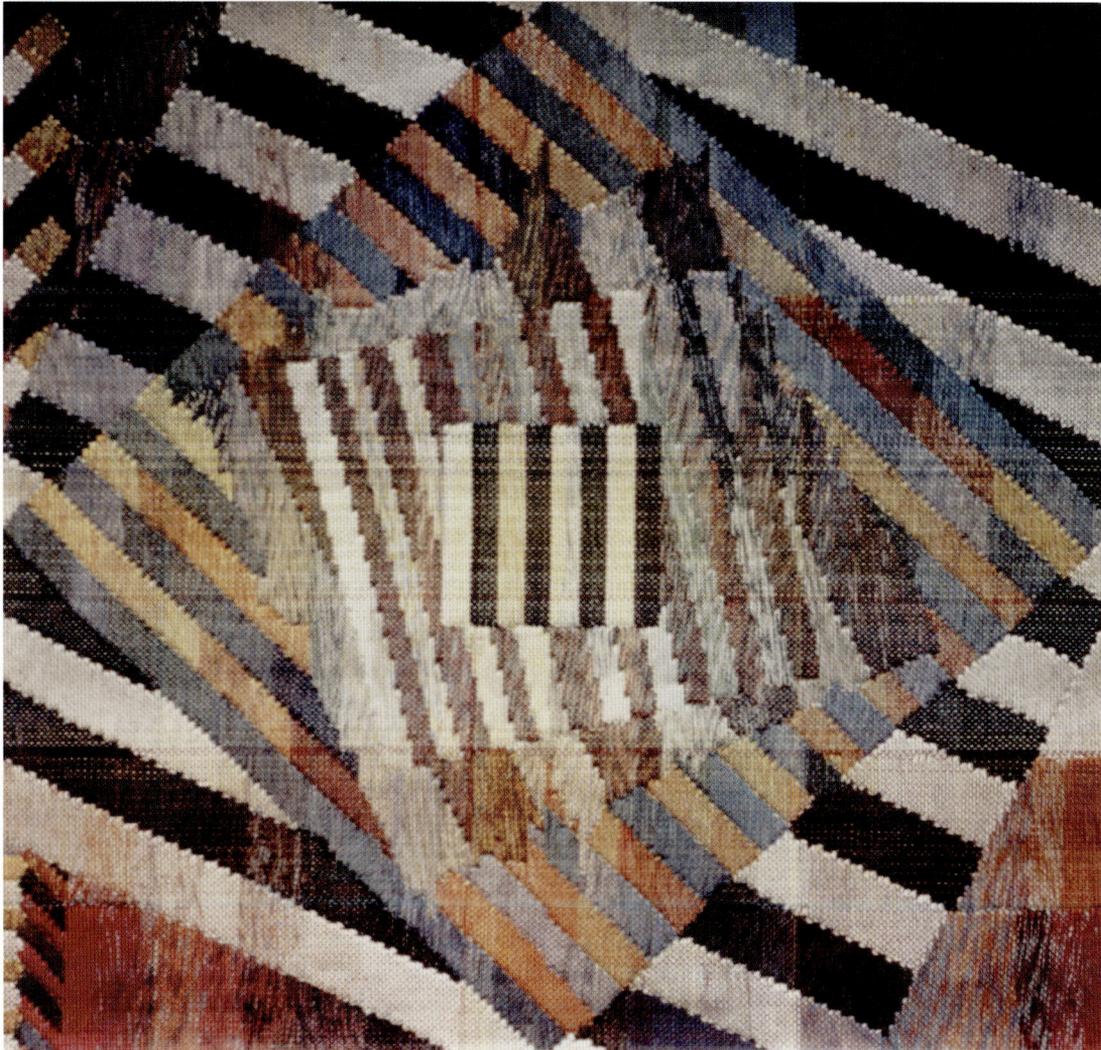

Seminole Salutation (left of a pair), each 72" x 108", linen inlay,
commissioned by the State of Florida for the lobby of the Hearing Building
in Satellite Office Park, Tallahassee, 1995.

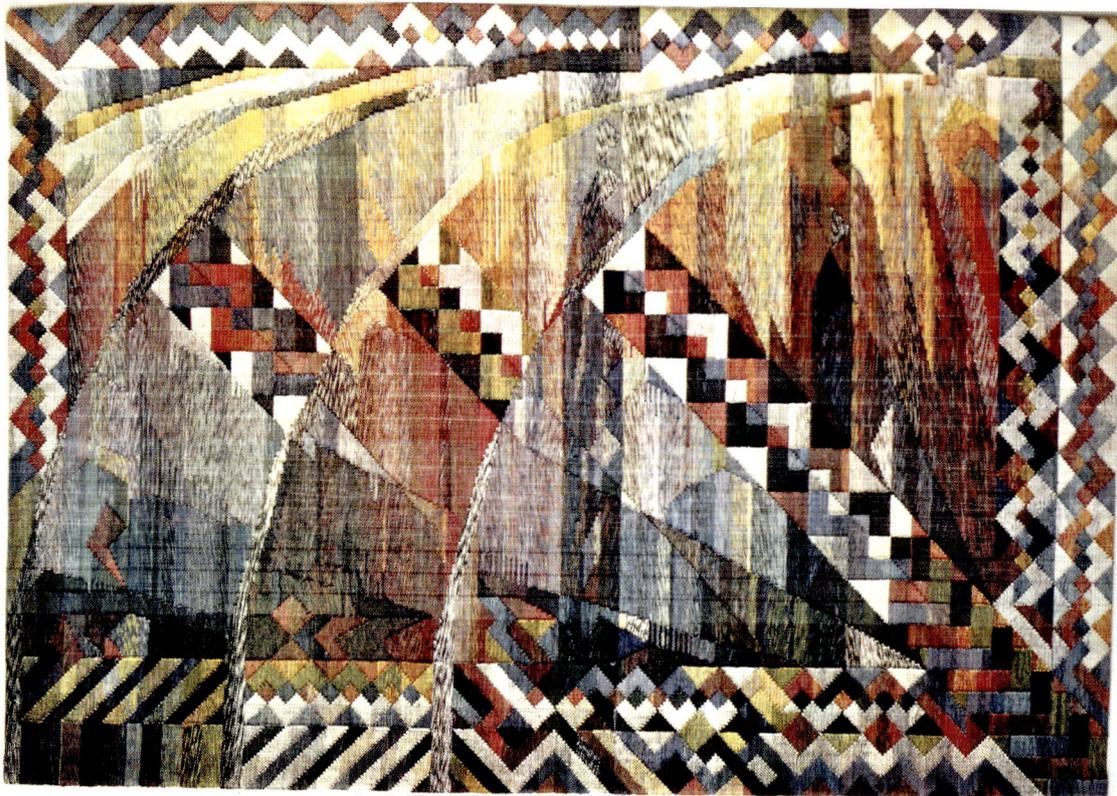

From the Proposal Description of Tapestries and Their Relationship to the Buildings:

The imagery in the tapestries is Seminole Indian Patchwork and quarter circles. My use of Seminole Indian Patchwork celebrates the unique contribution of the indigenous people of Florida to the arts. My use of the quarter circles is a response to the circular plan of the Hearing Building. The quarter circle also represents the foliage of the state tree of Florida, the Sabal Palm—a welcoming, ceremonial, fan shape. The imagery of Seminole Indian patchwork and quarter circles combined with the technique of twisted wefts produces a dynamic abstract subject matter of vibrant growth. The purpose of the tapestries is to represent a contemporary Florida: colorful, welcoming, celebratory of its native crafts, and growing.

Seminole Salutation (right of a pair)

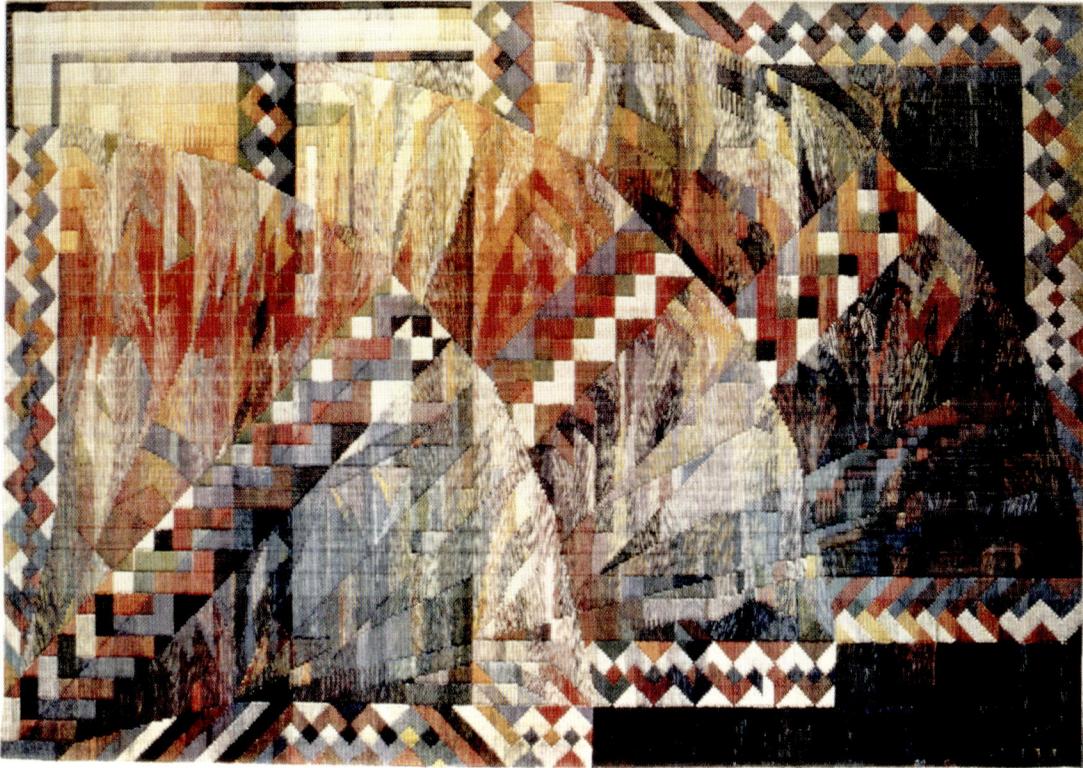

 "You know, by Florida standards your work is not highly colored." This remark, made by one of the female jurors during a pre-presentation interview on the phone, caused me to once again change directions. How could I heighten the tapestry's color? My large scale inlay weave clearly shows the warp. The warp can function as an unprimed canvas or as under painting. I did not abandon one inch warp guideline stripes, but I eliminated all natural warp thread and replaced it with colored. To enhance new color glowing from underneath the inlay, I strove for a transparent layering effect with new inlay wefts. I twisted together highly contrasted colors (blue and gold, black and white) for the inlay wefts. The juror's observation caused me to produce a newly vibrant veiled translucency, which acknowledges a vivid Floridian color sensibility, different from the pearly nuanced neutral of the Pacific Northwest.

Texts & Temples I and *II* were the first uses of a topsy-turvy axonometric perspective. Objects are woven at forty-five degree angles, but they are no longer placed according to past, logical rules. Allowing myself to break from strict axonometric perspective rules was perhaps only a momentary liberation. I wasn't able to make the break again until three years later with *Scutching Floor*.

Carolyn Kizer Woodbridge, a poet, and her husband, an architect, appreciated the imagery of *Texts & Temples I*, which was sold. Through the Laura Russo gallery, they commissioned *II*. I wove several changes, including a Renaissance temple instead of Greek.

Texts & Temples II was my sixth commission with the gallery, which has become a family hangout. At least once a week, usually accompanied by Tom, we walk there to do business, chat with the efficient, interested staff and other artists, and to buy fish at neighboring City Market. First Thursday gallery openings are always stimulating for their lively mix of artists, staff, and patrons. Because I work in solitude, I appreciate and look forward to the contacts available at the gallery, midway in a brisk walk.

Texts & Temples II, 59" x 53", linen inlay, commission for a Paris apartment, 1995.

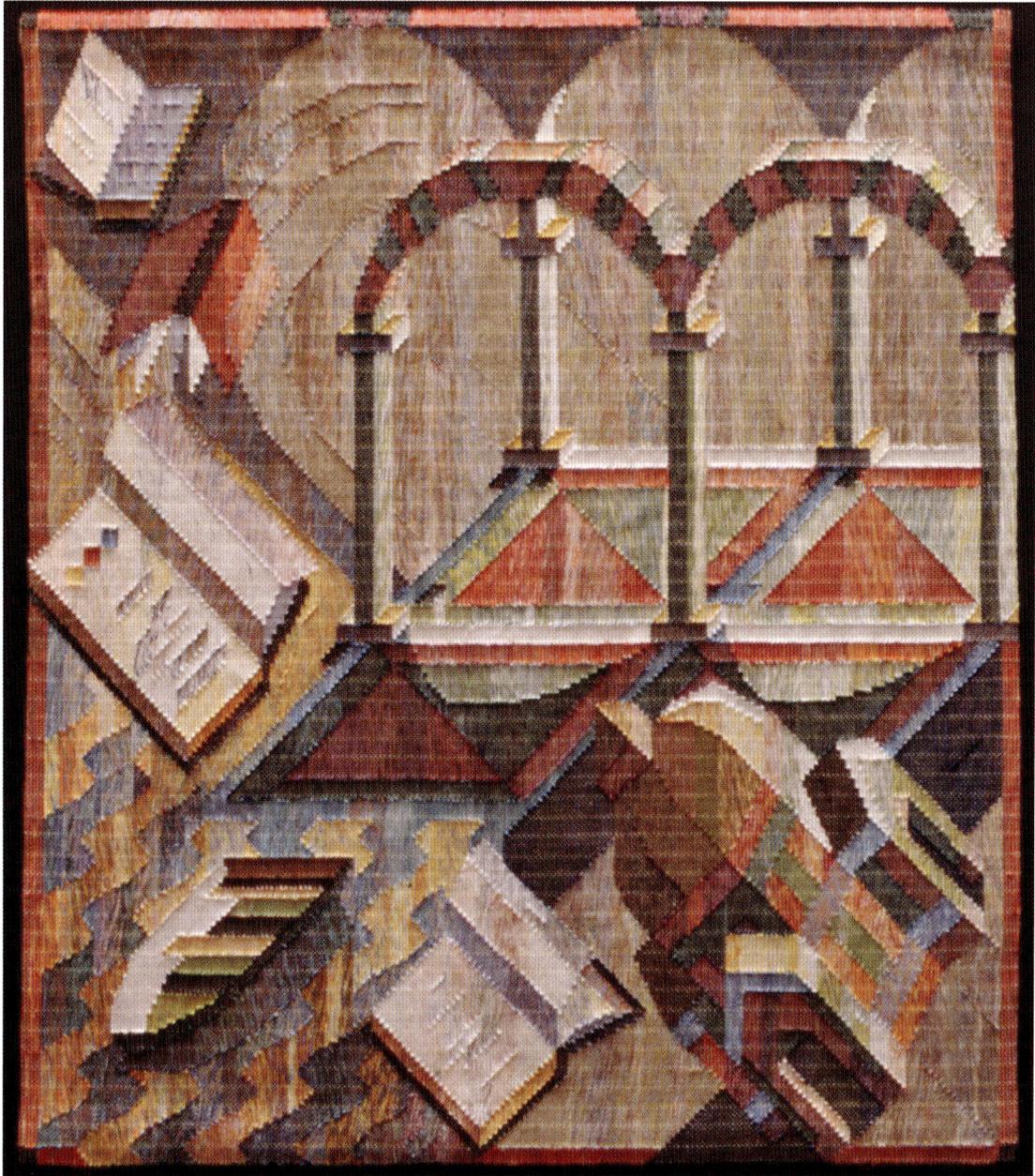

Chapter VI

Weaving a Weaver's World

Convergence '96, two thousand textile enthusiasts strong, met in Portland in July 1996. Along with an exhibition of my tapestries, I curated *Structural Appreciation* with works by Lia Cook, Richard Landis, John McQueen, Sheila O'Hara, and Cynthia Schira at the Laura Russo gallery. It was thrilling to be in the company of work by peers that I'd admired for years, mostly via reproductions. Tracy A. Smith wrote for the July 10-16, 1996, *Willamette Week* "For the Love of Art and Craft—Master weaver Judith Poxson Fawkes pays homage to her peers as she shows her own work."

Although Richard Landis is Fawkes' favorite, his two weavings might easily be overlooked by the casual observer. Yet these pieces alone make this show a must-see. According to Fawkes, "He's both a minimalist and a precisionist. I have admired him for years for his maniacal dedication to his craft."

Lia Cook, from the Bay Area, draws her inspiration from old master paintings and Leonardo da Vinci's drapery studies. Her pieces Fawkes notes, are "weavings about weaving."

Michigan weaver John McQueen, the only non-loom artist of the five, bends twigs, reeds, bark, and similar material to form sculptural shapes. It's not surprising that he began his artistic career as a basket weaver. "What really intrigues me about his work," Fawkes says, "is that quite often he renders a geometric shape such as a cube with non geometric materials and technique. It's this dichotomy that makes them so interesting."

In 1998, *Fabricated from Flax* showed in June at Contemporary Crafts gallery. In 1992, when I was the only American to attend the two week symposium *Flax: Past, Present, and Future* in Vilnius, Lithuania, the former Soviet Union produced eighty percent of the world's flax. Since then, I'd hoped for an exhibition of works in linen, the fiber made from the flax plant, in my home state, which had been the world's top producer of flax during World War II. I asked Adela Akers, Kate Anderson, Nancy Arthur Hoskins, Ferne Jacobs, Jane Sauer, and Kay Sekimachi to show with me. At the opening of *Fabricated from Flax* Nancy Arthur Hoskins presented the slide lecture *Oregon Flax and Linen*, the subject of an article of the same title for the March/April 1997 edition of *Handwoven* magazine.

Oregon's flax and linen production peaked during World War II as an "essential war product" with 18,000 acres of flax and fourteen processing plants.

Even with inexpensive prison labor, the cultivation and harvesting of flax were rarely profitable.

World War I, the Russian Revolution of 1917, the depression of the 1930s, and World War II all affected the ebb and flow of the flax industry.

Nevertheless, the lure of a flax and linen industry for Oregon has not died. An attempt was being made to revive the industry, and the Oregon Flax Association was organized to promote the product. Oregon State University's Alternative Crop Development in Crop and Soil Science sponsored some flax fields near Corvallis.

In the spring of 1997, Tom and I returned to Italy to visit specific Renaissance spaces for which works of art had been designed. The purpose of the visits was to understand the organization of the spaces by being in them. I had no expectations of finding tapestries new to me. I knew that countries south of the Alps are famous for fresco, not tapestry. But I was elated to find justification for my continuing awe of the achievement of the Twelve Months tapestries, *Dodici Mesi*, on a subsequent visit to them in Milan at the Castello Sforzesco. The commissioner of the tapestries was Gian Giacomo Trivulzio for his palace in Vigevano. The designer of the tapestries is a painter called Bramantino (because of his study with the architect Bramante). In two different museums I saw my first paintings by Bramantino. The five dark, lifeless paintings in comparison to the commandingly large colorful tapestries were proof of the weaver's free, inventive use of the technique of hatching to build color and depth. Bramantino's great achievement was not in painting but in the design of the twelve tapestry cartoons—with which the weavers had a field day of playful, ingenious fabrication. The Twelve Months tapestries are their weaver's triumph.

Unlike fresco, mosaic, tile, and intarsia, tapestries are easily moved. The Months tapestries are not displayed in the space for which they were designed. Neither are the three sets of the *Acts of the Apostles* tapestries that I saw in Mantova, Ferrara, and Rome. Although framed to the wall in several rooms in the Palazzo Ducale in Mantova, free hanging in Ferrara, and shamefully shown behind glass in the Vatican Museums, the *Acts* were specifically designed by Raphael for the lower walls of the *Sistine Chapel*. Because of the problems of mobility and duplication of Renaissance tapestries, I gladly looked instead at fresco, mosaic, tile, and intarsia for an understanding of the purpose of a room via its organization.

In all the Renaissance spaces we visited, I imagined weavers, flax processors, and dyers working. Frescoes of curtains, brocaded fabrics, and weavers themselves stimulated these imaginings.

Randy Gragg, in "Weaving a structure—Oregon Weaver Judith Poxson Fawkes likes textiles that are built systematically" (*Oregonian*, July 17, 1996), quoted me:

I think of this image (*Flax Market*, pictured in the *Oregonian*) as a river bank where people come to barter. The church-like building is a shelter with flax awnings. It's done in axonometric perspective, which I draw first on graph paper, one square equaling one square inch of weaving. The pattern on the left side of the building I've seen on Italian floors, but it's also an American quilting pattern called "Baby Blocks." It's interesting you can find this pattern in two entirely different cultures. I think textiles should be about pattern because it happens so naturally when weaving. I like the idea of a textile about textiles, a statement about fabric in fabric.

I started out as a painter but I realized later that I like the way textiles are built more systematically. It suits my temperament more. I find a lot of freedom in the limitations. In traditional tapestries, the warp—or the bones of the fabric—is covered up with fine wool. I think this is out of step with our times. They take forever to produce. In my tapestries, you see the structure much like you do in good architecture. I'm not into personal imagery. I want to think about how a textile will fit into a particular building or a particular community.

Flax Market was purchased by a *Convergence '96* participant and taken home to Santa Barbara, California.

Flax Market, 41" x 62", linen inlay, 1996.

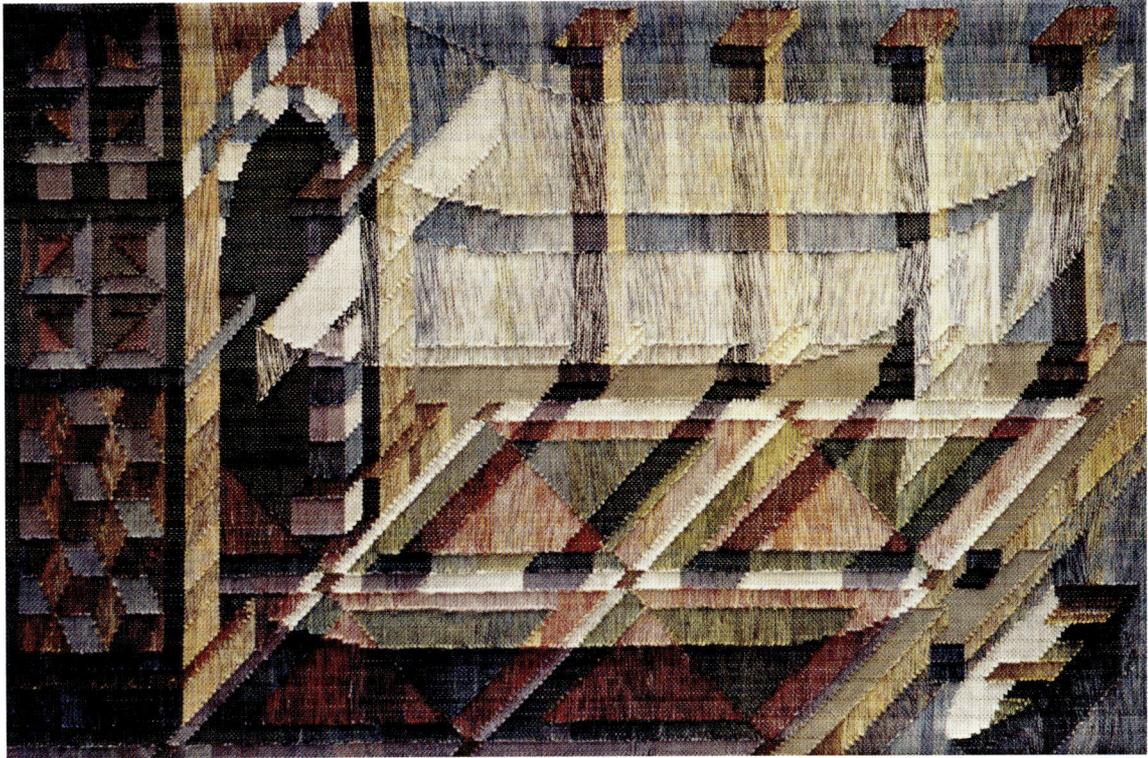

Weaver's Aria, 54" x 102", linen inlay, 1998.

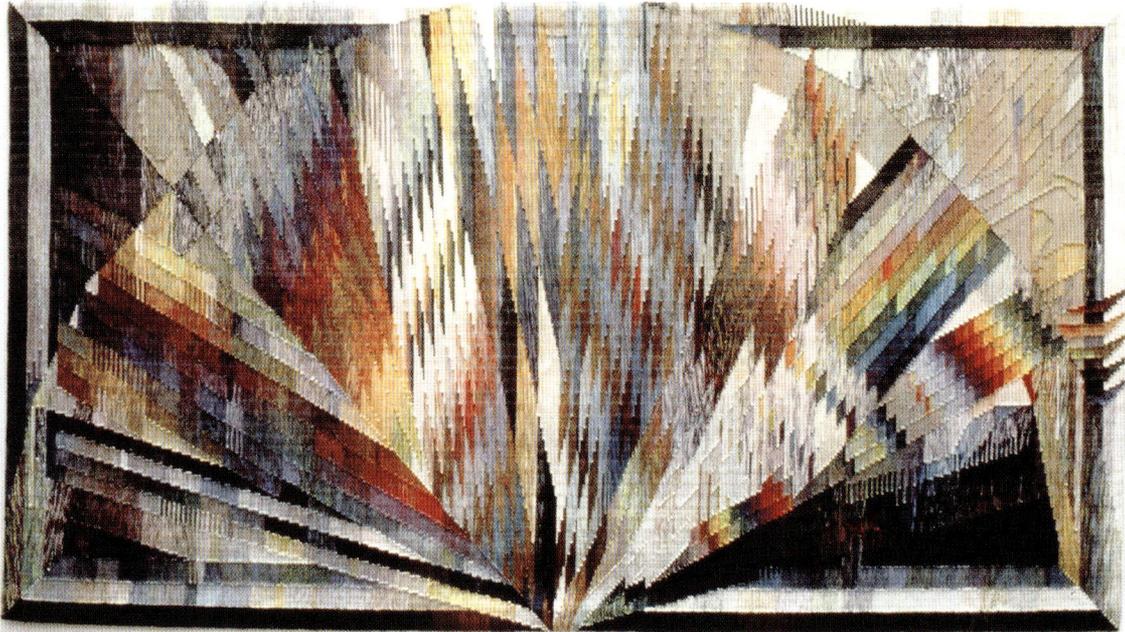

The size of the tapestry was determined by a 102 inch half circle drawn on graph paper. As usual, one square of graph paper equaling one square inch of tapestry. Using a straight edge pivoting at the bottom center, I carefully drew vertical lines thru the graph paper squares that indicated the angles of the colored blades. But most of the color was invented as I went along. The tapestry was woven sideways. Play!—but within a format.

When my 1998 exhibition closed, *Weaver's Aria* was chosen to be rehung in a smaller space, away from the galleries reserved for exhibitions, as is customary at the Laura Russo gallery. Displayed through the Thanksgiving holiday, Gwen Davidson, Office Manager, commented it was their turkey fan.

Water Music, 54" x 60", linen inlay, 1998.

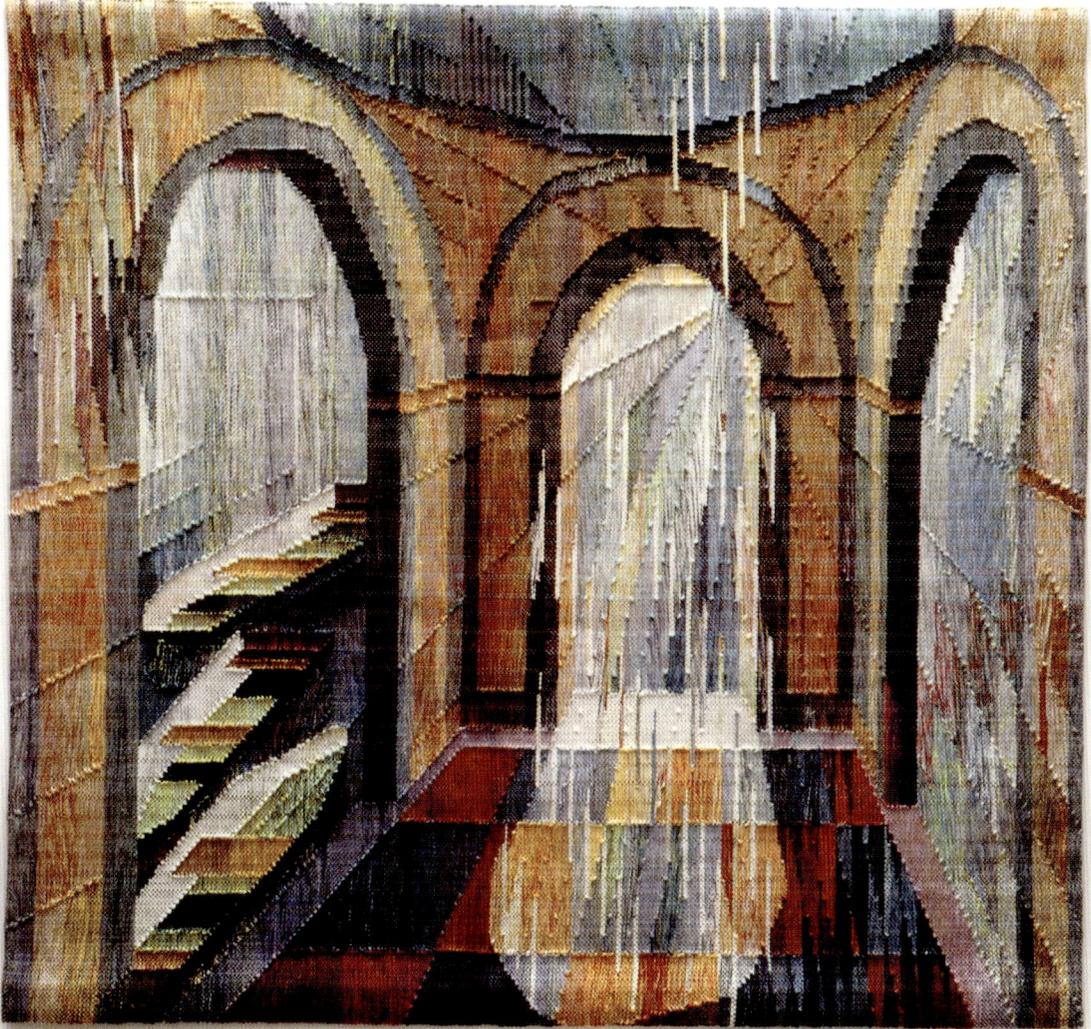

Perhaps flax was delivered from the fields to processing areas via boats with singing boat men?

Of the eight tapestries in the 1998 show at the Laura Russo gallery—announced on the card by *Curtained Cross Vaults*—five had blowing curtains and several made reference to the production of linen cloth with such titles as *Scutching Floor*, *Weaver's Passage*, *Dyer's Passage*, and *Weaver's Aria*. I envisioned the production of linen cloth by a group of weavers inhabiting the Renaissance spaces we'd visited. The proportions of the room and the blowing curtains in *Curtained Cross Vaults* are based on rooms in the Gonzaga and Montefeltro palaces.

In the spring of 1997 we arrived in Italy with an itinerary that took us to Renaissance commissioned works of art whose imagery reflects the purpose of the patron. I wanted to see works of art commissioned for situations that might feel familiar. In order for me to determine appropriate imagery, I need to know the purpose of the owner, the plan of the building, and its site. Before going abroad, I read about the patron families of northern Italy—the Gonzaga of Mantova, the Este of Ferrara, the Medici and Pazzi of Florence, and the Montefeltro of Urbino—and the social and political circumstances that fostered the creation of works of art for their courts. I wanted to experience the media of tapestry, fresco, and garden design that defined the uses of rooms in palaces. I wanted to see how concepts of grandeur, reverence, conviviality, and refuge are conveyed by the division of space and imagery. The Bridal Chamber in Mantova is compelling in the mystery of its intent.

In the northeast corner of the Castello, onto which the Gonzagas added rooms over several generations to total almost five hundred, is the *Camera degli Sposi*, The Bridal Chamber, frescoed by Mantegna. The room is in one of the four crenelated brick corner towers. The frescoes are on one inside and one outside wall. They meet at the corner where there is a recessed window. The other two walls are without figures but are divided, as is each wall, into three vertical parts that correspond to the ceiling bays. The cross vault construction of the ceiling is extended downward in painted pilasters that divide the square room into twelve parts. Mantegna has transformed the room into a curtained pavilion. Just below each arch vault, a painted curtain rod with drapery joins all the pilasters around the room. In the five bays with figures—the window eliminates a sixth—the painted drapery is drawn aside. In the bays with no figures, a closed patterned curtain is frescoed. The center of the ceiling contains the famous *tromp l'oeil* oculus open to the sky. A doorway in the left wall and a mantel piece in the right are utilized in the composition as variations in ground height on which Gonzaga figures sport. Thus the ducal family is shown in the landscape outside the curtained tent of the transformed Bridal Chamber. Not only has the space been architecturally divided and opened, but the owners are shown in the wider world beyond their fortifications. Was the purpose of the room a very private one? Were a bride and groom meant to lie in bed and contemplate their roles in the family shown outside their curtained pavilion?

Private collection, Portland.

Curtained Cross Vaults, 72" x 70", linen inlay, 1998.

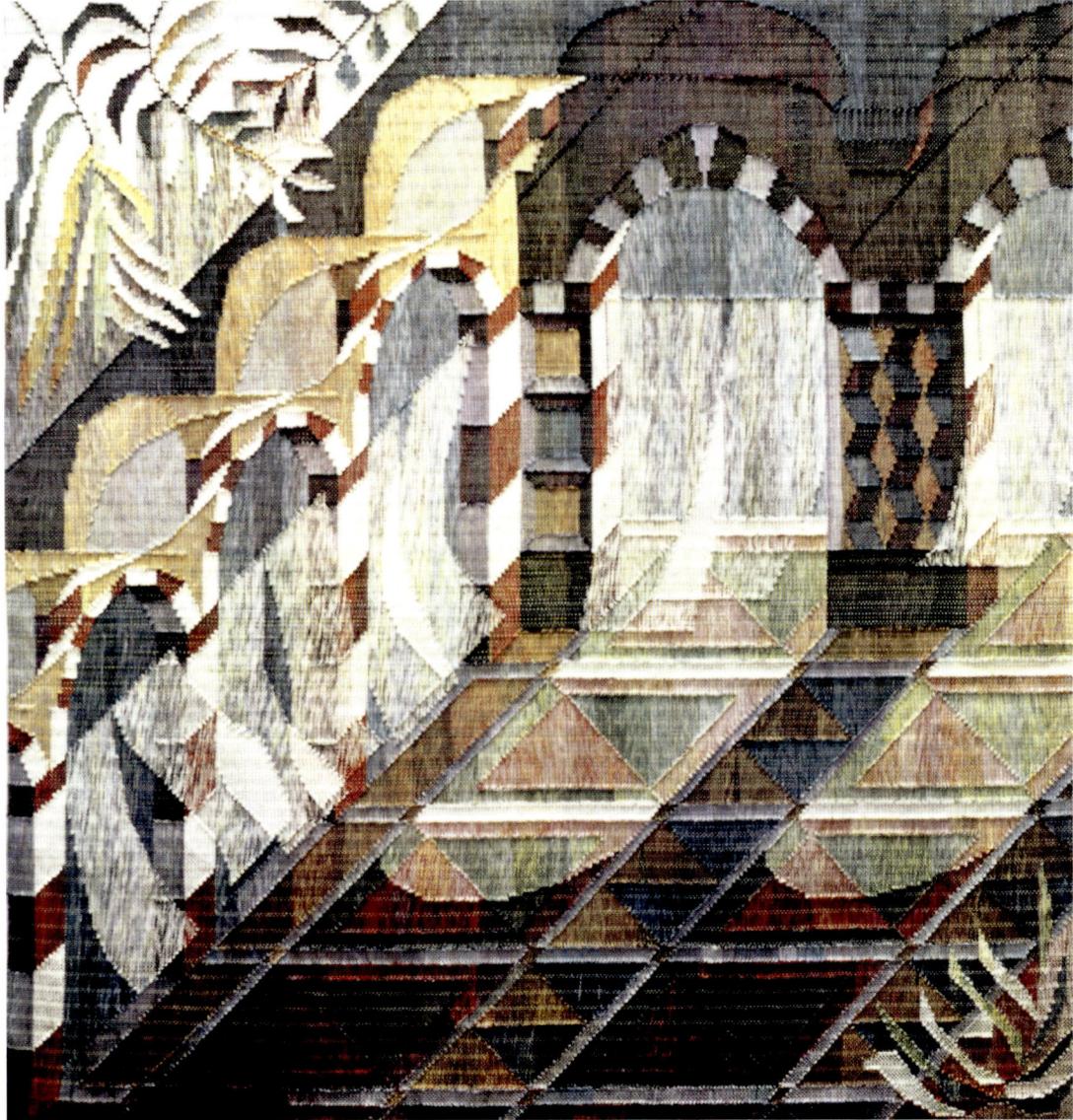

The proportions of the room in this tapestry are based on those of the Throne Room in Urbino's Palazzo Ducale. That magnificent space is bare except for being hung with a set of Raphael's *Acts of the Apostles*. If those tapestries were fortuitously removed to storage, the grand room would happily accommodate flax processing and be a fine scutching floor.

A similarly grand Renaissance space for weavers is the *Salone dei Mesi* in Ferrara in the Palazzo di Schifanoia. The amazing frescoed Salon of the Months combines classical mythology, signs of the zodiac, and events of the months. The frescoes are on two adjoining walls of the tall rectangular room; the other two walls are occupied by windows and the entrance door, which is gained after a grand staircase. The frescoes are divided into twelve verticals, one for each month. The verticals are divided into three unequal horizontal bands. The largest area at the bottom is filled with monthly events such as the palio including horse and running races for boys and girls. The smallest area in the center contains zodiac signs and figures arranged over a plain dark ground. In the top center, farthest from viewing mortals, mythical deities are painted in triumph on wagons. Groups of Renaissance figures flank them on each side, dividing the top band into thirds. In March, in the top right, beautifully dressed women are gathered at a loom. Schifanoia means carefree. The clarity of the wall divisions with the separate groups of amorous, frolicking, gorgeously clad people instill merriment. In the Salone, I was in awe at being joyously alive amidst the depictions of work, play, and sport of mortals and gods. As did the Este family and the painters of the Salon of the Months, I too aspire to hang a room with tapestries that will gladden and heighten the pleasure of life for inhabitants.

Scutching Floor, 57" x 78", linen inlay, 1998.

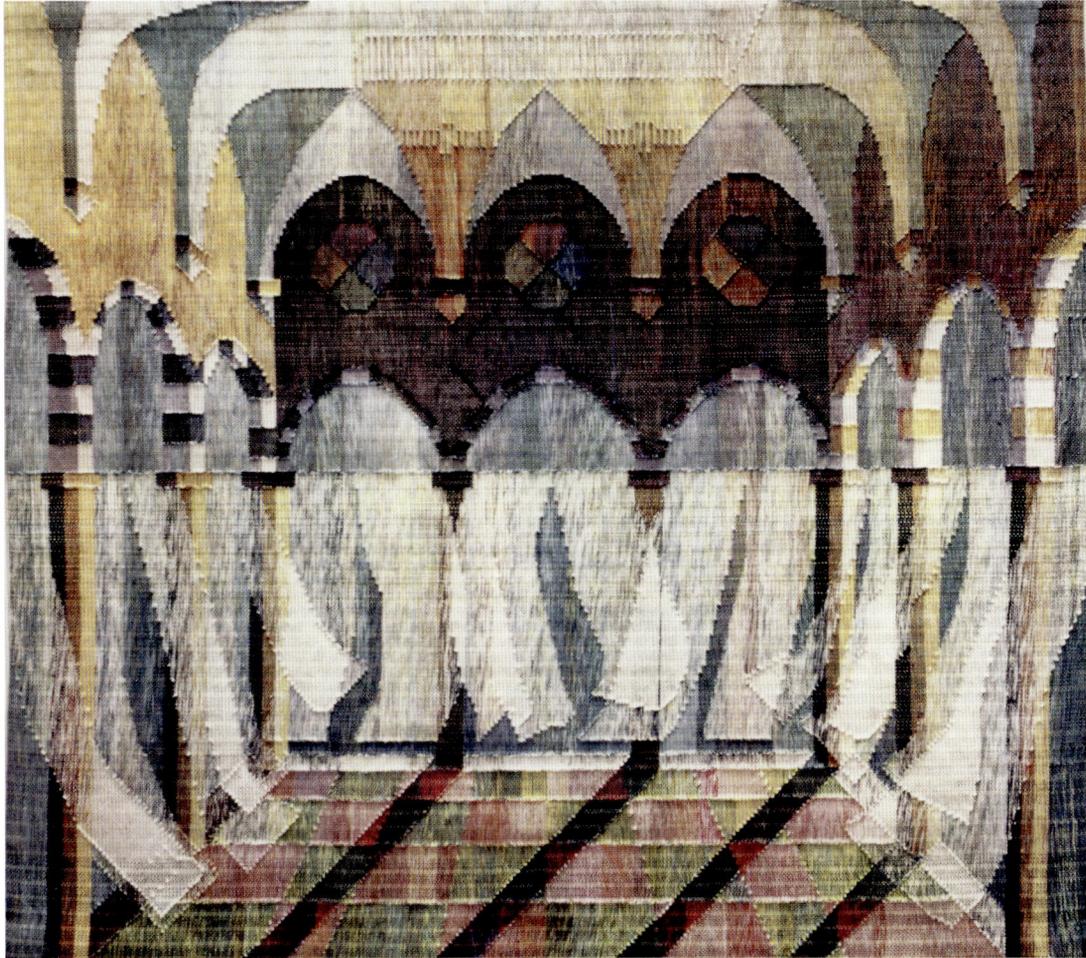

The last of the eight tapestries woven for the October 1998 show at Laura Russo gallery, *Homage to Flax*, was woven when the small plot of flax growing in my garden waved in the sunshine, visible from the studio windows. I'd obtained the Viking flax seed from Daryl Ehrensing of Oregon State University during a planning meeting for the exhibition *Fabricated From Flax*. I'd planted the flax seed, as is traditional, on Good Friday. To prepare the cartoon for the tapestry, I pulled bundles of flax (measuring fifty-two inches high), brought them to my drawing table, and traced their shapes onto the life-size cartoon. Unlike other plants in my garden, the flax plant presents buds, flowers, and seed pods simultaneously. The flax surrounding the globe in the tapestry is actual size.

In September, when *Homage to Flax* was finished and more seed pods than buds showed on the flax plants, I cut the seed pods and stored them in a paper bag. I harvested the flax by the traditional method of hand pulling so as to keep the stems together. I left them on a grassy slope to ret (ret being an ancient term for rot). For about two weeks I augmented the natural moisture of dew and small rain with my garden hose. When the color turned from gold to gray, I stored the flax on chicken wire in the basement to dry.

During the opening at the gallery, I was asked why I'd chosen to depict the hemisphere of the world that produces no flax. I hadn't thought of my choice of our western hemisphere, I simply wanted to weave it. Perhaps subconsciously I made a graphic juxtaposition of have and have-not—of the land of plenty without the now rare fiber that was once so plentiful here in the Willamette Valley that must now be imported into my studio. Perhaps I wove a hope for a return of the flax producing industry to the Willamette Valley that Oregon State University scientists were contemplating.

In 1953, my artist-painter friend Jay Backstrand, then nineteen years old, worked in a Salem, Oregon, mill making linen fish nets. The mill had strong competition from the Japanese who were making nylon fish nets and had developed a way of securing slipless knots. Jay remembers the mill trying to duplicate slipless knots in linen unsuccessfully. The mill closed a few years later.

Private collection, Portland.

Homage to Flax, 67" x 73", linen inlay, 1998.

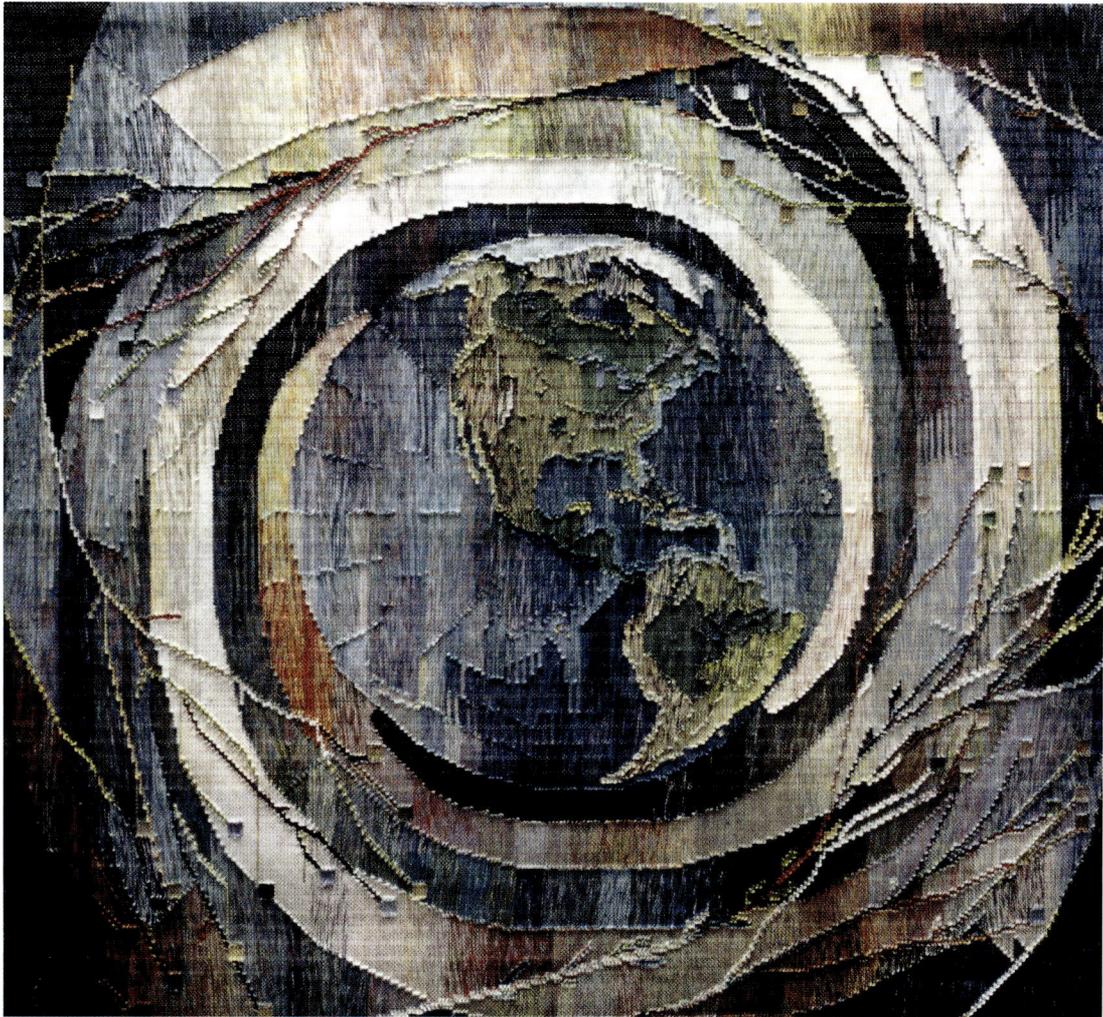

To appreciate the pleasures of the commission process—the exchange of words and images between patron and weaver that lead to visual clarity—one must necessarily experience situations where frustration dominates. Here is the story of tapestries created under conditions less than ideal.

Expectations were inflexible. No commissioner of a tapestry wants a surprise. The patron rightfully deserves a tapestry that looks like the proposal. The San Francisco agent for Trammell Crow had seen the three tapestries I'd made for the lobby of Two Union Square in Seattle and wanted a larger version of the same. She contacted a San Francisco art consultant. Together they measured the space, specified three separate California foliages and asked me to prepare renderings of the finished tapestries, suitable for framing, in order to secure funding from out-of-state CEOs. I flew to the Bay Area and photographed trees in the Berkeley Botanical Garden and Golden Gate Park. I sent the art consultant three photo collages. Two of the three were rejected. I offered to weave a sample rather than attempting more drawings. That idea was rejected and an illustrator was hired to draw a white oak. I protested I could not weave from a design that I had not initiated. I flew down for a second photo shoot of white oak arranged by my father, a Danville resident. A photograph of a venerable old oak, on the Podva acreage behind my parents' house, was finally approved, but only if I'd weave it sideways instead of in its natural pendulous position, which agent and consultant termed depressing.

I was dealt with as a sub-contractor. I met the agent from Trammell Crow only once—to secure approval for *White Oak,* the last of the three tapestries. Throughout the six months, I conversed only with the art consultant. I would have liked to consider mixed foliage of larger leaves in horizontal formats. I had no input in the process.

Labor was long, with little opportunity to invent as I wove. I accepted a six month deadline. Excluding weekends and three weeks for finishing each tapestry, I had seven weeks or thirty-five days to weave each twelve foot high tapestry. A days' weaving was four and a half inches in order to make the deadline. Following an eight foot wide cartoon suspended below the warp, often in intricate tiny leaf patterns, to build four and a half inches each day often kept me at my loom until seven P.M. I dared not stray from a strict adherence to my hard-won approved designs.

Installation was delayed, although tapestries were delivered on time. My flight south was for naught. Parents and out-of-towners were disappointed. As soon as the tapestries were in place, the consultant quit the business and his former partner was not interested in having the tapestries photographed. I took pictures myself.

California Redwood was hung on the west wall, the geographic direction inhabited by the species, *White Oak* on the east, and *Bigleaf Maple* on the north. What I liked best about this trio is that they fluttered in the fresh air that rolled through the circular doors—the same as their living look-alikes out in the California landscape.

Several years ago I found myself in San Francisco on California Street with friend Lucinda Reinold. I eagerly encouraged her to accompany me to see the tapestries. Gone! Bare walls!

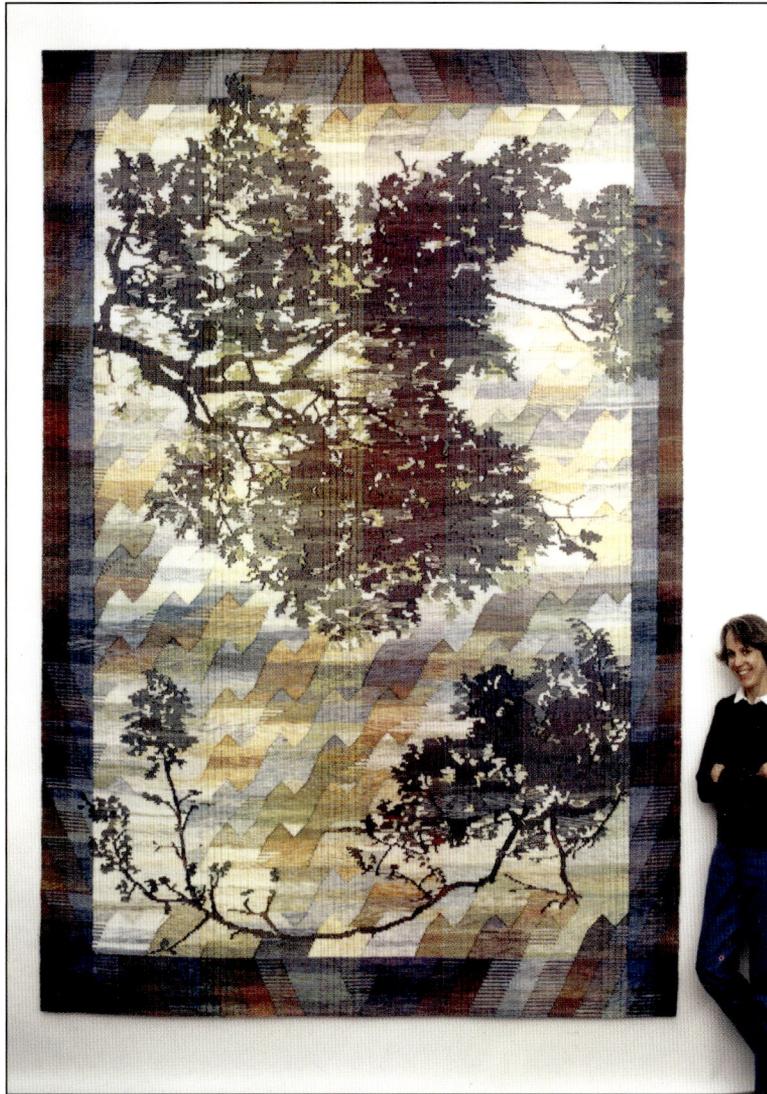

White Oak, (one of three) 144" x 96", linen inlay, commission by Trammel Crow for the lobby of 650 California Street, San Francisco, 1997, photographed in the commons of Pacific Northwest College of Art.

California Redwood, Bigleaf Maple, White Oak, each 144" x 96", linen inlay, commission by Trammel Crow for the lobby of 650 California Street, San Francisco, 1997.

In June 1995 I signed a contract with The General Services Administration for four tapestries for the new Mark O. Hatfield Federal Courthouse in Portland to be opened in 1997. A clause in the contract read, "The design concepts may be conveyed by the Contracting Officer to the National Museum of American Art for exhibiting purposes and permanent safekeeping." Although I'd represented tapestries on paper many times before, the knowledge that I might be remembered solely on paper in the museum in DC did not lessen my belief that the tapestry is primary and its design on paper is merely a working tool. The designs presented for approval for four tapestries for the courthouse were a combination of photo collage and actual size cartoons, which were used up during construction. Slides of the designs represent the project in the National Museum.

From the GSA brochure, U.S. Courthouse, Portland Oregon—Art in Architecture:

> Before I was brought aboard this glorious project, a sixteen member panel paved my way. The Community Art Panel, composed of local art professionals, community representatives, and the building's architect, reviewed over two hundred twenty artists' submissions. The Panel made recommendations to GSA about the type and locations of the artwork to be commissioned and nominated four artists to GSA. GSA endorsed the Panel's nominations and commissioned artwork from Tom Otterness, Eric Orr, Judith Poxson Fawkes, and Sandra Stone.
>
> The art was selected to complement the design and yet be sensitive to the function of the court. Its placement was selected to optimize its exposure to the public. It was our hope that the public would view the art as a calming influence from the anxiety normally associated with court proceedings. The pieces and quotations chosen allow space for contemplation, refection on our State's heritage, and provide some whimsy about the legal proceedings.
>
> Honorable Malcom F. Marsh

A series of meetings, beginning with a Kick-Off July 14, 1995, culminated in the gala day-long Dedication November 13, 1997. The first meeting had two objectives: to visit the construction site downtown with a detour to the Gus Solomon US Courthouse, and to introduce the artists to the Community Art Panel and the Project Management Team. I especially appreciated seeing two older courtrooms in which, according to Judge Marsh, people behave very differently: a two story courtroom with carved wood judge's bench, arched windows with long draperies, portraits of judges opposite the windows; and a courtroom remodeled in the 1970s in lattice work, electrical cables snaking around informal, moveable furniture, low ceiling, and no natural light. Later, in the conference room of BOORA Architects, introductions were made via a ten minute informal slide presentation by each artist and preliminary comments by Judge Marsh on US Courts Vision, John Meadows on Design, and Cynthia Gould on GSA's Art Program. At a second meeting, the artists presented preliminary design concepts to the same group. After the October 30, 1995, Formal Design Concept meeting, the artists were given the OK to go to work. We had fourteen months in which to complete fabrication.

In the three months preceding the Formal Design Concept meeting, I made several trips around the state to visit historic sites and to photograph Oregon foliage. I read Oregon history and met with Judge Marsh. The *Oregon and Justice* pair symbolize the function of the building. Two tapestries inside the Special Proceedings courtroom provide history and bring the light and foliage of the outdoors indoors.

Oregon & Justice, each 84" x 96", linen inlay, commission by General Services Administration for the lobby of the 16th floor of the Special Proceedings court room, Mark O. Hatfield US Courthouse, Portland, 1997.

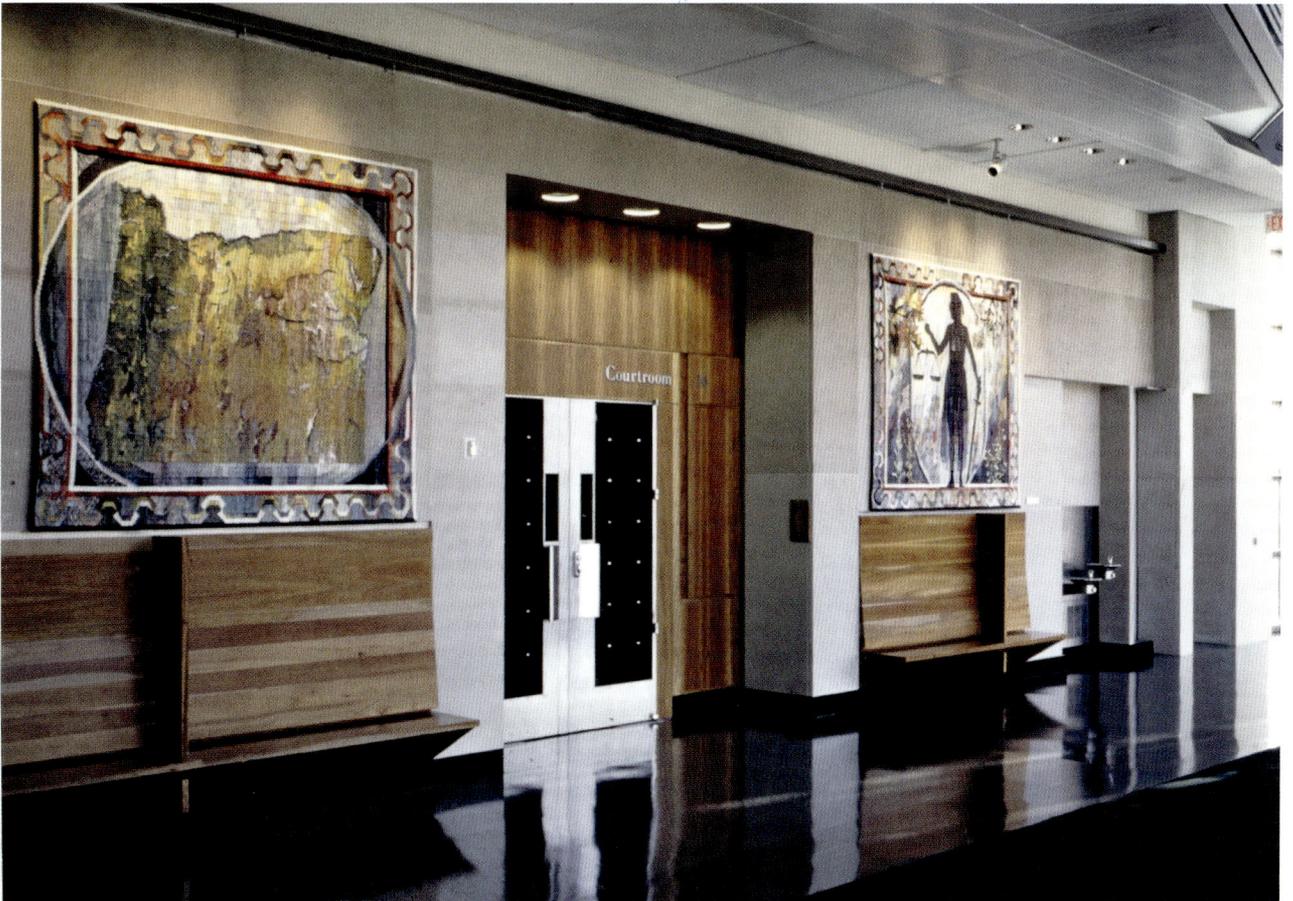

The *Judicial Heritage* tapestry presents the pre-history of the federal judicial system in the Oregon Country along the Columbia River. That pre-history spans fifty-six years. It begins with the first arrival of a non-native—Captain Robert Gray into the mouth of the Columbia in 1792—and ends with the Oregon Country becoming an official Territory of the United States of America in 1848 and thereby subject to the protection of U.S. courts. The *Judicial Heritage* tapestry is a map of the section of the Oregon Country along the Columbia River from the Pacific Ocean on the left to the Snake River on the right. The text of the tapestry, woven into the top border, is:

THE JUDICIAL HERITAGE OF THE OREGON COUNTRY 1792-1848.

Additional text woven into the tapestry names the earliest practitioners of justice that form the judicial heritage of the Oregon Country. These persons, institutions, and locations are located on the map by color coding the woven names to a colored dot on the map. These judicial influences are outlined by Terence O'Donnell in his Introduction to the book *The First Duty*. They are gathered into an oval framed legend as: CAPT. ROBERT GRAY, HUDSON'S BAY CO., DR. JOHN MCLOUGHLIN, LEWIS & CLARK, GREAT MIGRATION, MISSIONARIES, CHAMPOEG, TREATY TRIBES. These representatives of the judicial heritage are represented by a dotted line on the map, beginning at the mouth of the Columbia River, Astoria, Vancouver, Oregon City, all along the Columbia River to Walla Walla, and Champoeg.

The Judicial Heritage, 48" x 204", linen inlay, commission by General
Services Administration for the north wall of the Special Proceedings court
room, Mark O. Hatfield US Courthouse, Portland, 1997.

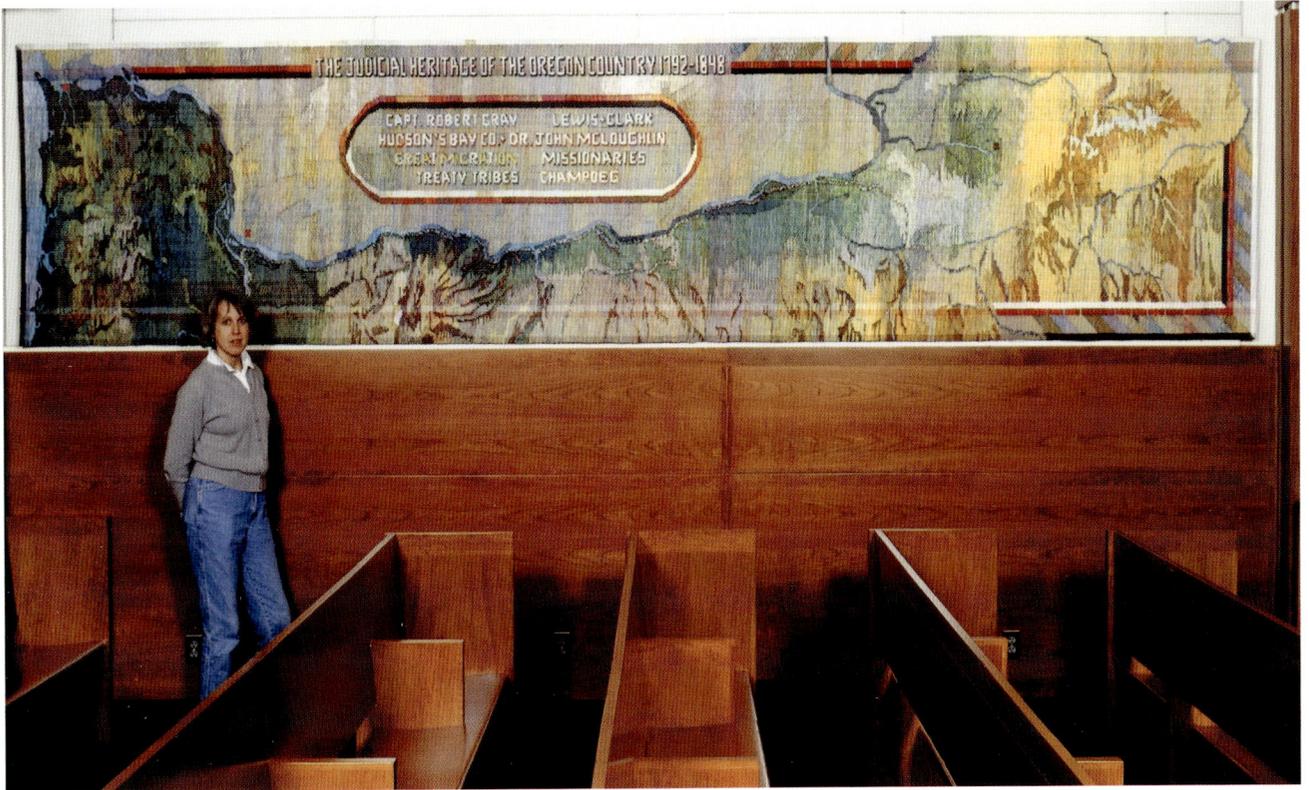

The *Oregon Environment* tapestry shows indigenous foliage over an abstract water/wave pattern. Plants, beginning in the west back corner of the room and progressing to the east, are: Douglas Fir, Thistle, Mullein, Big Leaf Maple, Rabbitbrush, Aspen, and Ponderosa Pine. The tapestry is a lyrical close-up view of foliage over water, as might have been seen by any of the inhabitants of the Oregon Country or by any individual today.

The tapestry pair is complimentary: one presents history in relation to specific locations on a map, the other an escape into the light and landscape of that history. Both tapestries begin in the back west corners of the courtroom and read toward the judge at the east end of the room.

The Oregon Environment, 48" x 204", linen inlay, commission by General Services Administration for the south wall of the Special Proceedings court room, Mark O. Hatfield US Courthouse, Portland, 1997.

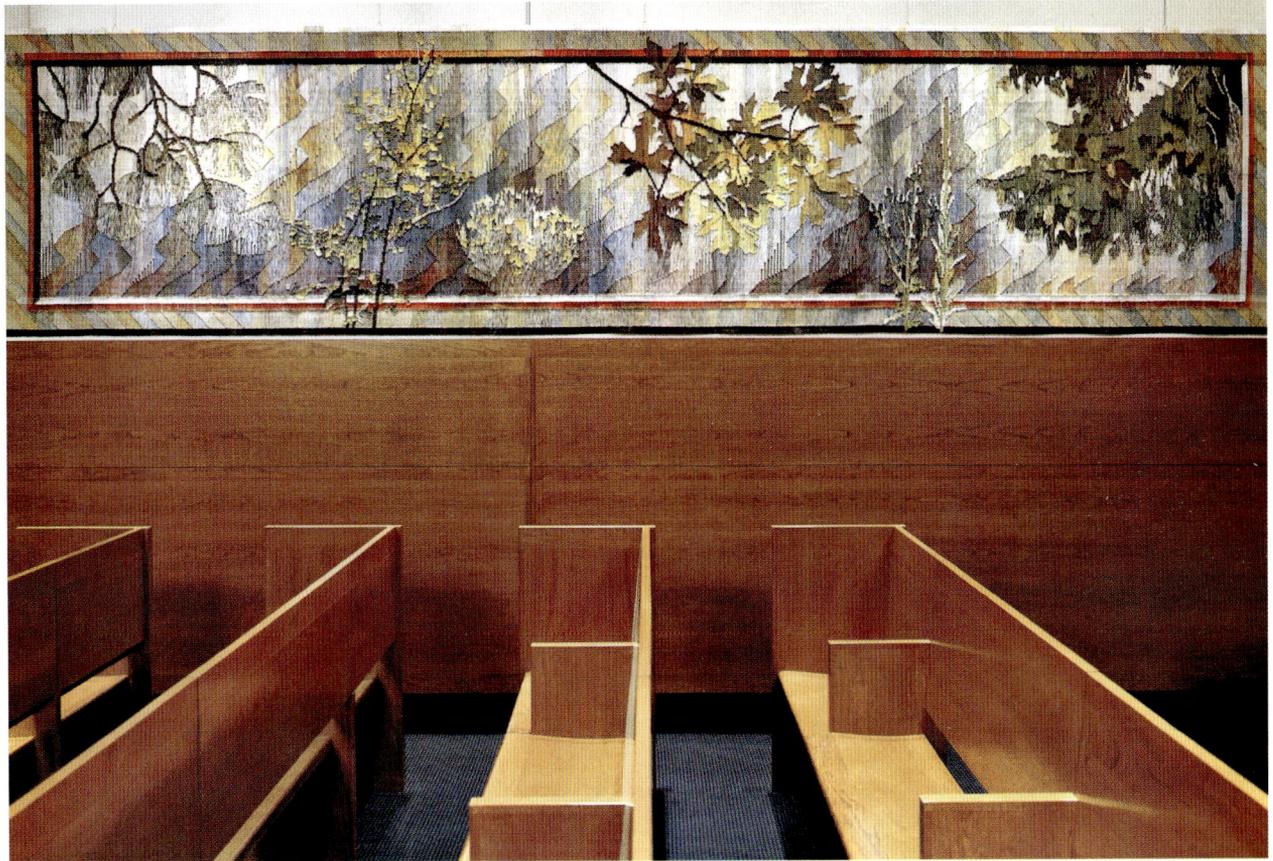

The Oregon Arts Commission specified two art sites: the two story lobby and a curved wall at the junction of three long hallways. I requested a list of PERS (Public Employees' Retirement System) members. The nineteen page list ranged from "Agriculture, OR Dept. of, Construction Contractors' Bd, Public Utility Com, to Yamhill Cty Sch Dist." *Oregon Sunrise* welcomes the diverse family of PERS members with imagery held in common—a map of Oregon, native Oregon plants and trees, and a colorful sun. Specifically, the five plants at the bottom of the tapestry beginning on the left, the west, and moving east to correspond to locations on the map in which they are found are: Mullein, Trillium, Rabbitbrush, Thistle, and Teasel. The trees are Bigleaf Maple. The map is topographic and does not include man-made features. This imagery is intended to be inclusive, to instill pride, and to be symbolic of new daily beginnings as well as hope for the future and the new dawn of retirement. The tall verticality of the tapestry begins about shoulder height and ends at about the top of the head of a spectator on the balcony.

Oregon Sunrise, 180" x 96", linen inlay, commission by the State of Oregon for the lobby of Public Employees' Retirement System, Tigard, 1998.

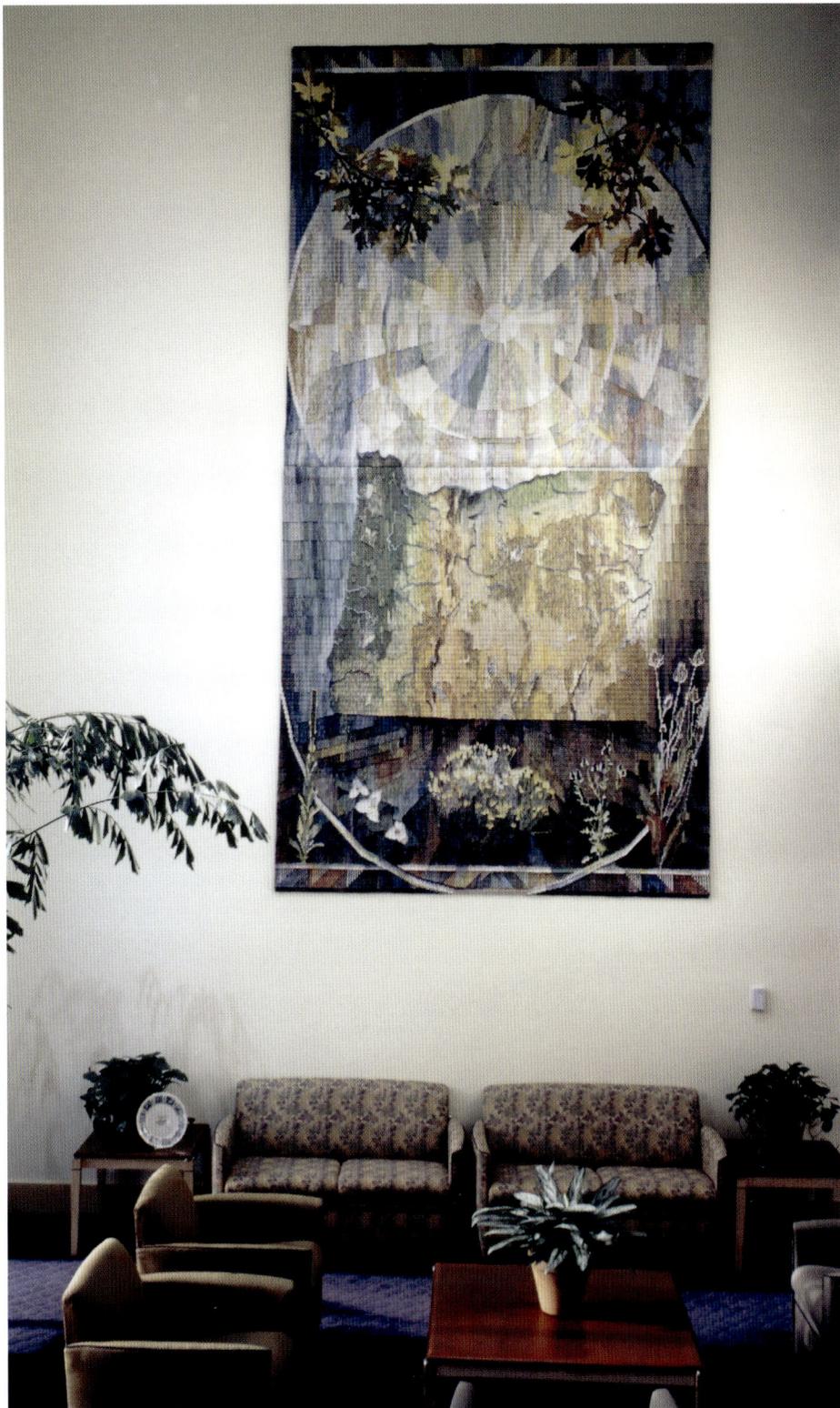

The use of a large circular sun shape in the second tapestry titled *The PERS Beacon* unites the two works of art and the two spaces. Visible down a long hall, on the curved wall between the entry doors to the Board Room, under a dome, in a chapel-like space The PERS Beacon tapestry reveals its imagery as the viewer moves closer. Symbols of the many members, spilling out of a circle, are its subject. Specifically, beginning at twelve o'clock and moving clockwise: Scales of Justice for Criminal Justice Council, Judges, Judicial Dept.; Shovel for Bureau of Labor and Industries, Land Use Board of Appeals; Planted rows for Depts. of Agriculture and Forestry, Land Conservation and Development, DEQ; Water Pipe and Water for Irrigation Districts, Water and Sanitary Districts; Boat for Ports, Parks, and Recreation Districts; Salmon for Fish and Wildlife, Salmon and Trawl Commissions, fisheries; Power Lines on Poles for Utilities and Dept. of Energy; Highway for Dept. of Transportation; Computer for all of PERS; Books for Teachers and Libraries. In the center of the tapestry the Level, along with the Hammer, Saw, and Blueprint scroll represent Housing Authorities and Boards of Architect and Engineering Examiners. The Fire Hose represents fire districts, the Stethoscope Health Boards and Board of Medical Examiners. The Mortar Board is for all school districts, Community Colleges, and Universities. I hope viewers will also add their own interpretations of the symbols.

Before the installation of the PERS tapestries on Valentine's Day 1998, capping two years of exhilarating commissions, I'd begun drawing for a series of tapestries for a show at the Laura Russo gallery in October '98. I picked up where I'd left off with *Flax Market*, but moved imagery indoors to recapture some of the Renaissance spaces Tom and I visited in the spring of '97.

The PERS Beacon, 60" square, linen inlay, commission by the State of Oregon for the hallway of Public Employees' Retirement System, Tigard, 1998.

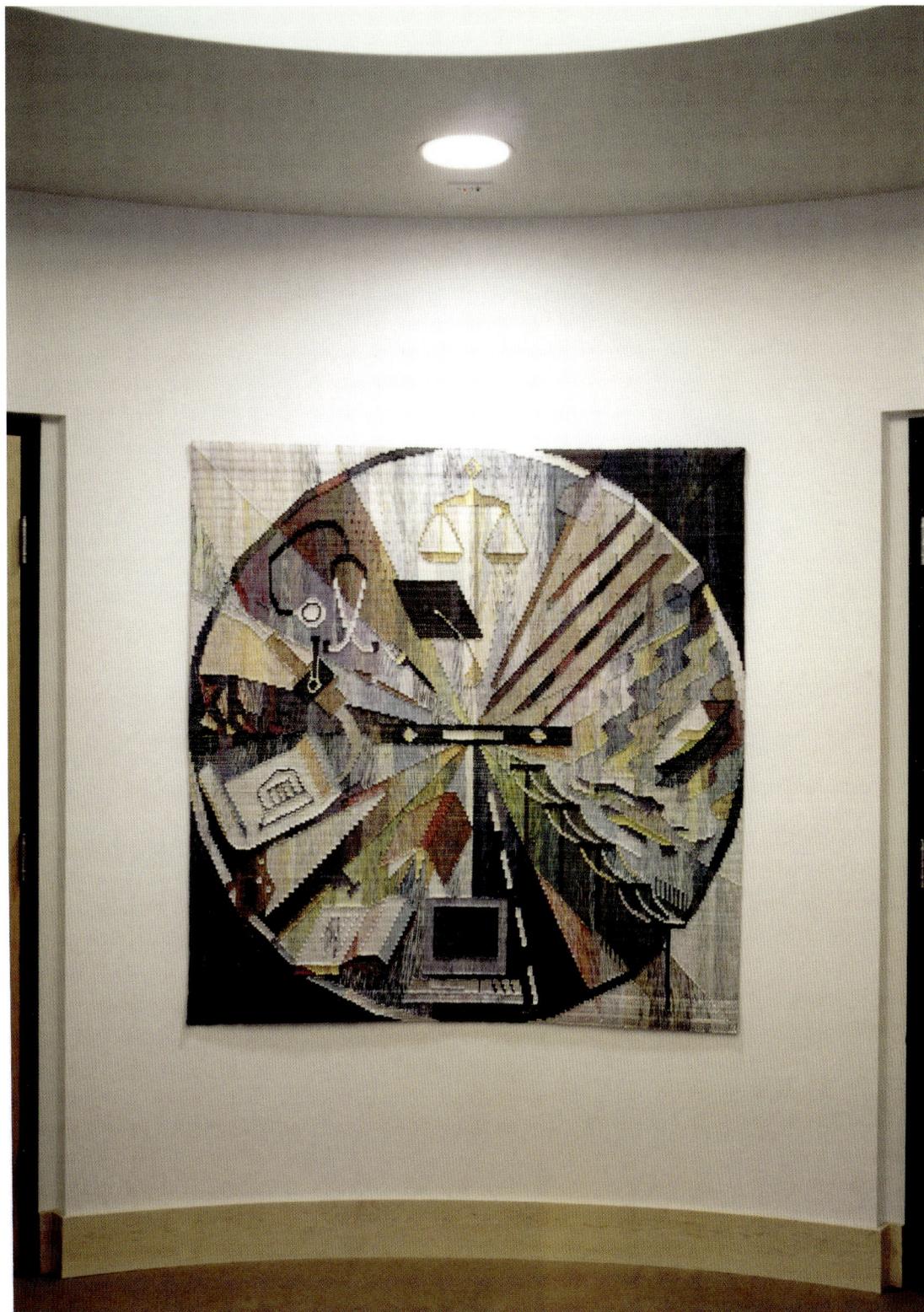

Chapter VII

Woven Landscapes—Near and Far

In five years, 1999 through 2003, I produced fifteen separate tapestries comprising ten commissions, five requiring out of state travel. All these tapestries were woven in the technique of inlay. I was getting quite quick and accomplished at inlay, understanding it as the best technique for the kind of imagery the commissioners wanted. Also it was interminably more of the same. For example, I must have woven bigleaf maple leaves, from photographs I took, in most of the commissioned tapestries.

In 2001, '02, and '03, I also wove seventeen tapestries incorporating my choice of imagery and returned to longed for double weave. Some of those seventeen tapestries comprised a show at the Linda Hodges gallery in Seattle in 2002.

Wood Intarsia panels made during the WPA were in storage and the lobby of the new Richardson Hall containing the Forest Ecosystem Research Laboratory at Oregon State University was designed to incorporate them. Three artists made proposals for the far wall that would be compatible with the panels. A *Tapestry Map for Chapman School* hangs in the school's entrance lobby within view of two similar inlaid wood panels that flank the auditorium—linen and wood, both fibrous, both grown from soil—make a good pair and so agreed the selection jury.

The following is from my proposal: The tapestry provides a lyrical celebration of Oregon's forests as well as a welcoming beacon to the working areas of the building. It pictures boughs of leaves representing native trees found in different regions of the state. The composition of the tapestry is broken into two ovals—one horizontal, one vertical. Although ecosystems have no such limits, the oval frames suggest different ways to focus the study of ecosystems. The ground of the tapestry is woven in abstract patterns of many colors to suggest sunlight, precipitation, and streams of the different climates, conditions, and seasons of Oregon. Foliage, beginning at the center top and moving clockwise, include: Ponderosa Pine, Shore Pine, Western White Pine, Black Cottonwood, Trillium, Douglas Fir, and Red Alder.

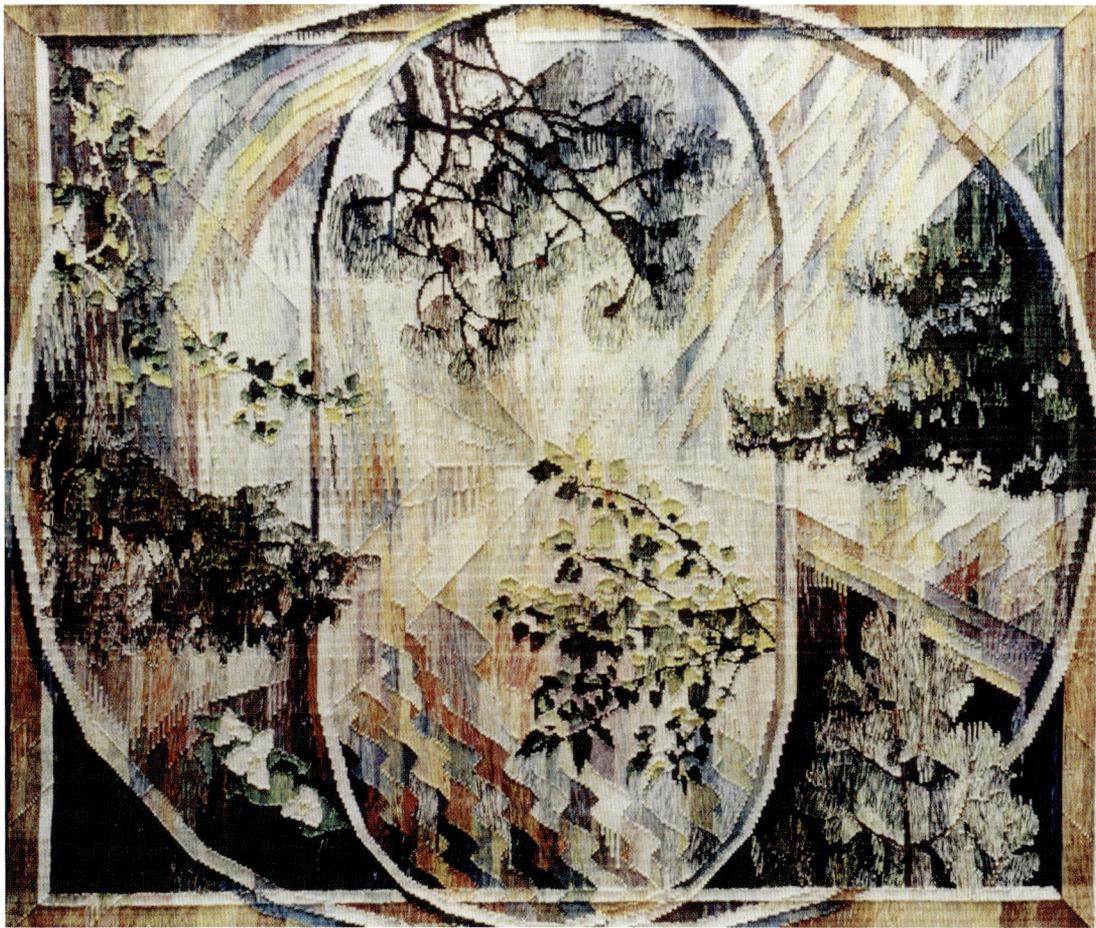

Oregon Foliage of the Forest Ecosystem, 94" x 102", linen inlay,
commission for Richardson Hall, Oregon State University, 1999

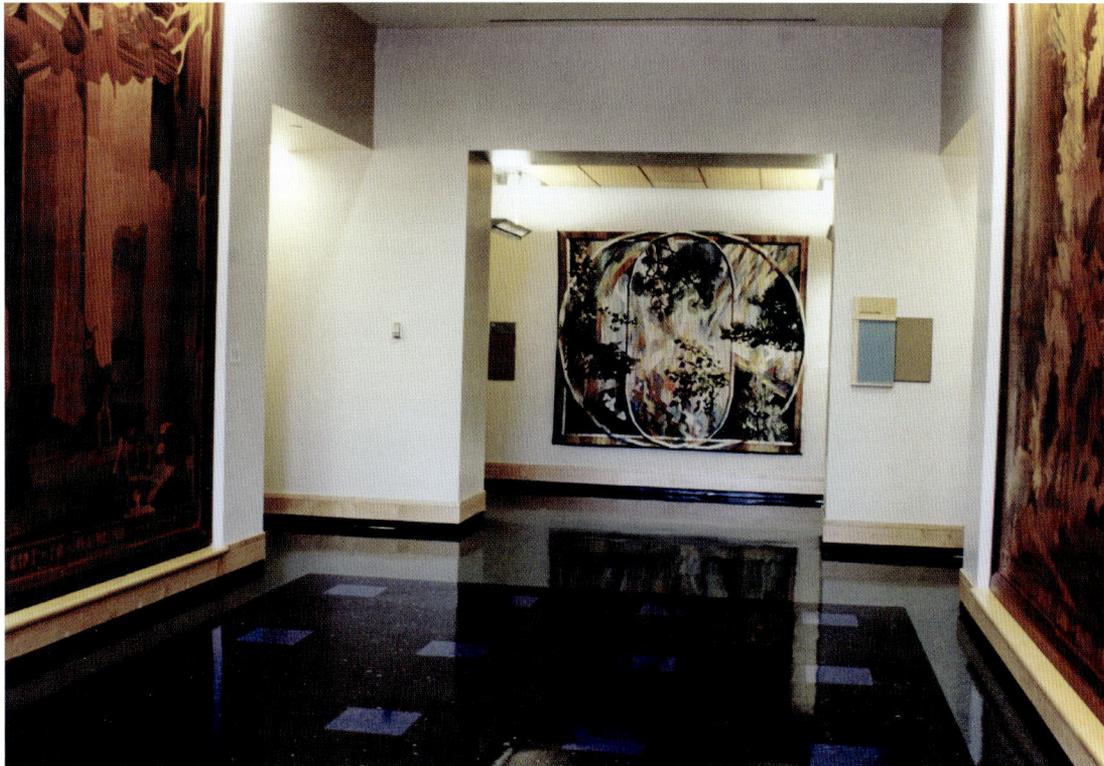

Installation view, *Oregon Foliage of the Forest Ecosystem*, Richardson Hall.

Old friends, Henderson Massengill art consultants Mikael Henderson and Gay Massengill, met Tom and me in San Antonio to tour us to missions, the River Walk, and other San Antonio attractions for me to photograph and secure a commission for two tapestries for Valero. Unlike other solo trips to secure commissions, together we all had a great time.

The following edited proposal was accepted.

Purpose of the Tapestries

The purpose of the pair of tapestries is to warm and enliven the main lobby and the employees' entrance of the new corporate headquarters in San Antonio. The tapestries will create a colorful, celebratory welcome for all visitors and employees by instilling pride in Valero and the city of San Antonio. The tapestries' imagery includes recognizable, historic San Antonio landmarks and the River Walk.

Valero in San Antonio—Past and Future

The large square tapestry for the main lobby, installed in the square marble inset wall beyond the elevators, will serve as a beacon to visitors entering the front doors of the impressive two story lobby. Titled *Valero in San Antonio: Past and Future* the tapestry will draw viewers to it via color and strong geometric organization. The graphic blue circle represents the River Walk. Inside the circle landmarks from San Antonio's past—the Alamo, the clock tower in the Quadrangle at Fort Sam Houston, and the Steves Homestead—will reveal themselves as viewers move forward. San Antonio's future in the form of the new Valero headquarters building is the base on which the historic buildings rest. The Alamo, founded as Mission San Antonio de Valero in 1718, is known throughout the world as a symbol of freedom and independence and is Valero's namesake. Construction of the clock tower and Quadrangle began at Fort Sam Houston in 1876, the same year the Steves Homestead was built on King William Street. I believe these two symbols—military and domestic—balance each other. The tapestry is finished with a beveled border suggesting a light source to the right, the direction of the employees' entrance. The corners are decorated with the same motifs that are painted on the facade of Mission San Jose.

Valero in San Antonio: Past and Future, 74" x 70", linen inlay,
commission for Valero Energy Corporation's headquarters, 1999.

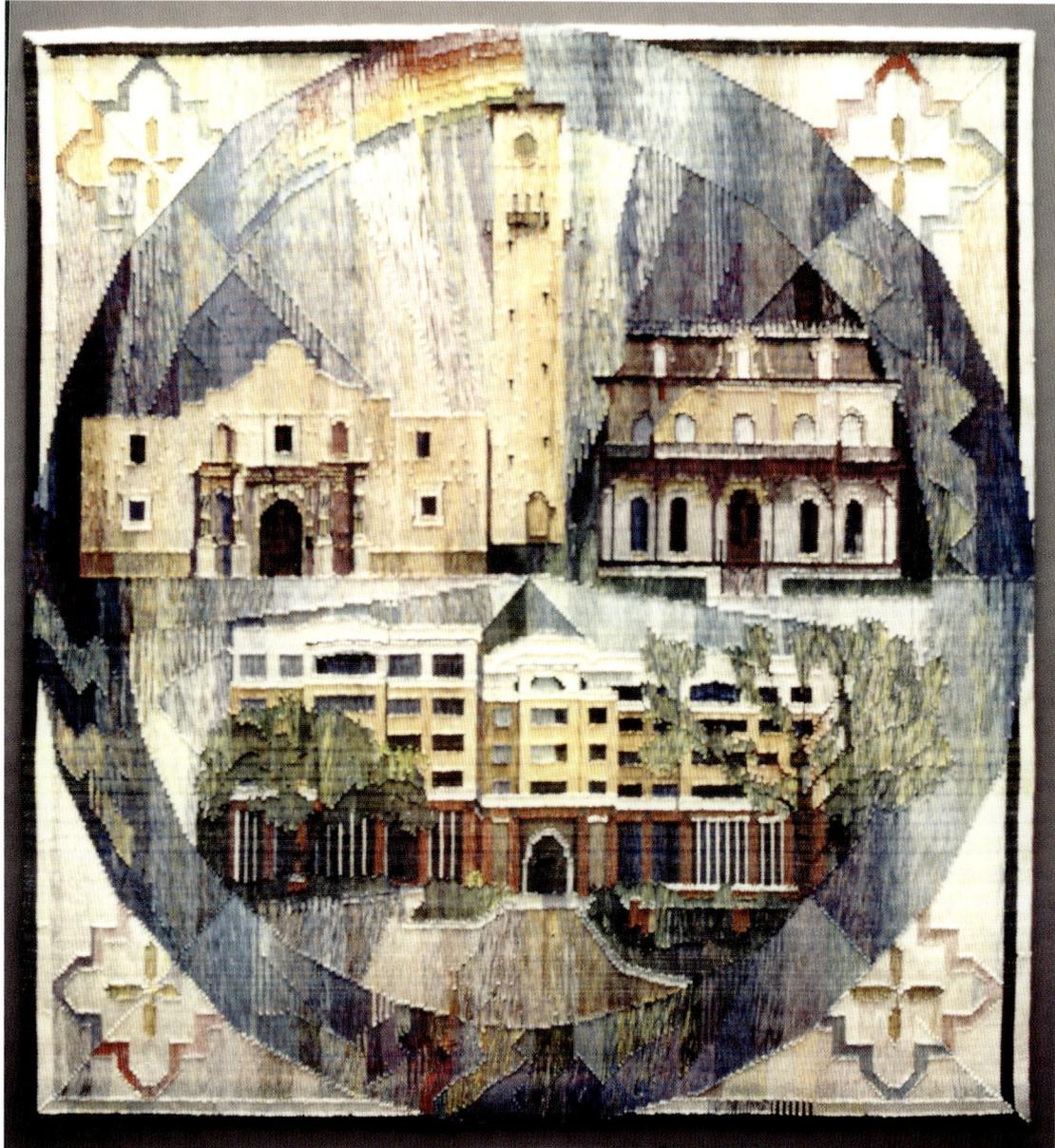

Celebrating San Antonio's Present

The tapestry for the employees' entrance titled *Celebrating San Antonio's Present*, on a wall facing *Valero in San Antonio—Past and Future*, features a horizontal oval frame containing images of good times in the city. Woven from left to right are: River Walk and Arneson River Theater with the Tower of the Americas against a night sky, Mariachi band musical instruments, the Tower Life Building at night, the Alamodome, and the Central Library. The same Mission San Jose quatrefoil motifs used in the first tapestry surround the oval inset, thereby uniting the two tapestries.

Submitted for Approval and Return

– Life size paper cartoons for *Valero in San Antonio—Past and Future* and *Celebrating San Antonio's Present*. Please adhere tape loops to the back corners of the smaller cartoon and hang in lobby. Please pin the larger cartoon to the wall facing the employees' entrance. View cartoons from a distance.

– Woven sample of water/wave pattern. Please hold woven sample near water areas in both cartoons to understand how the drawing will look when woven.

The two tapestries took three months and one week to complete.

Detail, *Celebrating San Antonio's Present*

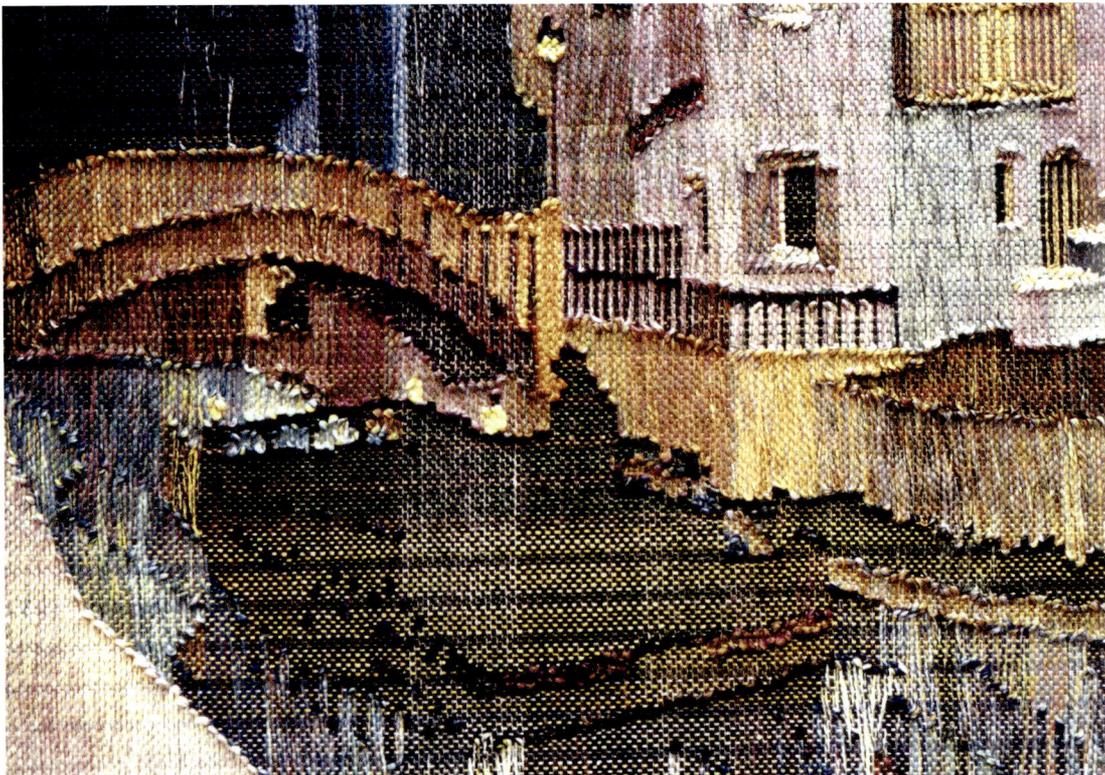

Celebrating San Antonio's Present, 75" x 99", linen inlay, commission for Valero
Energy Corporation's headquarters, 1999.

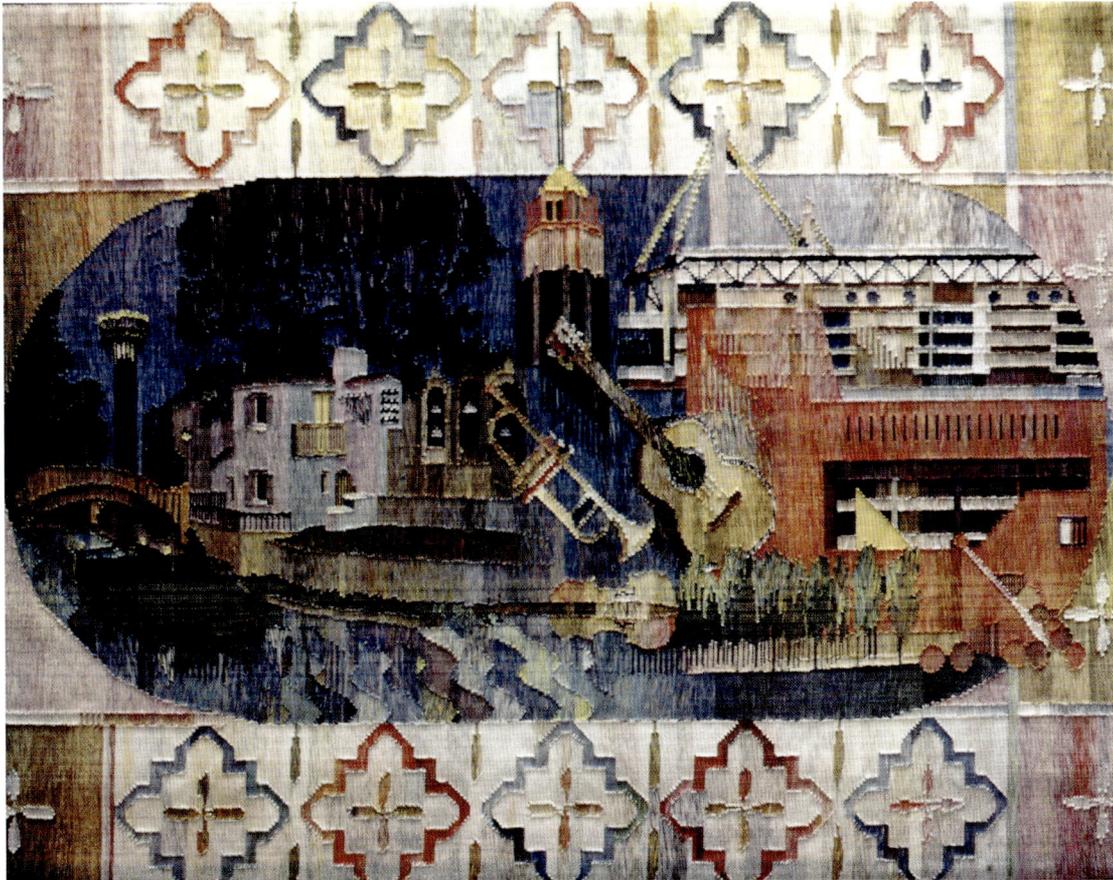

The call for artists promised a tour of the lobby, the landscape surrounding the new jail, and a canoe ride on the Columbia Slough. The latter peeked my interest, but alas a huge crowd turned out under warm sunshine and only the lobby was allowed and a speaker. I understood that children would visit the lobby, that the lobby was often fraught with visiting family and friends. I wanted to possibly change that environment with tapestries. I returned to the site with a camera, walked the Slough, read about it and used a bird guide to begin drawing and collaging a proposal.

From my proposal: The two tapestries, *Whitaker and Little Four-Corners Ponds of the Columbia Slough with Wildlife and Witnesses* celebrate the natural beauty of the surrounding outdoors in order to dignify, calm, warm, and add whimsy to the waiting area. *Witnesses* imagery in the tapestries also acknowledges the cultural diversity of users and staff.

The horizontal tapestries, separated by the eight inch wide concrete block pilaster, are a panorama of separate parts of the whole slough that unite a stimulating variety of wildlife and human observers. Indigenous foliage and wildlife pictured in the tapestry on the left, beginning in the left are: Cottonwood and Bigleaf Maple in the corners, Ring-necked Pheasants and Whitaker Pond surrounded by three witnesses. The flying birds in the top border are Caspian Terns, Northern Flicker, and Bald Eagle. The bottom border contains Gadwell, a wading Great Blue Heron, a Coyote pouncing on a Chipmunk, and a River Otter.

Continuing in the right tapestry surrounding Little Four-Corners Pond: a flying Great Blue Heron, Coyote, and three witnesses—including myself in place of a signature. Birds in the top border are: diving Belted Kingfishers, Red-tailed Hawk, Caspian Tern, and Great Horned Owl. The bottom border contains two swimming Western Painted Turtles. On the far right, a Raccoon emerges from the dark, Red Alder fills the corners. The oval divisions of the picture plane are reminiscent of eyes or views through binoculars. The curving borders that loop to surround the various witness-observer profiles are symbolic of the interconnectedness of humans with one another and with the environment.

Whitaker and Little Four-Corners Ponds of the Columbia Slough with Wildlife and Witnesses, linen inlay, each 65" x 121", mounted on hardboard, commission for the lobby of Inverness Jail, 2000.

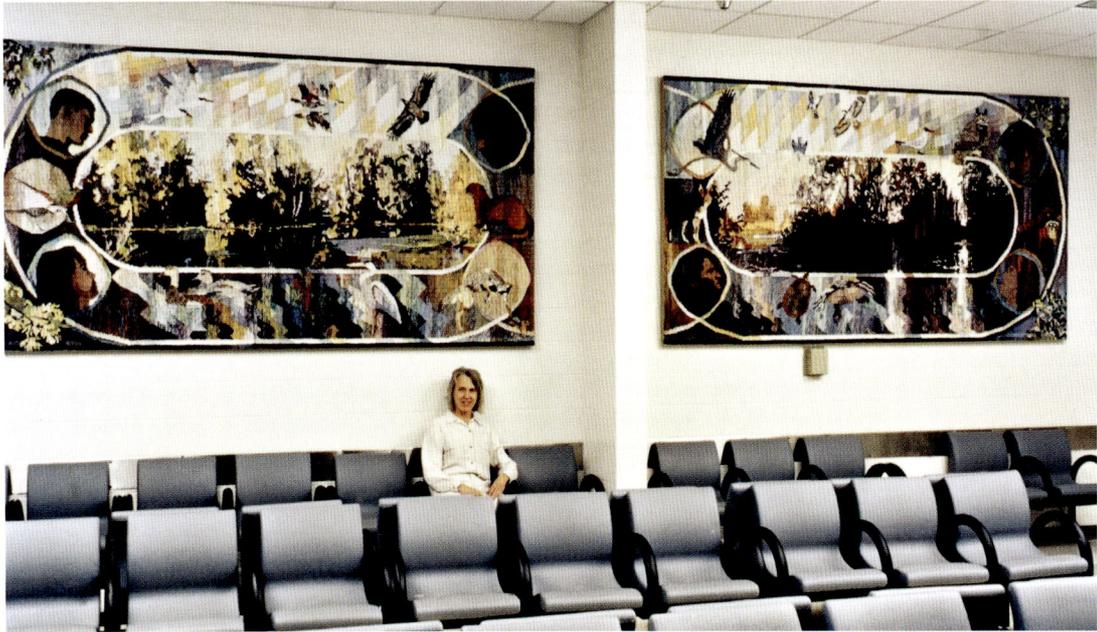

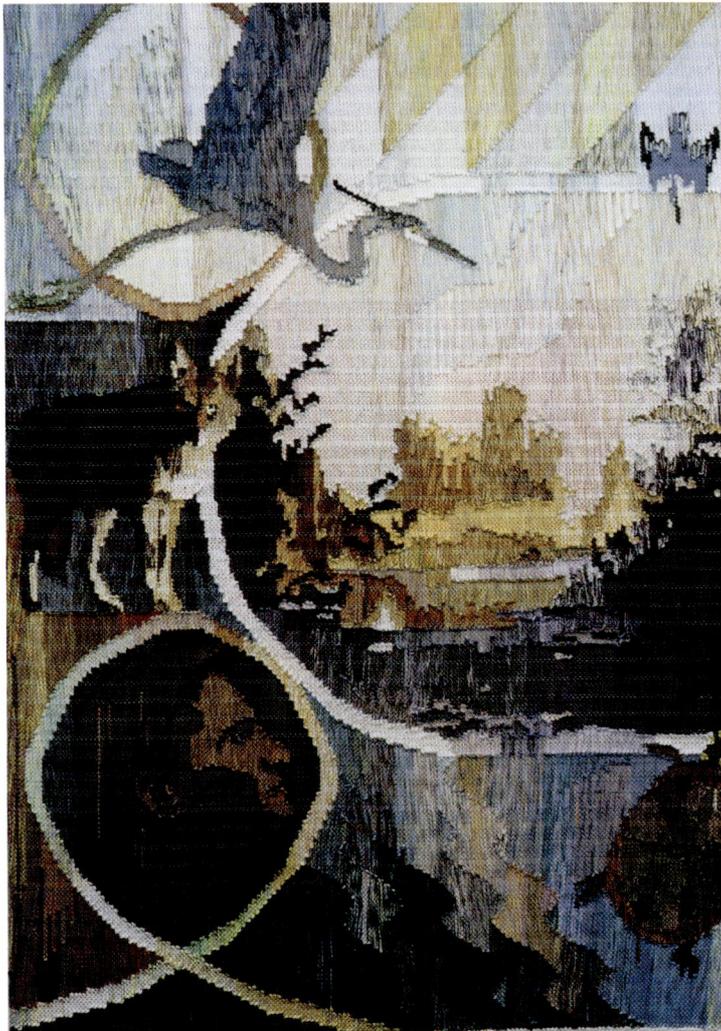

Detail, *Whitaker and Little Four-Corners Ponds of the Columbia Slough with Wildlife and Witnesses.*

This commission required study on the World Wide Web that led to drawings of our world and its surrounding cyberspace. I drew on large sheets of paper pinned to my drawing studio's eight foot by twelve foot plywood wall.

From my proposal: The tapestries relate to the function of the Student Life Building and especially to the function of the Cyber Cafe in three different ways: graphically, symbolically, and technically. Graphically, several of the tapestries depict realistic maps of recognizable places, including the spaces around them containing weather and cybernetics. Symbolically, tapestry is a metaphor for the web of people that make up a University and the World Wide Web. Technically, tapestries themselves are a web constructed on a grid of warp and weft on the loom and could be considered a metaphor for a computer monitor because both machines assemble and weave together a coherent picture.

FSU in Cyber Space, 44" x 448", linen inlay, commission by Florida State University for the Cyber Cafe in the Student Life Building, 2001.

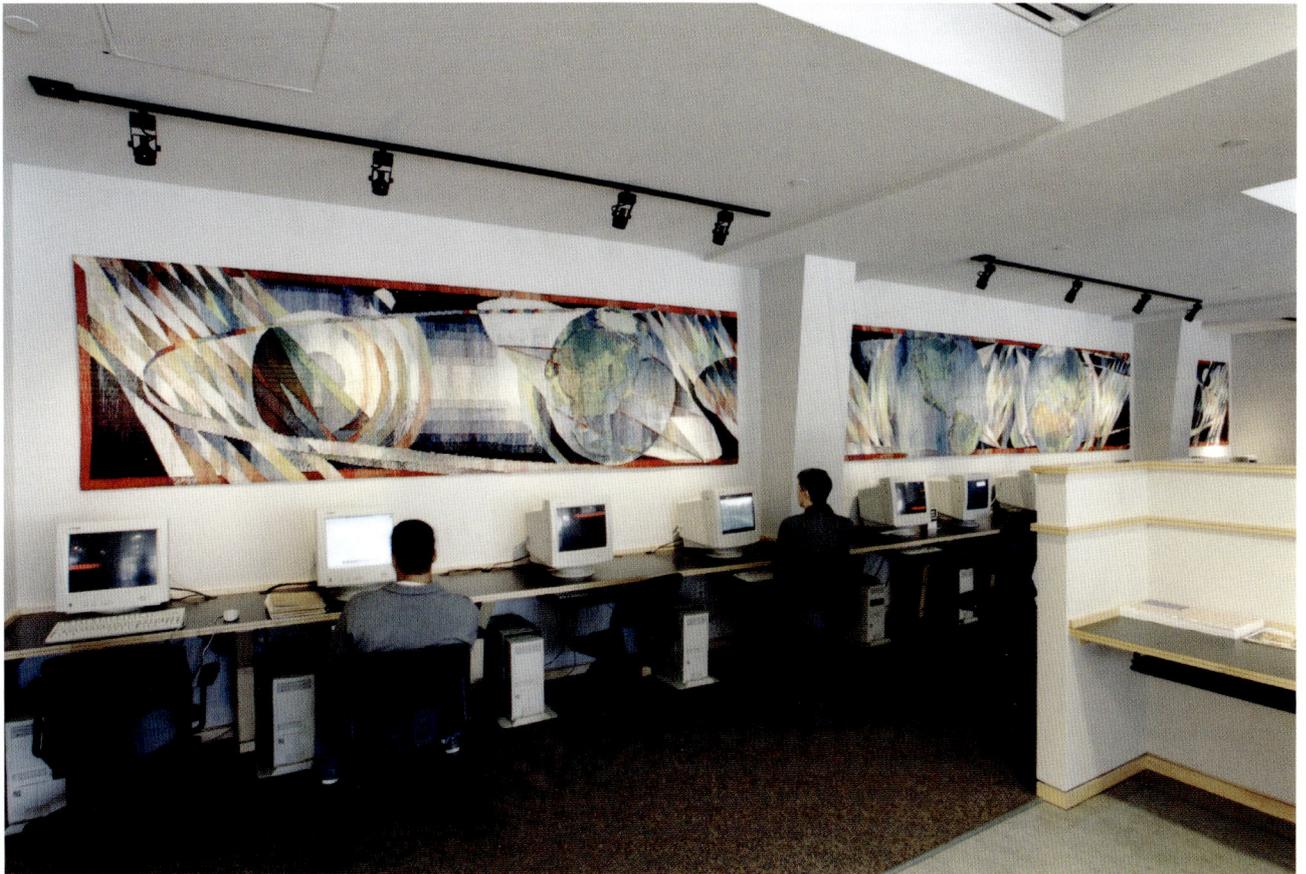

Three trips to Aurora from Portland were required for this commission. My first presentation was turned down and assigned to a competing artist. I was called back to present for a new site, the main lobby. After the third trip, with the following suggested corrections, I was awarded the commission. When the tapestries were received in Aurora, they were hung side by side, with TV screens below each, instead of on the North and South walls that flank the west lobby in what I consider a cluttered environment.

From my proposal: *Early Aurora* and *Aurora Now*. The subject matter of the tapestries is Aurora history told via historic buildings, aircraft, indigenous and planted trees and shrubs. The purpose of using this subject matter is to show the progress of the city of Aurora from its founding in 1907 and to celebrate the opening of the new Municipal Center.

I divided the history in the two tapestries at the year 1945. In the sky, fore- and mid-grounds of *Early Aurora* are the native trees and shrubs of cottonwood, pine, rabbitbrush, thistle, and mullein. Historic buildings pictured are, from left to right, John Gully Homestead, 1871; Melvin School, 1922; DeLaney Round Barn, 1902; Aurora Town Hall, 1907; in the background Fitzsimmons Hospital, 1942; and in the sky aircraft of Lowry Field, circa 1943.

Aurora Now pictures the new Nighthorse Campbell building of the University of Colorado Health Sciences Center, the new Aurora Municipal Center with circular shape representing the fountain, the Chapel at Fitzsimmons, the Fox Arts Theater, the Buckley Satellite Trackers, new neighborhoods, and two F-16 aircraft in the sky represent the progress of the city. Trees in the foreground are Blue Spruce– the state tree of Colorado, Pine, and Aspen. Trees against the sky are those approved by the city for street trees: maples and pines. The city seal, center bottom, encloses the name of the city, Aurora.

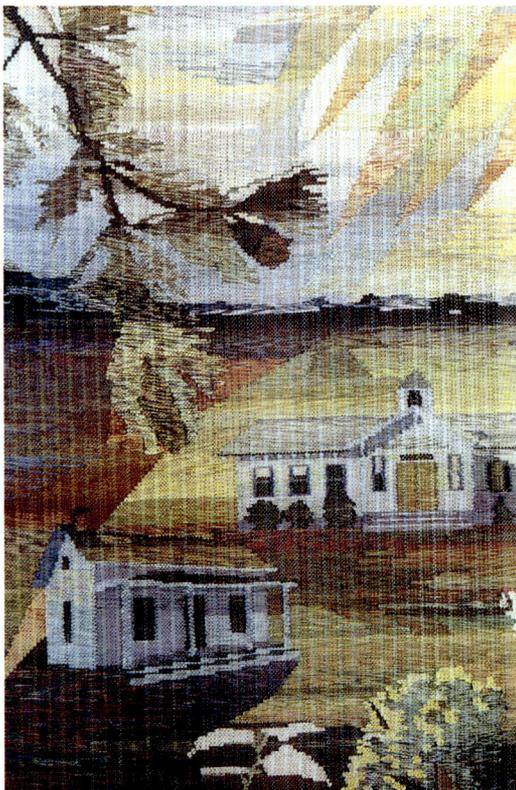

Early Aurora detail.

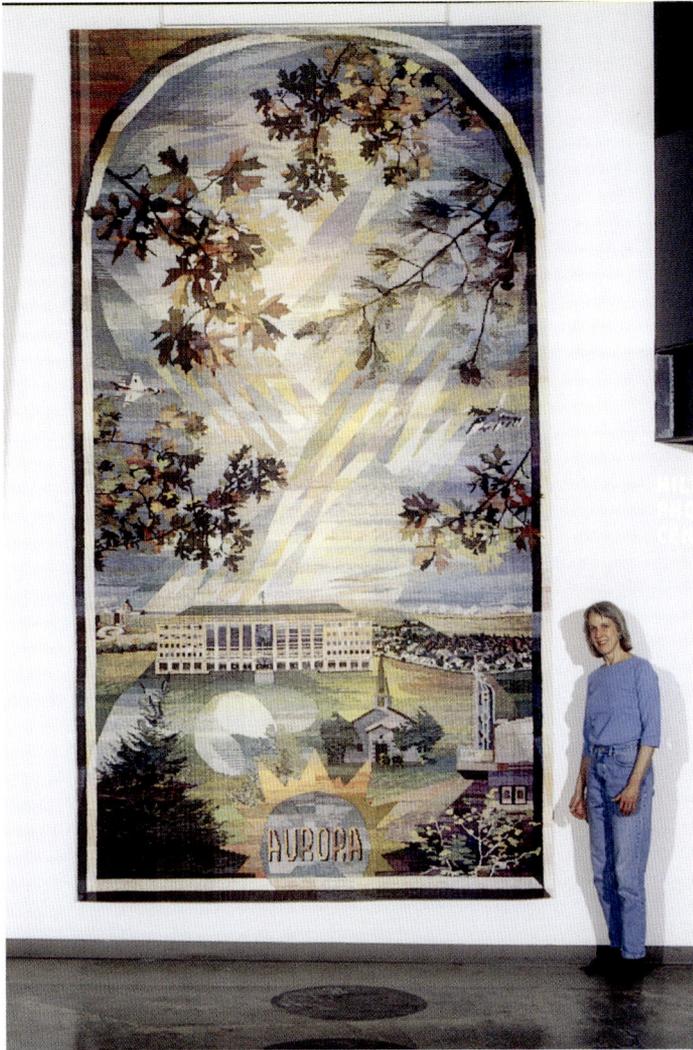

Early Aurora, 180" x 96", linen inlay, commission for the new Aurora (Colorado) Municipal Center, 2003, photographed in the Commons of Pacific Northwest College of Art, Portland.

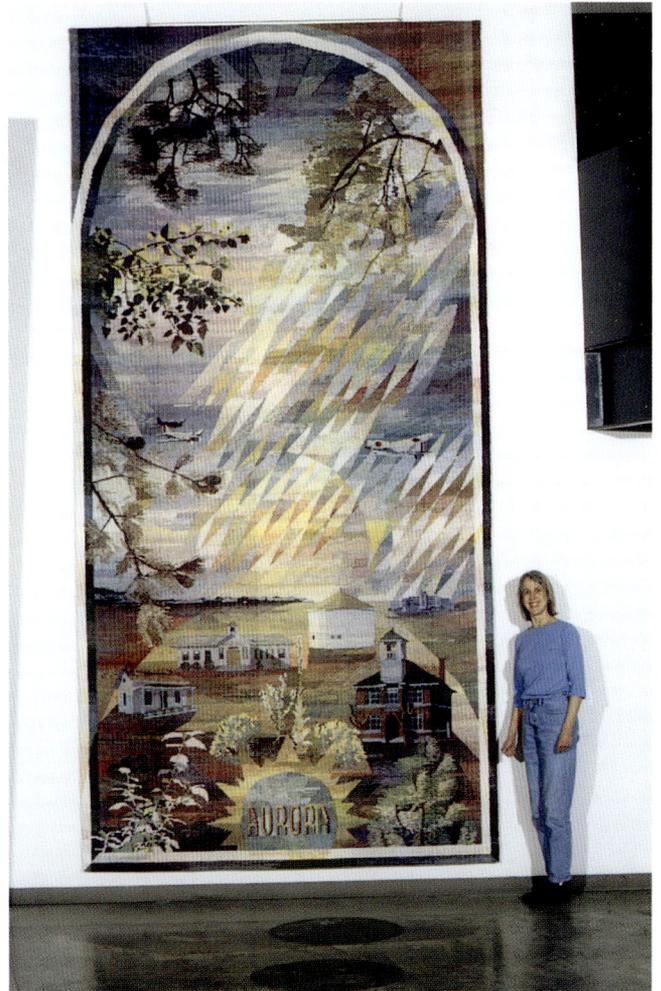

Aurora Now, 180" x 96", linen inlay, commission for the new Aurora (Colorado) Municipal Center, 2003, photographed in the Commons of Pacific Northwest College of Art, Portland.

Dawn, Afloat, 45" x 47", linen inlay , 2007.

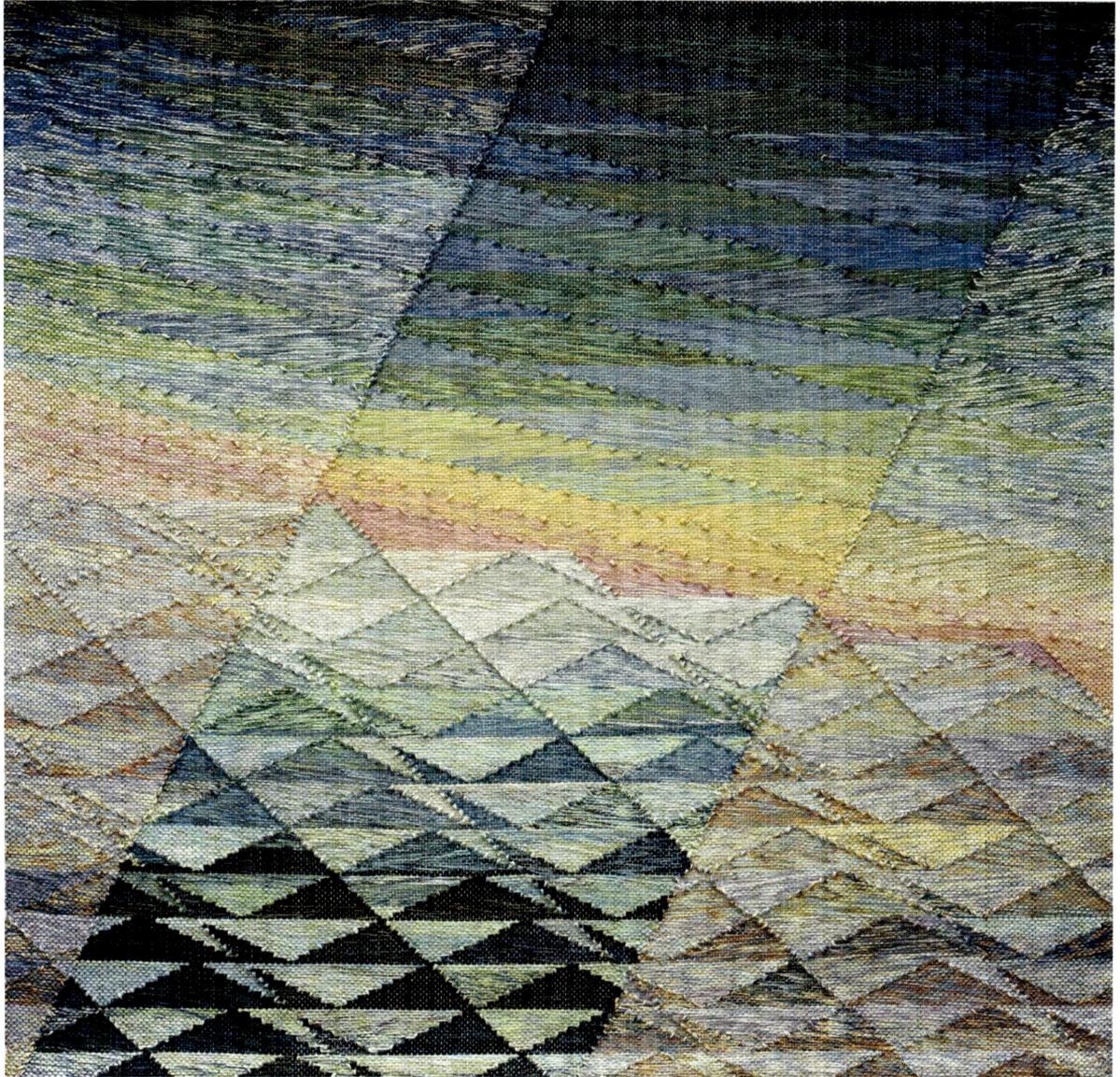

CHAPTER X

AFTER LAURA

Tom and I showed together for the first time at the Laura Russo gallery in April 2010, Tom in the front gallery, I up a few steps in the upper gallery.

I returned to double weave with much enthusiasm. Of the eleven exhibited weavings, seven were double weave. I titled my show *Water and Wind*.

The two different warps for *Armada* and *Armada II* each have eight threads per inch, two of the eight are contrasting colored threads that delineate the edges of the vertical strips. Weaving progresses bottom to top and eight rows weave one inch, making a firm, balanced weave. Weaving progresses thusly—Pick up the strips on a pick up stick, push the stick toward the beater, weave first row of bottom layer, beat, push pick up stick to beater, weave second row of bottom layer. Pull out pick up stick, weave two rows of strips on the top layer. Repeat ... Please see an additional explanation of double weave accompanying *Blue, Green and White*, 1968.

Armada and *Armada II* both in private collections, Portland.

Armada, 44" x 37", linen double weave, 2009.

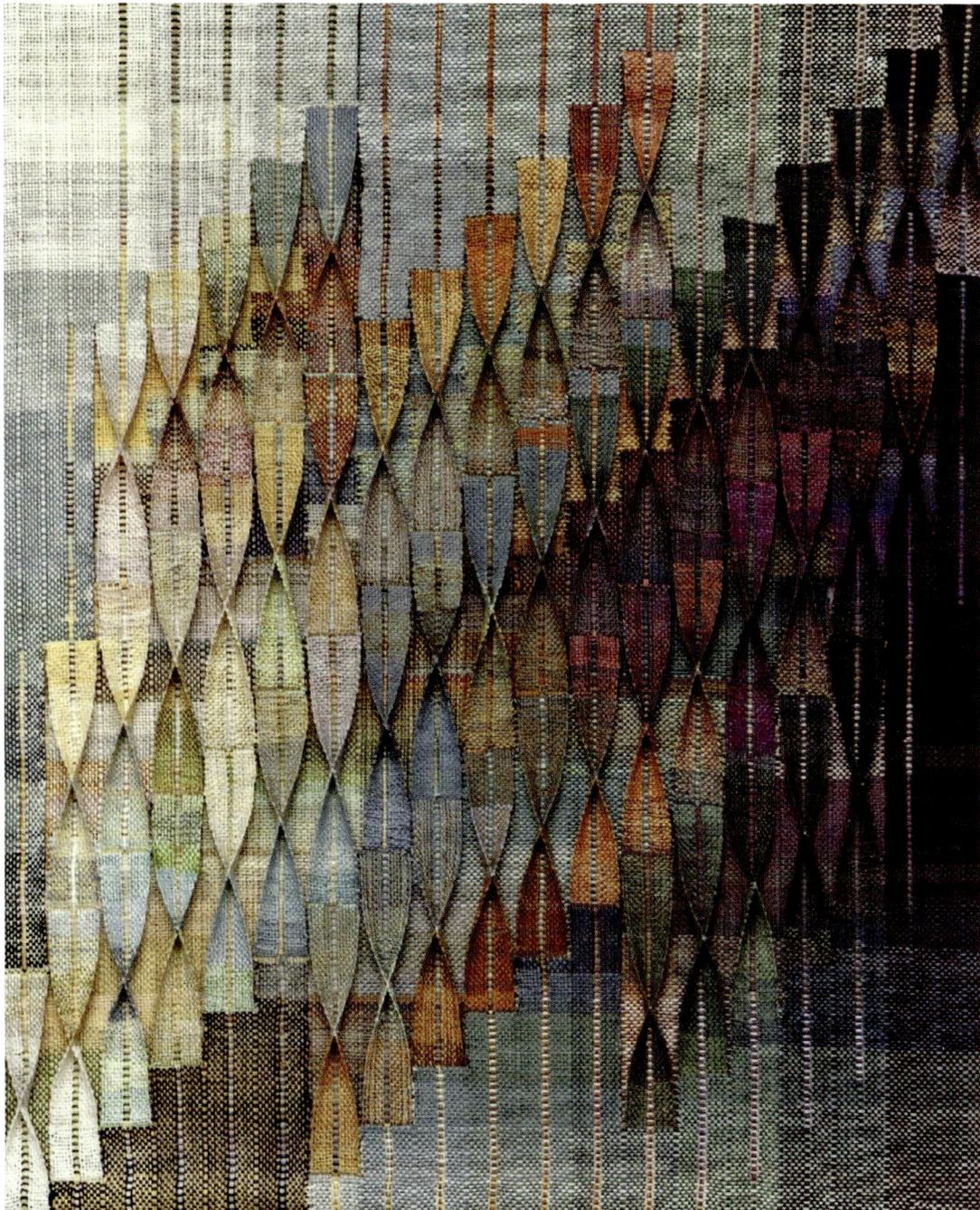

Armada II, 41" square, linen double weave, 2009.

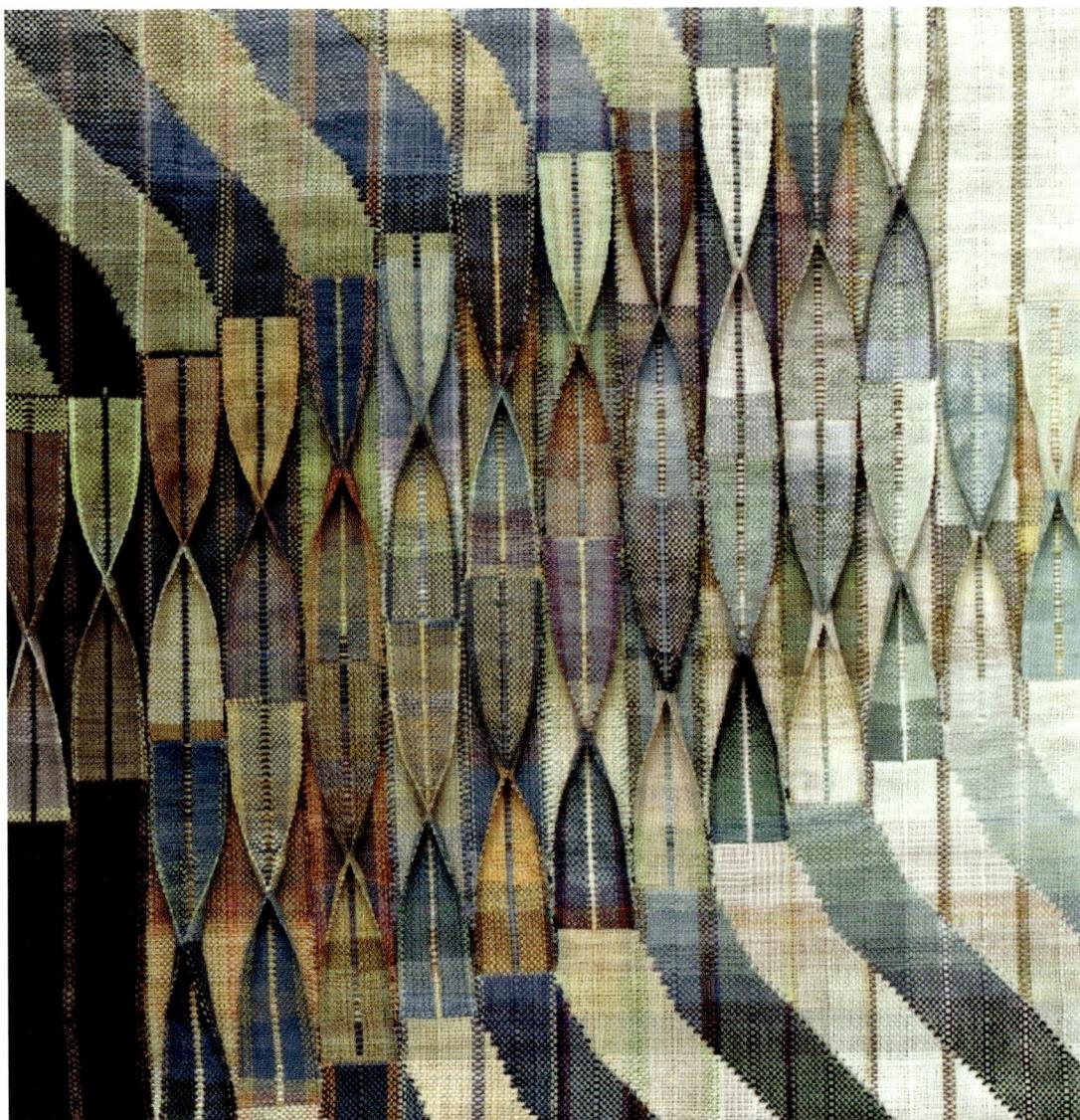

Detail, *Armada II.*

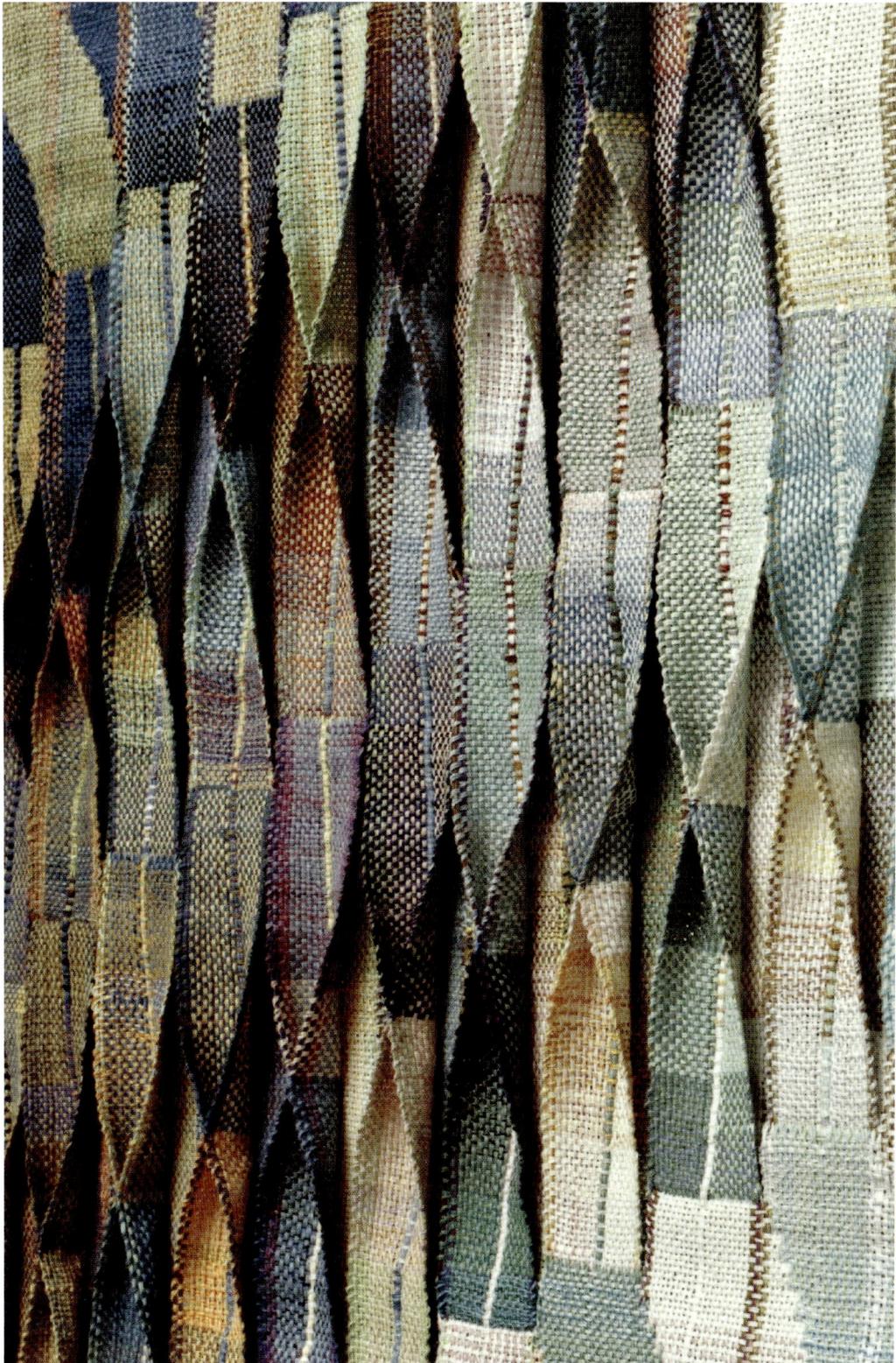

A twinkling of falling water across perhaps a rocky wall. The plan was drawn on graph paper using a repeating bar motif with drip lines that grow longer at the bottom of the falls. Colors chosen as I wove.

Twin Falls private collection, Eugene.

Twin Falls, 47" x 48", linen inlay, 2008

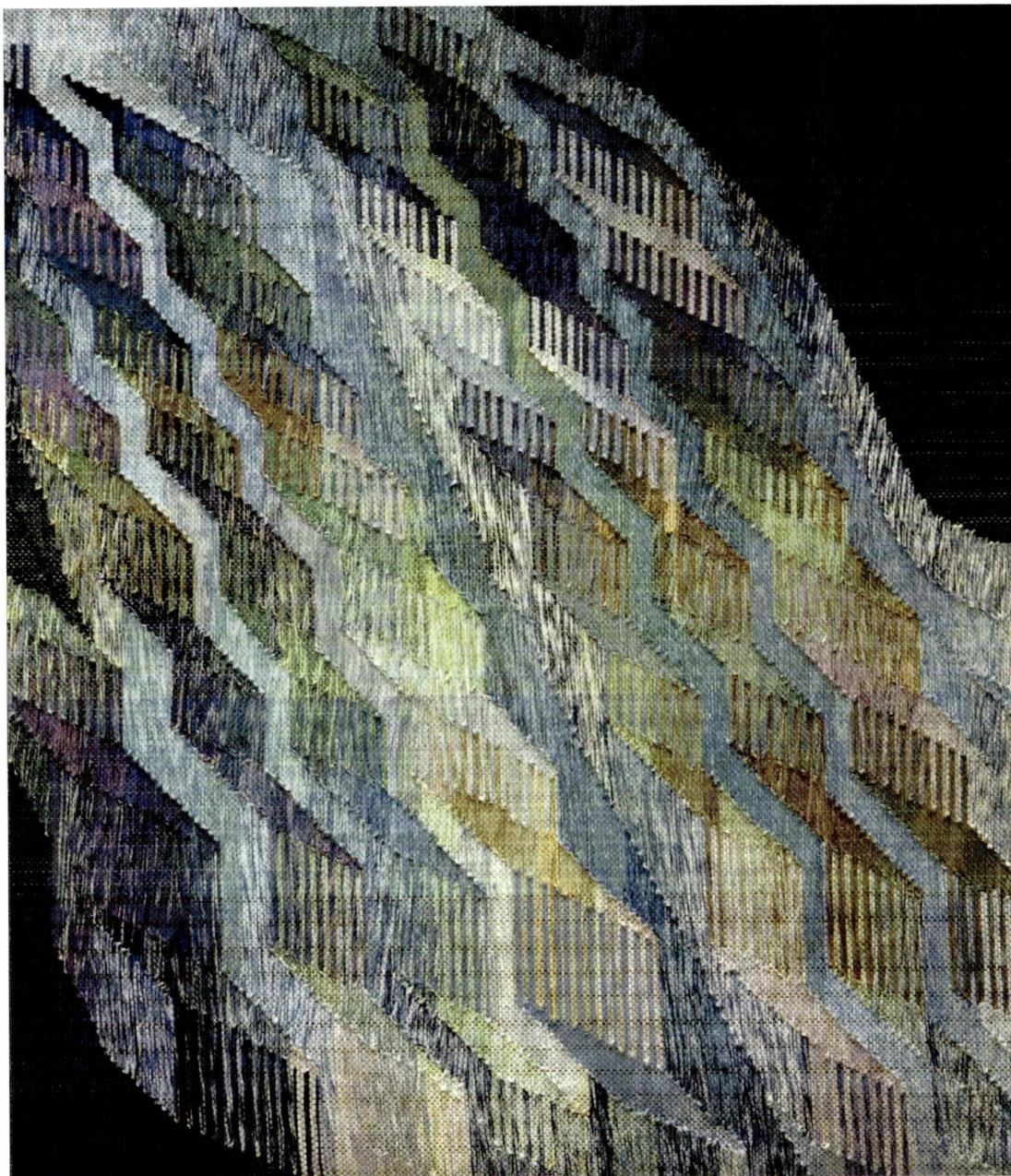

Boats are natural companions of wind and water. I couldn't leave them out of the exhibition. *Fleet* private collection, Portland.

Fleet, 31" x 39", linen inlay, 2009.

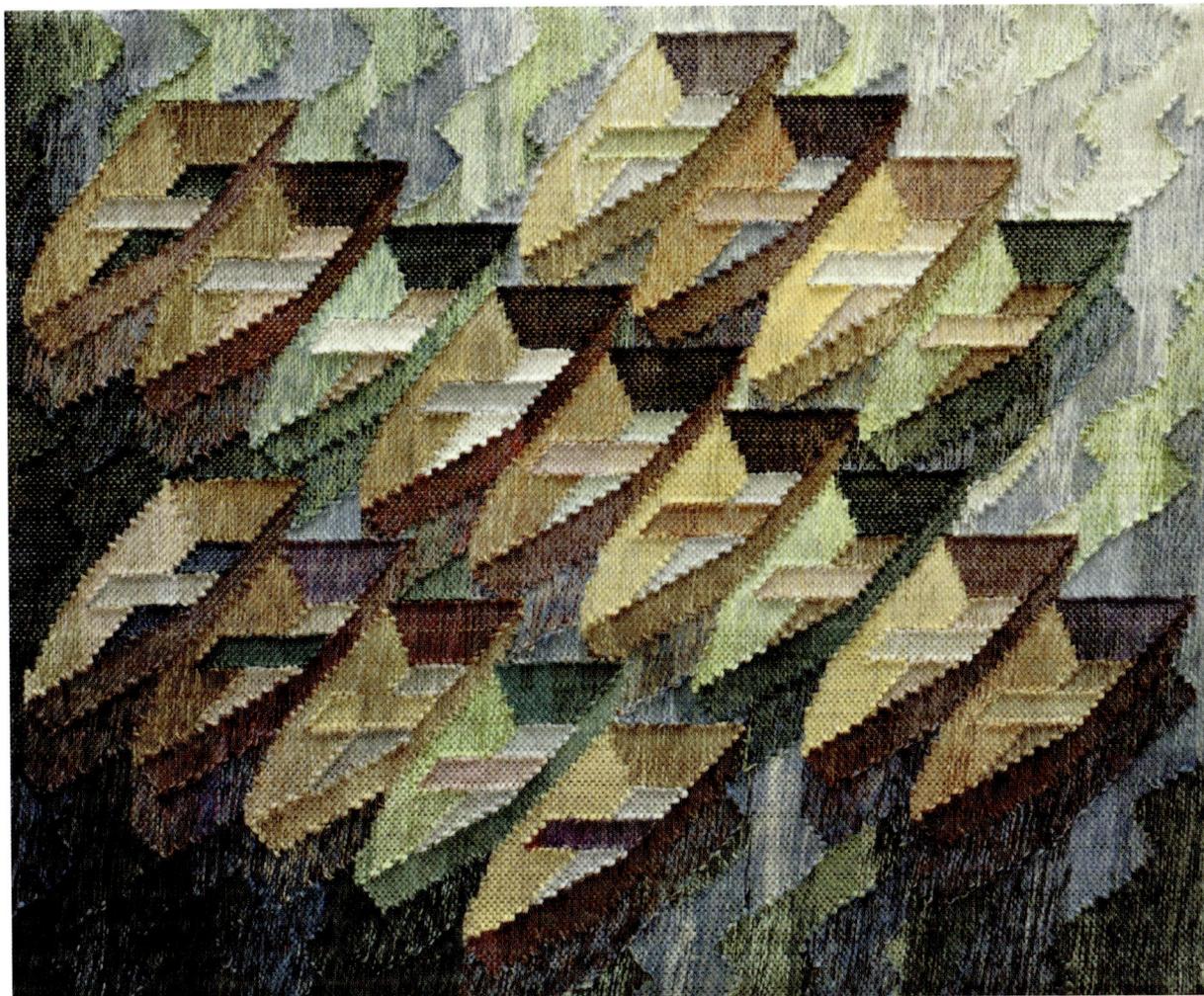

Both wind inspired double weaves spring from the same warp made of Euroflax 14/4 doubled, set at 8 ends per inch. The weft was the same, sometimes varied by quadrupled 16/2 linen threads.

Gust private collection, Tallahassee, Florida.

Northeaster private collection, Portland.

Gust, 45" x 41", linen double weave, 2009.

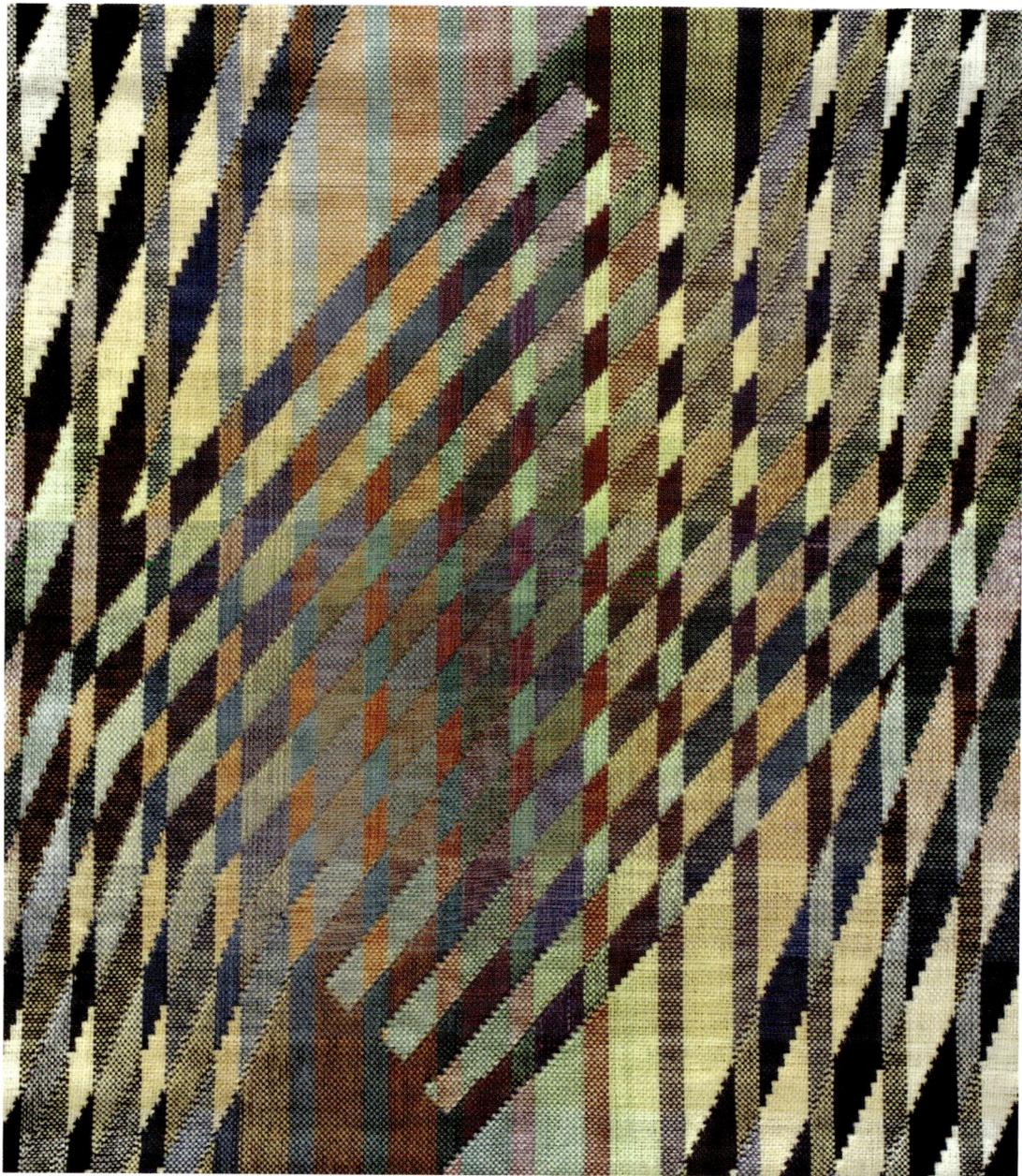

Northeaster, 42" x 41", linen double weave, 2009.

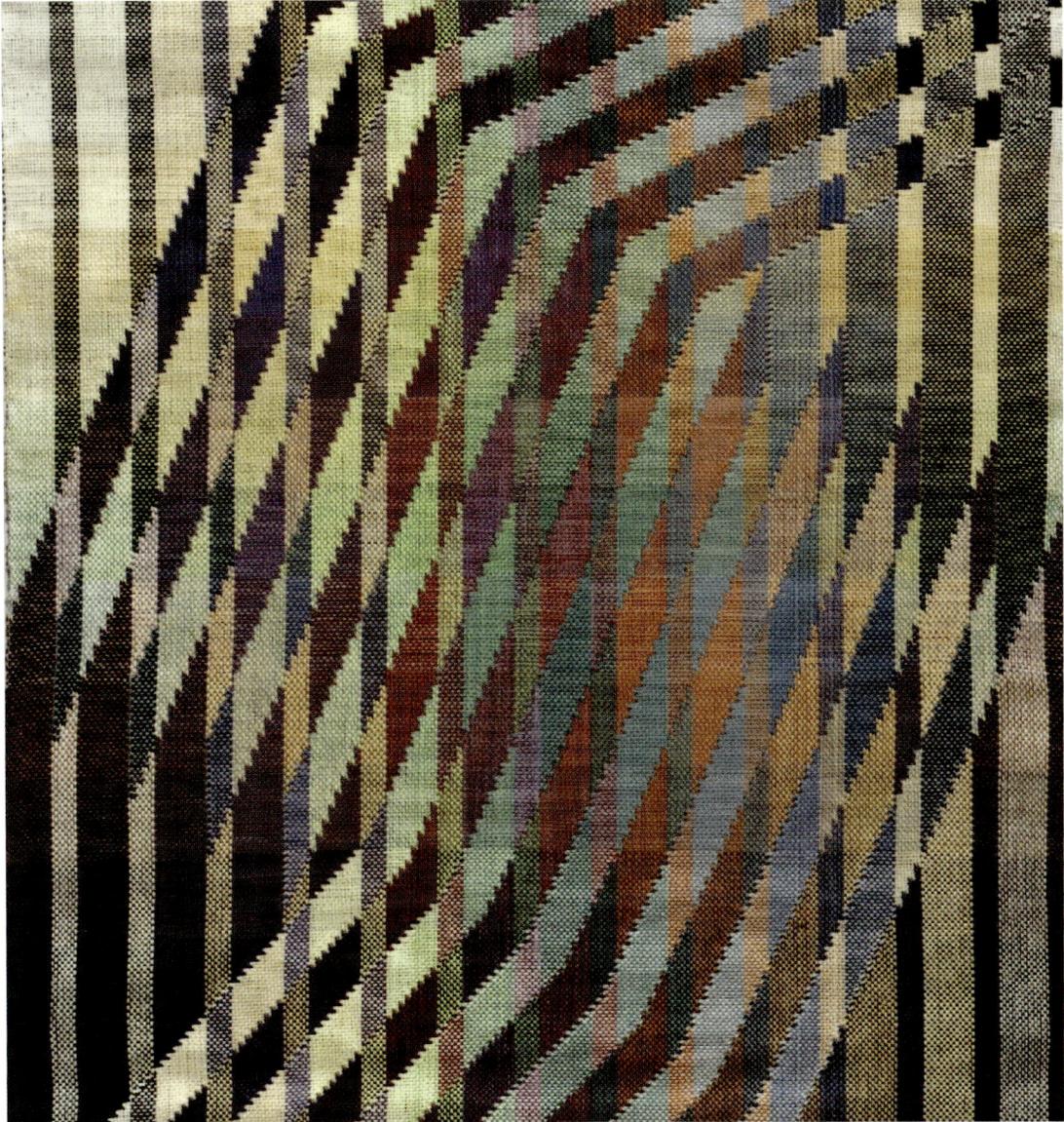

Remembering that walk with Liz years ago on a Hawaii beach, I made many drawings on graph paper. This double weave is as close as I could get to memorializing those sunny reunions during the middle of this decade.

Sea and Sand, private collection, Portland.

During the exhibition I gave my first PowerPoint presentation, assembled by Katrina Woltze, to the Portland Handweaver's Guild at the Multnomah Art Center. The crowd was estimated at over 100 and I had a very good time meeting new and old weavers.

Of eleven tapestries in the 2010 exhibition, seven sold, the most sales I've ever had in eight exhibitions at the Laura Russo gallery. The sales, so soon after Laura's death and during the lingering recession, cheered me and the gallery staff.

Soon after these fortuitous events my right arm and shoulder painfully froze, causing a very limited range of motion. I knew intuitively that inserting the metal pick up rod over and over for the seven double weaves had caused the problem. After half a year of physical therapy, acupuncture, and home and class exercises I am almost my old self.

And so I've just completed four new inlay tapestries based on color graded geometric shapes, not yet hemmed or pressed. On my next birthday I turn 70 and hope to be weaving into a productive older age.

Sea and Sand, 31" x 42", linen double weave, 2009.

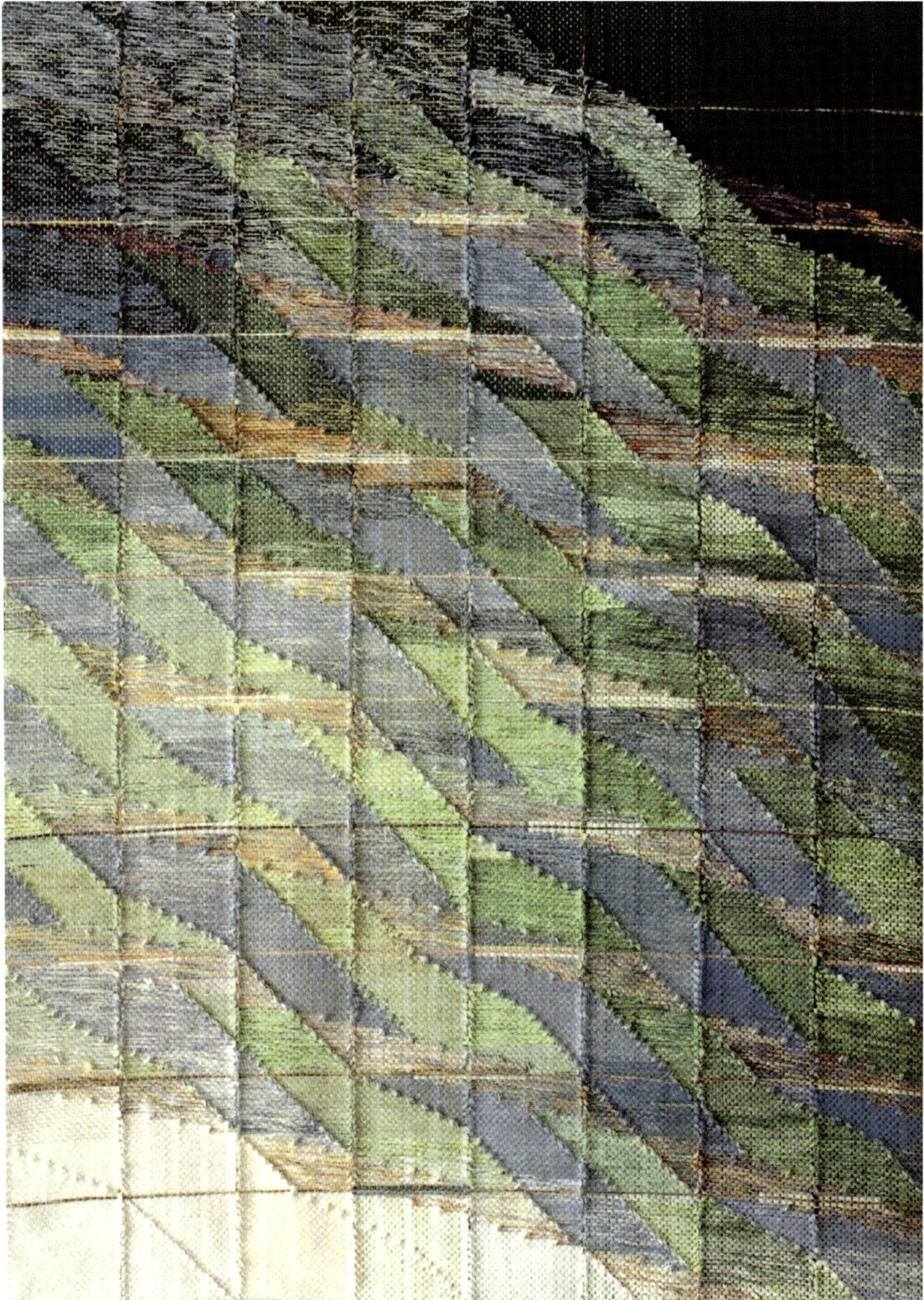